For Cathy

Contents

Chapter 5
Choosing a Digital Camera 131

Preface

You've taken your last snapshot, and grabbed your last video clip! This book will help you move to the next level, using digital imagery to create exciting images of your favorite photo subjects and events. Whether you're looking to create picture-perfect stills or transfer your videos to neatly-edited, professional-looking DVDs, you'll find everything you need to know in this book.

This book is your introduction to all the exciting things you can do with images, from your camera to your printer, from your print to your computer, and videotape to DVD…plus a lot more!

About the Book

Images and sound have always fascinated us, because of their power to preserve memories, tell stories, and convey information quickly and memorably. Digital imagery takes traditional photography and video to the next level, giving you the power of the computer to shape pictures and sound into the exact finished product you want.

This book is organized into easy-to-digest bites, with stand-alone chapters you can read in any order to learn exactly what you want to know about computers; capturing, editing and transferring videos; shooting digital still photos; sharing pictures; and making prints.

The great Hewlett Packard products are used as examples throughout this book, because HP is the only manufacturer that produces every component (other than video cameras) that you

need to enjoy digital imagery. These include media-ready computers, digital cameras, scanners, DVD burners with built-in video capture capabilities, and printers. However, if you use components from other manufacturers—say a different computer or DVD drive—everything in this book will still be useful to you.

So, if you want to know how to outfit your computer for best results, you can start out with Chapter 1, "Your Digital Imagery Computer." If you'd rather jump right in to learning how to capture or transfer your existing videos to digital form, you can skip ahead to Chapter 2, "Preparing to Capture Your Videos" or Chapter 3, "Transferring Your Video to Computer." Need to edit your videos? Chapter 4 shows you how.

Perhaps still photos are more your cup of tea. You can learn how to choose a digital camera in Chapter 5, and discover some ways to take better pictures in Chapter 6, "Going Beyond Point-and-Shoot." Chapter 7 will get you started editing your digital photos, and Chapter 8 offers tips on how to share them with others through email, Web pages, or digital photo albums.

If you want to digitize your existing snapshots so you can edit them in your computer, Chapter 9, "Grabbing Images with a Scanner," reveals the secrets of the HP ScanJet line. The company's other claim to fame, printers, is the focus of Chapter 10.

Even if you purchased this book because you wanted to learn just one thing, say, how to transfer VHS videos to your computer, I hope you'll explore everything that digital imagery has to offer. Still photos, videos, prints, and online images all provide you with different ways of enjoying and sharing the sights and sounds that make your life interesting.

Acknowledgements

Thanks to the folks at Prentice Hall Professional Technical Reference, including executive editor Jill Harry, production editor Kathleen Caren, and the panel of reviewers. Thanks again to my agent, Carole McClendon, for putting this all together.

About the Author

David D. Busch has been demystifying arcane computer and imaging technology since the early 1980s. However, he had a successful career as a professional photographer for a decade before he sat down at the keyboard of his first personal computer. Busch has worked as a newspaper photographer, done commercial studio and portrait work, shot weddings, and roved the United States and Europe as a photojournalist. His articles on photography and image editing have appeared in magazines as diverse as *Popular Photography and Imaging, Petersen's PhotoGraphic, The Rangefinder,* and *The Professional Photographer,* as well as computer magazines such as *Macworld* and *Computer Shopper.* He's currently reviewing digital cameras for CNet.

Busch has written more than 75 books since 1983, including the mega-best-sellers *Digital Photography All-In-One Desk Reference for Dummies* and *The Official Hewlett-Packard Scanner Handbook.* Other recent books include *Digital Photography Solutions, Mastering Digital Photography,* and *Mastering Digital Scanning with Slides, Film, and Transparencies.*

He earned top category honors in the Computer Press Awards the first two years they were given, and later served as Master of Ceremonies for the awards.

Your Digital Imagery Computer

In this chapter...

✔ **What Do You Need?**

✔ **Microprocessors**

✔ **Memory**

✔ **Operating System**

✔ **Video**

✔ **Monitors**

✔ **Storage**

✔ **Other Computer Considerations**

Compared to mundane applications like word processing or Web browsing, digital imagery places some special demands on your computer. An older computer that works just fine for accessing email might not have the punch needed to smoothly display DVDs, convert video to a digital format, or manipulate large images from your digital camera. To improve your productivity, save tons of time, and multiply the fun factor, you'll want a speedy computer that's ready for everything you throw at it.

That's not to say that if your computer is a year or two old, you need to junk it. There are a few simple and inexpensive upgrades that you or your computer retailer can perform that will add years to the life of your computer, while giving it renewed pep. However, when you see just how much more newer computers can do, at relatively low prices, you may want to go ahead and spring for a new system especially designed for creating DVDs, printing images, and working with digital camera files. This chapter will explain the features you should look for in a computer that will handle all your digital imagery needs, and show you how to upgrade your existing system if you wish. You'll also learn everything you need to choose that dream computer that will serve you now and in the future.

What Do You Need?

The basic requirements for a versatile and robust computer fall into a few simple categories. These include the following items. If you don't know what some of these components are or what they do now, don't worry. I'll explain them all in the following sections.

- **Microprocessor speed.** How fast do the "brains" of your computer operate?
- **Operating system software.** The operating system is the software that controls all the functions of your computer, including how other applications work, how your digital files are stored and retrieved, and how your computer works with devices such as DVD player/writers and printers. Some versions are better than others and offer more features for digital imaging!
- **Memory.** Your computer's memory is that very fast, but temporary storage used to hold programs, images, and commands

while you're working. How do you decide how much memory you need? I'll tell you!

- **Video.** The video system of a modern computer really gets a workout. This system consists of two parts: the display screen itself (which can be a traditional CRT or a sexy new liquid crystal display [LCD]) and the component called a video card, which generates the output and, sometimes, receives input from your camcorder, VCR, or other source. Your video system must be fast and capable of handling the most complex DVD and 3D game displays you work with.

- **Storage.** Where do you store your pictures, videos, and other files? Today your options are both extensive and open-ended. The traditional storage location, your computer's hard disk drive, has morphed into a faster, more spacious destination for digital files. And newer options, such as DVDs, provide more generous space, plus the ability to share your files with others who have home DVD players or DVD drives included in their computers.

- **Connectors.** Your computer may need certain connectors, called interfaces or ports, to link up with some of the equipment you want to use. These interfaces have names like USB and FireWire, and all computers sold in the last few years either already have them or can easily be expanded to include them.

Learn more about each of these components in the next sections.

Microprocessors

Microprocessors, the brains inside a computer, are everywhere these days. Your automobile probably has more computing power than the systems used to send astronauts to the moon. You'll find incredibly complex microprocessors inside your microwave oven, your television, or even that cell phone that can double as a camera, personal digital assistant (PDA), or game machine.

Your computer has a microprocessor, of course, and probably includes several of them, each more sophisticated than the computer chips found in the earliest personal computers. One large microprocessor handles all the "computing" that you do. Others may reside on the video card that displays your applications, inside the DVD/CD burner that creates your digital movies and archives files, and even in your computer display and keyboard. All work together so that when you press a key, click with the mouse, or perform some other function, something happens.

The most important microprocessor is the main chip that drives your computer. Today, 90 percent of all computers sold use either Pentium 4 chips from Intel or Athlon processors from Advanced Micro Devices. Each has advantages of its own, and Hewlett-Packard offers Presario and Pavilion computers built around both brands of microprocessor.

Athlon processors, like the one shown in Figure 1.1, are often priced a little more economically than Pentium 4 processors with similar performance, and are often used in entry-level computers to provide the most bang for the buck. In the past, Pentium 4 processors were sometimes favored for business applications and for home users who want "deluxe everything" in their systems. However, the higher speed AMD chips are just as fast as the speediest Intel processors, and the latest Athlon 64 chips found on several HP Pavilion PCs are truly state of the art. You can trust the designers of your computer to match the right microprocessor with the application that computer is intended for, using descriptions like "superior performance," "value and flexibility," or "Media Center PC" to help to match your needs with the computer that will do the job.

FIGURE 1.1 AMD's Athlon microprocessors provide exceptional performance at an economical price.

In practice, it really doesn't make a lot of difference which microprocessor your computer includes. Instead, the operating speed is more important, because the speed at which the computer's brains operate helps determine just how quickly your applications run, including image-editing programs for your digital pictures or DVD movie players.

That operating speed is measured using a yardstick called "gigahertz," abbreviated GHz. The number refers to the number of processing cycles per second, in billions. (Today's trivia: Like many electronic terms, including Ohm, Watt, and Ampere, Hertz was named after an actual person, physicist Heinrich Hertz.) You'll also see the term "megahertz" used, which refers to millions of cycles per second. So, 2000 and 2400 Mhz microprocessors are the same as 2.0 and 2.4 GHz processors, from a speed standpoint. The important thing to know is whether you are using or considering a 2.0 or 2.4 or 2.8 or 3.0 GHz computer, or one operating at another speed.

The higher the gigahertz measurement, the faster the computer operates. For image editing and digital movie-making, a computer in the 1.0 GHz range can be pressed into service (if you have lots of

memory and hard disk space), but you'll get the best results from one with a speed rating of at least 2.0 GHz or the equivalent.

Of course, the speed of a computer depends on many more things than just the speed in gigahertz. The number of computer commands your computer can carry out during each of those millions of cycles per second, as well as how those commands are lined up and fed to the microprocessor, can be important, too. That's why AMD microprocessors aren't rated like the Intel chips, using the pure processor speed in gigahertz. In some ways, AMD processors are more efficient than their Intel counterparts, so an Athlon chip that runs at 2 GHz may equal or exceed an Intel microprocessor at 2.4 GHz. For that reason, Athlon processors are rated according to their equivalent speed. An Athlon 2400+ chip runs at about the same speed as a 2.4 GHz Intel Pentium 4, an Athlon 3000+ is roughly the same as a Pentium 4 3.0 GHz chip, and so forth, for all practical purposes.

So, when shopping for a new computer, you'll want to compare the speed ratings, however they are calculated. A 2.4 GHz Pentium 4 (or 2400+ Athlon) is faster than a 2.0 GHz Pentium 4, and 2.8 GHz or 3.0 GHz chips run faster yet. It's hard to go wrong in estimating processor speed if you use these figures. Of course, other factors, including how much memory you have, the speed of your hard drive, video card, and DVD drive can affect how quickly your computer runs, but we'll get into those later on.

Just how fast a computer do you need? As I mentioned earlier, for basic editing of digital camera images, viewing DVDs, or creating DVD movies, an older 1.0 GHz computer may do a fine job. You might have to add more memory, upgrade to a larger hard drive, or be willing to wait awhile as your computer grinds away, but you can still have a lot of fun. If you're thinking of jumping right into digital imagery and buying a camera or, perhaps, an external accessory like the HP DVD Movie Writer DC3000, go ahead. These components can be quickly moved to your new computer when (not if) you decide to upgrade to a faster computer later on. The money you spend now will be well-applied when you graduate to a speedier system.

However, if you already own a computer that operates in the 1.8–2.0 GHz range or faster, you're probably all set in terms of microprocessor speed. I'll recommend some additional upgrades to consider later on.

Should you be considering the purchase of a spanking new computer, by all means look at the many models available with speeds of 2.0 GHz and faster. If your budget can manage it, purchase the fastest system you can justify. While all that speed won't make your word processing software run any faster, when you begin editing digital camera images or making DVDs and movies, you'll be glad you have the extra horsepower. Faster computers are great for running games, too!

Memory

Random access memory, often called RAM for short, is the next most important component you should ponder when purchasing or upgrading a computer intended for digital imagery. RAM are those very fast computer chips, like the one shown in Figure 1.2, that store your pictures, movies, and other data while the microprocessor is manipulating it. This kind of memory is considered volatile, because when you turn your computer off the information in RAM is lost. By then, however, you will have stored it more permanently on your hard disk, a CD-ROM, or DVD. RAM is intended to store your data only while you are actively using it.

FIGURE 1.2 Memory modules are solid-state devices that fit in slots inside your computer.

RAM consists of silicon chips in your computer that store programs and data for as long as the computer needs them, until you replace that information with other information or turn the computer off. RAM is sometimes called volatile memory, because it is temporary and is not saved.

Memory is able to supply the required information to your microprocessor, video card, or other component that needs it very, very quickly. If your computer doesn't have enough memory to hold all the information that is required, it will have to retrieve it from some storage option, such as your hard disk drive. Fetching data from a hard disk is much, much slower than getting it from RAM. You can see this by comparing the increments used to measure memory speed and hard disk speed. Memory speed is measured in nanoseconds (one billionth of a second) while the speed of hard disk drives, CD-ROM drives, and DVD readers is measured in milliseconds (one thousandth of a second). That's quite a difference, even though both are such a brief time span that humans find it difficult to conceive of them. Yet, it's roughly the

difference between saying, "Wait a second..." and "Wait six and a half months..."

To keep your computer from waiting what will seem like months (to the computer), you'll want to have enough memory to handle the common tasks you'll be carrying out. Many chores, like working on a word processing document or browsing the Internet, don't require a lot of memory. In fact, your operating system (more on that later) probably requires more memory just for itself than either of those tasks.

You need a certain minimum amount of RAM just for your computer to perform basic functions and run programs. Most computers need 256 megabytes of memory just for starters. Additional RAM is used to run larger, more complex programs, and for the documents, pictures, or movies you're working with.

If you're dealing with large images or documents, your system can run out of RAM. When that happens, the computer must use hard disk space as temporary storage instead, which slows things down considerably. Even the speediest microprocessor will grind to a halt if it's constantly waiting for the data it needs to be loaded from a pokey hard disk drive.

So, it's in your best interest to have enough memory to keep your system operating smoothly and efficiently. The good news is that memory is cheap enough that having more than enough needn't be expensive. Most computers sold today are equipped with 256 to 512 megabytes of RAM. The upper figure is roughly the minimum amount of memory that you should have. If your current computer has less, you should consider upgrading. You may be able to double your RAM for $100 or less, including installation.

If 512MB is a reasonable minimum, 768MB to a gigabyte or more of RAM is even better, because you'll be able to run more programs and have larger images in memory at one time. You'll want to be sure to purchase the kind of memory that is compatible with your computer. There are several varieties, and your retailer or the manufacturer of your computer can advise you which type is needed for your system. Web sites belonging to the major memory manufacturers often have search features that let you type in the name of your computer and see a listing of the kinds of memory best suited for it.

Installing extra memory is one of the easiest upgrades possible, even for the novice. You simply open your computer case and slip the memory sticks into the appropriate slots inside your computer. They fit only the correct way, and the whole installation takes just a few minutes. Of course, figuring out how to open some computers is a challenge! If you'd rather not open your computer case, you might want to go ahead and let your retailer do it for you.

Operating System

The operating system, or OS, is the master program that controls everything your computer does. It manages your RAM, stores and retrieves information from your hard disk, supervises devices such as your printer or DVD burner, and it runs your programs. As you've learned, the number crunching and program instructions flow through the microprocessor, and all the data passes through the RAM, but the OS tells all of them what to do.

When it comes to desktop computers used in home and business applications, some form of Microsoft Windows is used on upwards of 90 percent of all the installed systems. The Macintosh operating system commands a significant percentage of the rest, while other OSes (including the techie favorite Linux) are popular for specialized applications, such as the computers that function as Internet Web servers. For most of us reading this book, Windows is the OS we'll be using.

Most new computers, including all the computers sold by Hewlett-Packard, are furnished with either Windows XP Home or Windows XP Professional. XP Home lacks a few networking features and other options useful for business applications, but otherwise includes all the features you'll need for digital imaging. Unless you're networking a large group of computers in an office environment or running your own Web page server, you probably don't need Windows XP Professional.

XP Home has great features for those involved in digital imagery. For example, it can automatically recognize memory cards from your digital camera when you insert them in a memory card adapter slot

(built right into many Hewlett-Packard computers), and will offer to display the images or copy them from the card to your hard disk if you like, as shown in Figure 1.3. XP Home also includes Windows Movie Maker, which you can use to edit digital movies and burn them to DVD. While not as complete as the DVD multimedia software furnished with many new HP computers, or with the HP DVD Movie Writer DC3000, Movie Maker is easy to use and a lot of fun.

FIGURE 1.3 *Windows XP can recognize disks and memory cards containing movies and other multimedia files and copy them to your computer automatically.*

So, if you're purchasing a new computer, you'll probably end up with Windows XP Home. Your existing computer may be running an earlier version of Windows, such as Windows 95, Windows 98, Windows Me, or Windows 2000. All these, except for Windows 2000, are built on an earlier operating system foundation that is inherently less stable and that provides less support for modern hardware compon-

ents. For example, you may find that one of these older versions of Windows doesn't have the support you need for the larger hard disk drives that are common today, or for connectors such as universal serial bus (USB), which is heavily used by digital cameras, scanners, and external DVD drives.

Windows 2000 is built on the same foundation as Windows XP, and while it is stable and offers support for the latest gadgets, it doesn't have the same convenience and ease of use XP Home offers individual users.

If you're using an older version of Windows, you can upgrade to Windows XP Home for around $100. You can buy the OS and install it yourself on top of your existing operating system, if you like. It's smart enough to retain all your programs and data while you update your computer's control program. Or, your retailer can install it for you.

A better choice might be to install Windows XP "clean" as a brand-new operating system on your hard disk. That avoids any potential compatibility problems between the old and new OS. Sometimes stray files from the older operating system or its programs remain behind and can cause minor conflicts. Installing a brand-new version of the operating system eliminates this possibility.

A clean installation lets you retain your picture files, but you may have to reinstall many of your software programs, email programs, and other settings individually. Unless you are familiar with installing operating systems and programs, this might be a step to turn over to your retailer. A "clean" install isn't particularly difficult, but there are a lot of details that are easy to overlook if you've never done it before.

Video

Your computer's video system consists of two different components: an electronic component inside your computer called a video card (although it might be built right into the computer and not as a separate card), and the video display, which is the monitor screen that shows your programs, movies, and other visuals.

Video Cards

The video card determines what is displayed on the screen, how quickly it is shown, and the quality level (including sharpness and number of colors used). For certain kinds of programs, such as sophisticated games, the video card also can provide the 3D and motion effects that make the game appear to be realistic. All this is possible because video cards are tiny computers in their own right, complete with microprocessors and memory. In fact, many video cards designed for gaming have 128MB or more of RAM, which can equal or exceed the amount of memory available to the computer's own brain!

Your video card can affect how smoothly your DVD movies appear on your monitor screen, as well as how faithfully your digital camera images appear. Some video cards are capable of sending a picture to more than one monitor simultaneously, so you can run programs on one screen while viewing something else on another. For example, you might want to have a DVD movie, such as that new Bruce Springsteen concert program, running on your second monitor while you continue to work with your word processor or surf the Internet on your main screen. Those serious about their image-editing work might keep an editing program on the main screen with the picture shown as large as possible, and move all the application's editing tools to the second display, where they are out of the way but readily accessible.

Virtually all video cards today "talk" to your computer using an interface called Accelerated Graphics Port, and abbreviated AGP. AGP video may be built into your computer's motherboard, or supplied by a removable card that resides in a special AGP card slot. Older computers probably use a slot-based interface called PCI (short for the mind-numbing term Peripheral Components Interconnect). The PCI graphics interface is generally slower than AGP, and is useful chiefly if you happen to need a second video card in one computer (you'll learn why shortly).

The key things to consider for a video card are these:

- **Amount of memory.** In practice, the amount of memory built into the video card helps determine the other features, described

next. More memory allows display of more colors and higher resolutions. Most newer video cards have 64MB or more of RAM built right in, and a few can be expanded with additional memory you or your retailer can add later. For working with digital images, 64MB to 128MB of memory is probably more than sufficient. Extra memory above those levels can provide some benefits to gamers who want their games to operate at the highest possible levels.

- **Resolution.** Resolution is the number of pixels that can be displayed at one time. You might want to view 1024 x 768 pixels on your display screen, or if you have a larger display, might prefer a higher resolution such as 1600 x 1200 pixels or even 1920 x 1440 pixels. The amount of memory of your video card and the capabilities of your display monitor determine what resolution settings you can use.

- **Number of colors.** The number of colors that can be displayed at one time at a particular resolution is determined by the amount of memory included in your video card. The goal is to have a "full-color" display of 16.8 million different colors, also called "24-bit" color. Today, most video cards can provide a full-color display at all the resolutions they offer. If your computer is an older one with a video card that has less than 32MB of memory, you may find that at higher resolutions your card may be unable to support 24-bit color and may, instead, show only 32,767 different hues. Such a display may look OK, but for serious image editing you should settle for nothing less than a full-color, 24-bit display at your chosen resolution. If you plan to stick with your older computer, you might want to consider upgrading to a newer video card.

There are a few other considerations that apply to specific situations. These include:

- **3D support.** For most applications, including digital image editing and video, good old "2D" (two-dimensional) video capabilities are fine. If you're using your computer extensively for

sophisticated computer games, you might want enhanced 3D support, which enables the video card to handle creating three-dimensional effects, textures, shadows, and other details that enhance the appearance of video games that support those features.

- **Analog/digital output.** Most computers have what is called "VGA" output, suitable for the standard type of display monitor that's used the most widely. Other kinds of monitors, especially some of the newer liquid crystal display (LCD) monitors, can use something called a digital video interface. LCD monitors don't automatically require a DVI connector; many use the VGA connector or can work with both. However, if your monitor can use the digital interface, you'll get better results and will want a video card that supports that option.

- **S-Video output.** Many video cards have a connector that allows them to be linked to a VCR, television, or other device that accepts S-Video inputs. (Check your video card's manual to see if you have this capability, or look for a socket with four or seven holes on the back of your computer, right near where the monitor plugs in.) You can use this capability to display your computer's video output on a television, or direct it to a VCR for recording video tapes. If your video card has S-Video output, but your TV or other component has only composite input (that set of red, white, and yellow RCA jacks), you can convert your video card's S-Video output to composite. Converters and cables that perform this magic, like the component shown in Figure 1.4, can be found at **www.svideo-rca.com**.

- **Video capture.** Some video cards include a facility for capturing your video input and converting it to digital form. This is an important capability for those who want to convert their movies to DVD or other form, and we'll be looking at the requirements for these cards in Chapter 2. However, some other peripherals, such as the HP DVD Movie Writer DC3000, have video capture capabilities built in, so you can convert your movies even if

your video card doesn't have that feature. We'll look at video capture hardware in more detail in Chapter 2.

• **Dual monitor support.** If you'd like to run two monitors (say, to view a DVD movie on one screen while you continue to work on another application using a second screen), you'll want a video card that can provide output to both. You don't even need special software to use more than one monitor; Windows XP supports this mode automatically if a second video card or a card with two monitor connections is installed.

• **TV display.** A few versatile video cards include a television tuner, so you can connect them to a TV signal source, such as your cable TV connection, and watch or record television right on your computer. This is especially handy if you have two monitors, because you can watch TV on one screen while you continue to work on the other.

FIGURE 1.4 A simple converter can let you direct your computer's video output to a television set that doesn't have S-Video inputs.

Monitors

The display monitor is the other half of your video subsystem, and one of the most important components of your computer, because you'll be staring at it for hours at a time. In fact, if you're serious about working with digital images, your choice of a computer display for viewing and editing images can be as important as the digital camera or movie camera you use to capture those images.

However, picking the right monitor from the dozens of models available can be a daunting task, which is another reason to consider buying a new computer system with a display that has been matched to your needs.

After all, some models look great in the store, feature impressive resolutions and controls, and may even claim to be perfect for viewing digital images, when in fact they produce distorted or inconsistent colors and give you eyestrain. The right monitor makes image editing a joy, delivers accurate, consistent colors and an easy-on-the-eyes view, and shouldn't cost a fortune. So how do you choose the best monitor for your needs? Here are some tips and suggestions for making sure your monitor passes its screen test.

LCD or CRT?

More alphabet soup! An LCD monitor is simply one of those flat, thin, liquid crystal displays furnished with many newer computers, while a CRT is a tube-type display that looks like a television. Some users favor the older CRT technology for image editing, while others prefer the extra bright screen and compact footprint of the LCD. While LCD displays still cost a little more than CRT monitors, the difference in price is shrinking. Someday, the LCD will become the predominant type of computer display (if it isn't supplanted by even newer technologies such as the Organic Light Emitting Diode—OLED—display!). The choice is up to you and your budget, and might depend on a few other factors you'll see discussed next. An HP Pavilion LCD display is shown in Figure 1.5.

FIGURE 1.5 LCD displays are bright and easy to view, and don't take up much space on your desktop.

Size Really Matters

We may be biased, but when it comes to editing images, bigger is better. That said, bigger is also more expensive, but monitor prices have come down significantly in the last few years. Although you can do some serious work with a 17-inch display, a 19-inch monitor is really the minimum size you should be considering for image editing or digital movie-making. At 19 inches or larger, you can see more of the photo you're editing at a comfortable viewing distance, and still be able to keep your favorite controls and tool boxes open around the image.

Monitor manufacturers use two measurements to describe the size of their monitors: the actual size of the monitor and the viewable screen area. These are not the same for CRT (cathode ray tube) moni-

tors but are usually similar for LCD (liquid crystal display) monitors. On a CRT, there is usually a border area around the viewable area, so a 19-inch monitor (measured diagonally) may actually have only 18 inches of viewable area. The full area of an LCD display is visible, so, in practice, an 18-inch LCD may offer a view equal to or larger than that of a 19-inch CRT monitor. To compare apples to apples, just compare the viewable area specs of the monitors you're considering.

How Many Monitors?

The monitor furnished with your computer can do a fine job, but if your work becomes more serious, you might want to consider going the dual-monitor route. If your older computer came with a 15- or 17-inch monitor, don't get rid of it when you upgrade to a new computer or purchase a larger screen for your existing computer. You might be able to use the old display as a second monitor.

Work like the pros. Most use two monitors: one to display the actual image and the other to hold all of the control panels and tools. Current versions of Microsoft Windows support the use of multiple monitors. Many recent video cards offer a "dual-display" capability, but if you're upgrading an existing computer, you can buy an inexpensive video card for your secondary monitor (prices start at under $100) or a single "dual-display" card for about $130.

tip **If your main display is attached to an AGP-based card, buy a PCI card for your secondary display, because most computers can have only one AGP video card. The Setup programs of most computers let you specify whether to use the AGP or PCI video as your default display. Once you've hooked two displays up to your computer, you'll need to access the relevant Windows Display control panel to make some minor configuration adjustments (including exactly where your second monitor's extended desktop resides in relation to your main screen).**

If you're upgrading to a 19-inch or larger display, position the old, smaller monitor to one side as a virtual extension of your main screen. When you slide the cursor off the desktop of your primary screen, it

will move right onto the second monitor. You can keep your two monitors busy even when you're not manipulating images. For example, you can open two browser windows in full-screen mode on different monitors, compare word processing documents side-by-side, flip between two applications quickly, or keep your MP3 player constantly on view in the second monitor.

Choose the Right Interface for Your Monitor

Monitors today accept either an old-style analog (VGA) signal or the new digital visual interface (DVI) connection. Newer video cards may provide both types of output (plus S-Video, which is useful for video editing or connecting to a large TV monitor or projector). Monitors, both CRT and LCD, may accept both types of signal, or only one. If you're buying a tube-type monitor, you'll probably opt for the venerable VGA interface; if an LCD monitor is your choice, you'll get the best results from a digital connection. However, digital-ready CRT monitors are widely available and offer improved image quality, while many LCD monitors accept both analog and digital input.

What Resolution?

Monitor resolutions don't work the same as digital camera resolutions. For example, choosing a higher resolution setting won't make your movies or photos look any sharper on-screen. Instead, it will make them look smaller! But that means you can view more of the image on the screen, since even a point-and-shoot digital camera with a very modest 1280 x 960 resolution (1.2 megapixels) produces an image that is too large to view in its entirety on a monitor set to 1024 x 768 pixels. On that same screen, only a small portion of a 5 MP image (2500 x 2000 pixels) would be visible at 100% magnification (a setting that allows you to see all of the detail in an image).

At higher resolutions, menus, title bars, palettes, and dialog boxes also occupy less space on the screen, leaving that much more to display your image. However, you may find yourself squinting to read text with any setting higher than 1600 x 1200. Your monitor and video card determine the highest resolution you can use. CRT monitors have a

top resolution limit that they can physically handle (which may be more than the video card can process), while LCD displays have a native maximum resolution that simply corresponds to the number of pixels available horizontally and vertically to show the image. The amount of RAM memory available to your video card (or actually found on the card) may determine how many pixels the card can process in full color at one time.

Figures 1.6 and 1.7 show you the difference screen resolution can make. Figure 1.6 is a typical Windows XP screen at 800 x 600 pixel resolution. Figure 1.7 shows just how much extra "real estate" you have available on the screen by switching to the higher resolution of 1024 x 768 pixels.

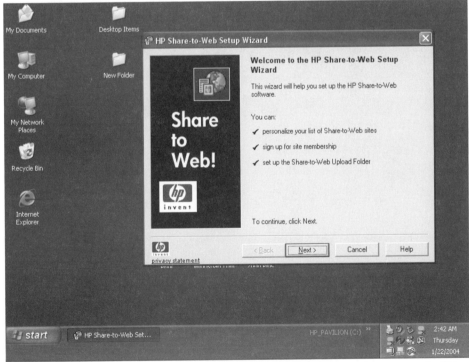

FIGURE 1.6 At 800 x 600 pixel resolution, the dialog box takes up most of the screen.

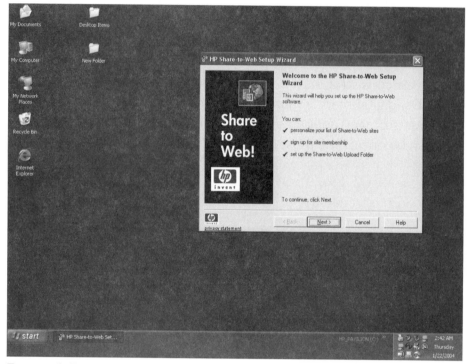

FIGURE 1.7 Switch to 1024 x 768 pixel resolution and see how much more space you have to work with.

Other Features

In addition to a monitor's image quality, there are several other features that have more to do with convenience and comfort. For example, many monitors offer an adjustable, swivel base that allows you to easily reposition the monitor for a variety of users (important these days, since the family that retouches together, stays together). Several monitors also feature a built-in USB hub, which allows you to connect all of your USB peripherals, such as memory card readers, scanners, and printers, directly to your monitor. Others ship with multimedia features, such as a microphone and/or speakers. Avoid the ones with the speakers built into the monitor housing unless the speakers are well-shielded, since, in poorly designed units, the speaker magnets tend to degrade the sharpness of the monitor.

Storage

The final general-purpose feature you'll want to ponder is the storage space available for your movies and digital pictures. Your computer's storage can consist of hard disk drives, removable media such as CDs and DVDs, digital memory cards, and other options. You need to consider your storage requirements carefully, because, after RAM, disk space can be one of the most limiting bottlenecks in your quest for digital fun.

Let's look at each of the key storage options you'll be considering.

Hard Disk Storage

Your hard drive is your computer's main permanent or semi-permanent information depot. Unlike RAM, the hard drive retains all the information you've saved, even when the computer is turned off. But, like memory, the more hard disk space you have, the better. This versatile storage space serves multiple functions.

First, it allows you to keep as many images and movies as possible available for near-instant access. You can store all your current projects and those from past months for quick reference or reuse. With a large hard drive, you can store a virtual library of photographs, movie clips, sounds, and other media as a resource library.

Next, a hard disk gives you the working space you need for your current projects. As you capture video clips or copy digital photos to your hard drive, you might find that you don't need all of them permanently, but it's nice to have all the alternate versions and extra footage available while you're editing and polishing your project.

Hard disk drives can also be used for archiving and exchanging information, particularly if you have an external hard drive that plugs into your computer's USB or FireWire port and can be moved to a different computer. Most of us use CD or DVD for this purpose, but hard disk drives can do the job, too.

As noted earlier, your hard drive also can function as a slower, but reliable substitute for memory. If a demanding project requires more RAM than you have installed, hard disk space can be pressed into service.

Finally, your hard disk lets you store additional applications, such as image editors, utilities that carry out computer-oriented functions such as virus protection, or additional DVD creation and viewing programs.

As far as capacity goes, even the least expensive new computers today have 40G or larger hard disk drives. You'll find that a drive with 120G to 160G or more costs only a little more, and you'll have a great deal more room to store your movies and digital images. Standard hard drives are installed in your computer when you purchase it. Most computers can accept up to four drives internally (including CD-ROM and DVD drives), so, depending on how your computer is set up, you might be able to add one or two more for extra capacity. Your retailer can install the new drive for you, or you might want to tackle the chore yourself.

An easier choice, however, might be to plug in an external drive, which attaches to your computer's USB or FireWire port. The external drive has a separate power cord, and you'll need to find a place on your desktop for it, but connecting one of these is a no-brainer. As I mentioned, an external drive can be detached from your computer and connected to another computer in your household, or taken to a friend or colleague's location and quickly plugged in. This is a great way of sharing your movies-in-progress that haven't been burned onto a CD or DVD yet.

Archival Storage

As you work with digital images, you'll find yourself accumulating lots of images, clips, music, and other components that you don't necessarily need instant access to. For security reasons, you'll also want to create back-up copies of files that are difficult or impossible to replace. Archival storage is your long-term solution to your media file management, back-up, and sharing needs.

In the past, a variety of media have been used, ranging from floppy disk drives to ZIP disks. Today, neither is particularly popular. The 1.44MB floppy disk drive doesn't have enough capacity to store even a single 5-megapixel digital camera image, and some new computers are furnished without this drive at all. ZIP disks looked as if they were going to be the ubiquitous "floppy-of-the-future," but the relatively high cost of the media doomed this option as well. Do you really want to pay roughly $10 for a magnetic media disk that can store, say 250MB of information, when a rewriteable CD-ROM can hold three times as much information for less than 25 percent of the cost?

Indeed, CDs have become the "future floppy." Even the oldest PCs still in use have drives that can read CDs, and most recent computers have CD "burners" that can write CDs, too. Modern operating systems like Windows XP support dragging and dropping files directly on CDs, making these drives an excellent choice for managing files, creating back-up copies, or sharing files with others. CDs can cost less than $1.00 each, too, so the media is very economical.

CD-ROMs come in two varieties: the rewriteable kind (called CD-RW) that you can use over and over, and the write-once type (called CD-R) that, once it is filled with data, cannot be erased and used over. Both kinds hold about 700MB of data, which is plenty for storing digital photos (you can put several hundred 5-megapixel pictures on a CD), and useful for less ambitious movie projects. They're less useful for backing up an entire hard disk (you'd need 57 of them to copy everything from a 40G hard drive), but quite handy for backing up specific projects and data files.

It's more likely that DVD, shown in Figure 1.8, will become the "off-line" storage media of the future. There are only two factors that keep DVD from taking over completely right now. First, not all computers can read DVD disks, and fewer still have the ability to write DVDs. Second, there has been some confusion over competing DVD formats with names like DVD+R and DVD-R. This has been more of a tempest in a teapot than anything else, because, recently, vendors like Hewlett Packard have offered DVD drives that can read and write all of the available formats.

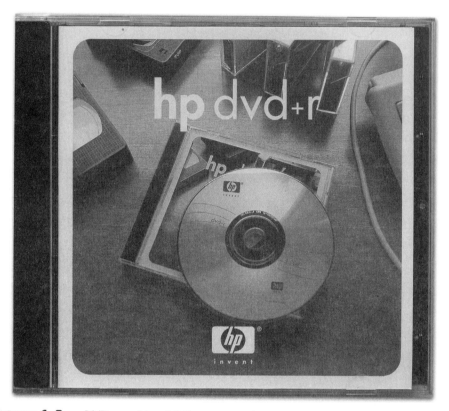

FIGURE 1.8 DVD provides 4.7G or more of storage on a single disk.

There are many advantages to DVDs. Their 4.7G storage capacity is more useful in these days of 120G hard drives, and in mid-2004 some vendors began shipping "dual layer" DVDs with double the standard capacity.

Another plus for DVDs is that you can create movies that are viewable on standard DVD players, so that film masterpiece you create can be enjoyed by anyone with a DVD player attached to his or her television. He or she doesn't even need to own a computer!

We'll look at DVD drives in more detail in Chapters 2 and 3.

Memory Cards

A third kind of storage is the memory card, sometimes called flash memory, used in your digital camera, MP3 player, or other device. These compact wafers of silicon can store a surprising amount of infor-

mation, from 16MB up to a whopping 4GB or more. They can be used to transfer pictures from your digital camera to your computer, store music files, or even to exchange data between computers (as sort of a miniature, solid-state floppy disk).

Many computers, including Hewlett-Packard Pavilion models, include memory card readers, like the one shown in Figure 1.9, so that all you have to do is slip the card into a slot and then access the information. Windows XP can even pop up a window and offer to copy or move the data for you.

FIGURE 1.9 *Some computers include built-in memory card readers.*

There are several different kinds of memory cards, including Compact Flash, xD-Picture Card, Memory Stick, Secure Data (SD), and the MultiMedia Card (MMC). The last two are identical in size, but not identical internally, so that some devices may take both but others may not. An SD card is shown in Figure 1.10. Two other types of cards, the SmartMedia and PC Card formats, were popular in the past, but fell out of favor when the flash memory cards that were smaller and/or of higher capacity were introduced.

To make things even more interesting, there is yet another removable storage option that looks and works like a Compact Flash card, yet is actually a miniature hard disk. These tiny card-like disk drives fit the Compact Flash Type II slot found in some higher-end digital cameras, as well as other devices. They're available in sizes up to 4GB, roughly the same capacity as the largest solid-state Compact Flash cards.

Figure 1.10 SD memory cards, about the size of a postage stamp, are small enough to allow designing more compact digital cameras and other devices.

While you won't be using any of these cards as primary or even backup storage for your computer, you'll find them very useful for exchanging data between computers, for offloading images from your digital camera, or for loading up MP3 files for your portable music player. Choosing which format you prefer for your external device is your decision, but you'll probably want your computer to be able to handle all of them. Fortunately, many computers, including HP Pavilion models, include card readers with multiple slots that will accept any of the common memory cards. If your computer lacks this feature, you can also purchase external card readers for a specific kind of memory card or a 5-in-1, 6-in-1, or 7-in-1 reader to handle multiple formats. These external readers plug into a free USB port on your computer. If you're running Windows XP, they require no special software; Windows will recognize each disk as you insert it.

Other Computer Considerations

We've looked at the most important components of your digital image-capable computer. There are a few others with features that can make your job easier. For example, keyboards can include special programming that lets you activate email programs, start surfing the Web, pop up a Help window, or provide other services at the press of a button.

Pointing devices like mice and digital tablets, external video capture devices, and other accessories will be discussed as they come up in later chapters in this book. You've gotten enough background in this chapter to get your old or new computer fine-tuned and ready for making great digital images.

2

Preparing to Capture Your Videos

In this chapter...

✓ How We Got Here

✓ What You Can Do

✓ The Equipment You Need

✓ Selecting a Video Source

Although movies are a relatively new art form (compared to still photography), when done properly they can be as compelling, or even more so, as snapshots when it comes to capturing our attention. We love looking at still photographs of ourselves, our friends and family, or interesting people and places, but when you add motion and sound to the equation, our interest kicks up another notch.

Now, enhance the movie/video experience by making it easy to edit these productions, save them to computer media, and view them on television, and you've got an unbeatable combination. Almost nothing is more engaging than a slick video presentation prepared quickly and easily by you.

This chapter will show you how you can become a director of your own movies with video capture of footage you collect using your VHS, VHS-C, Hi-8, or digital camcorder. You'll learn everything you need to know to assemble the gear you need, capture the video, and archive it to CD or DVD. I'll lead you quickly through the alphabet soup of video standards like NTSC, PAL, and SECOM and move into easier-on-the-brain sections on how to select the features you really need to have. Then, in the chapters that follow this one, you'll find information on transferring existing video and editing your productions, too.

How We Got Here

The concept of producing successive images that appeared to move has been around for a long time, dating back to shortly after the Civil War, when machines like the "zoopraxiscope" displayed moving drawings and photographs that could be viewed through a slit in the side of a rotating drum. However, motion pictures didn't really get off the ground until Thomas Edison began producing Kinetoscopes on film in the early 1890s. (George Eastman deserves a nod, too, for introducing flexible, celluloid film at that time.)

Within 20 years motion pictures had become a huge industry, with films by early stars like Charlie Chaplin wildly popular in theaters and nickelodeons worldwide. Towns like Hollywood grew and prospered as hundreds of firms vied to create the movies and talking pictures that

were, with radio, one of the primary sources of entertainment in the days before television.

By the 1950s, consumers were able to shoot their own silent movies, and in the 1970s the home-movie "talkie" became possible. These home movies were surprisingly popular even though film and processing could easily cost $1.00 a minute, and it was often necessary to wait days to see your results. The urge to create our motion pictures was strong enough that consumers were willing to put up with finicky 8mm and Super 8mm cameras that were costly to operate and produced films that were difficult to edit, tended to fade over time, and that could easily be damaged in the clunky movie projectors of the time.

Consumer video systems removed those limitations. You could record clips, review them instantly, and create a new recording immediately if you were dissatisfied with the results. Tapes that could record hours of video cost only a few dollars and could be reused over and over. Tape didn't fade quickly over time (although repeated playings could wear out the tape's magnetic coating and over the long term tape could, indeed, lose its signal), and instead of needing to snip sequences apart and glue them together (which was required with movies on film), videotape could be edited simply by copying only the portions you wanted to retain over to another tape.

The first home video outfits were AC-powered cameras (often capable of shooting only in black-and-white) that were tethered by a cable to an equally non-portable Betamax or VHS recorder. Many early videos were shot solely in the living room or family room where the VCR was stationed, or in adjoining rooms that could be reached with the cabled video camera.

Despite having limitations of its own, home video was the answer to the prayers of many consumers who wanted to document their babies' first steps and words, to record parties and celebrations, or create amateur motion picture productions. When portable camcorders like the one shown in Figure 2.1 became available, complete with battery power and internal playback systems for reviewing shots, the home video revolution began. Vendors introduced smaller and smaller

cameras, better image quality, and innovations like full digital capture to meet the demands of the enthusiastic consumer market.

FIGURE 2.1 Portable camcorders made home video practical for the average consumer.

After all, video has a lot going for it. As I mentioned, videotape or other media used to capture motion and sound is cheap and reusable. You can view your results on your television, with no need to set up a projector and screen.

Video is easy to edit, too, even without the power of the computer to streamline things, so you can remove scenes you don't want, re-order clips in the sequence you desire, add titles and other text, create interesting transitions, or add special effects.

These things were all possible with ordinary video cameras and special electronic editing gear, of course, but have become even easier with the advent of digital video. You don't need an electronic editing workstation to manipulate your videos: your personal computer will do just fine. All the interesting things that could be done with video five or ten years ago can be accomplished today, much more easily and inexpensively, and usually with a finished product that is higher in quality.

What You Can Do

There are tons of great things you can do with video, especially when you have the added advantage of being able to edit and enhance your work with your computer. If it moves, you can probably capture it on video. And if you can capture it, there are ways to manipulate your clips in ways you may not have dreamed possible. Here's a quick list of some things you might, or might not, have thought of.

Document Family Special Events

Special events are one of the key traditional uses for movies and video. That camcorder may sit in the closet for much of the year, but when that special day rolls around, out it comes, ready to record the memories of the special event.

Of course, once you begin transferring your video to your computer and discover all the things you can do with it, special events will be only a starting point, and your camcorder will spend a lot less time in the closet. You'll think of many more milestones in the lives of you, your children, and your other relatives that should all be captured in video and sound. As mundane as an event may seem now, a decade or two down the road you'll cherish the moments.

Birthday parties, first steps, that first day of school, and graduations are all obvious events suitable for preservation. Religious celebrations such as baptisms, First Communions, bar/bat mitzvahs, and weddings, like the one shown in Figure 2.2, can be commemorated in videos. Traditional festivities like "sweet 16" parties, proms, or an Hispanic girl's Quinceañera also make good fodder for videos.

Anytime there's something to celebrate, your video camera should be out and running, at least part of the time. Don't make the mistake of viewing the entire event through a viewfinder! Pass the camcorder around and let everyone get in on the fun. Then, transfer the video to your computer, edit the footage, and make DVD copies for everyone who might be interested.

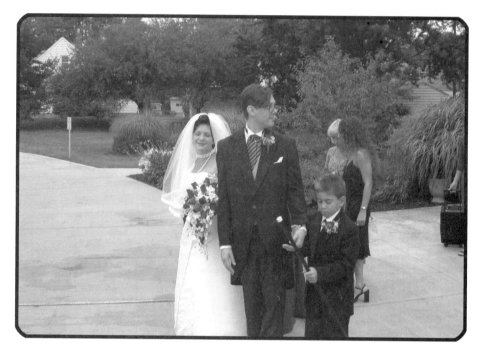

FIGURE 2.2 Anytime there's something to celebrate, your video camera should be running!

Capturing Everyday Life

You needn't wait for a special event to capture video. A shot of you playing catch with your kids in the backyard, a clip of you and your spouse cooking dinner, casual footage of your weekly bridge foursome, a memorable sequence that shows how your garage was—finally—cleaned out. These all will be of interest in a few years when you've moved and lost touch with friends, the kids have grown, or the garage has magically refilled itself with junk.

There are dozens of things you can do with these clips aside from viewing the raw footage nostalgically. Assemble many different shots from various videos into a "this is your life" compilation for a favorite friend or relative. Collect all the best moments from your child's amateur baseball career into a cavalcade of sports history. Build your own blooper reel. The possibilities are endless. Who knows? If one of your

subjects later becomes a famous movie star, sports hero, or politician, your clips may actually be extremely valuable. Or, if you happen to be the one who becomes a famous movie star, sports hero, or politician, you may be glad you've got potentially embarrassing moments firmly in your control to release (or hide away) as you choose!

Pass Along Your Heritage

One of the cool things about digital video is that after you've spent years accumulating lots of interesting family events, you don't have to decide which of your relatives "inherits" your home videos. You can make DVD copies of everything and give each descendant a copy of his or her own, like the one shown in Figure 2.3, when the time comes. Because everything is stored digitally, every copy is just as sharp and clear as the original. Write-once DVDs can cost as little as $1.00, and the price is sure to go down.

Christopher
& Gina's
Wedding

FIGURE 2.3 Make DVD copies of all your videos for each member of the family.

Home Video Inventory

Have you taken an inventory at your home? Would you like to do it the fastest way possible? Just pan and scan around each room of your house, taking in all the furniture, hobby collections, jewelry, or other objects that you might want to replace if they were lost or damaged. You can make several copies, store one of the copies off-site (in a safety deposit box, at the office, or at a friend's house), and always have an inventory available for insurance purposes. When you buy something new or dispose of something old, you can update your inventory with some new clips and a little editing.

Don't forget to shoot the outside of your home, too. That custom-built playground, those outbuildings, and even your landscaping are probably covered by your homeowner's insurance, if you have some visual proof of your investment.

Video home inventories can be fun in their own right later in life, when you view them and wonder how you ever managed to live with that horrible couch for so long, or admire those rose bushes that you had to leave behind when you moved to a new home on the opposite coast. Something as ordinary as an inventory shot for insurance purposes can hold a lot of interest in surprising ways after enough time has elapsed.

FIGURE 2.4 When this elaborate, custom-built playground was destroyed by a falling tree, the insurance company used the video clip showing the structure from all angles to estimate its replacement cost.

Create Your Own Productions

One of the most popular applications for videos is for creating your own motion picture extravaganzas. Whether you round up all the neighbors and their kids as actors, decide to put together a documentary about problems in your community, or want to capture your amateur or school drama club's production of *West Side Story*, video is the perfect medium, and your computer is the perfect tool for editing and reproducing the finished work.

Amateurs (and would-be professionals) have been creating their own masterpieces on film and video for years, but the added dimension of the computer makes editing easier and distribution a lot less expensive. Instead of making poor-quality VHS dubs of your production (losing quality each time you duplicate a copy of a copy), you can create DVDs that are each as good as the final edited version.

The Equipment You Need

What do you need to shoot and edit your own video? If you have a digital camcorder and a computer, you probably have almost everything you require. Should you own an older analog camcorder, you might need an extra gadget or two to help you transfer the video to your computer, but the add-ons required aren't particularly expensive.

I provided a general description of the kind of computer equipment required for digital imagery in Chapter 1. Everything you learned there will serve you well as you begin assembling your digital video studio. This section will provide some additional information on the exact gear you need.

Computer

The specs laid out in Chapter 1 for processor speed, memory, and hard disk space all apply directly to your digital video workstation. You'll recall that my advice, in brief, was that more speed, more memory, and more disk space are always better. However, even when similarly equipped with the basic hardware, some computers are more equal than others.

For example, HP Media Center PCs and some Pavilion models come with extras that make them particularly pleasant tools for digital video editing. For example, the so-called "Front Productivity Ports" put the connectors you use most for digital video right on the front of the computer, where you can access them most conveniently.

When you're busy plugging and unplugging a digital camcorder that uses a FireWire connection, you'll be thankful for a FireWire port right on the front of the computer. Need to plug in headphones to listen to an audio track? Want to plug in a microphone to add narration? You'll find jacks for those accessories right on the front, too (see Figure 2.5).

FIGURE 2.5 Having a FireWire port and audio connectors on the front of your computer makes connecting your camcorder easy.

Duplicate connectors are on the back of the computer in the traditional locations, as well, so you can connect peripherals in the traditional "out of sight, out of mind" way, when you need to. It's great to have a choice of how you connect and disconnect your gadgets.

Computers with TV-out (S-Video) connections are handy, too, because you can view your work on the same television screen that will be used to admire the finished production. Good-quality speakers and an audio upgrade like the Sound Blaster Audigy option available with some HP computers will provide you with more life-like sound and some additional sound-editing capabilities.

If you meet all the speed, memory, and hard disk requirements described in Chapter 1, the only significant addition you may need to make to your computer is the addition of a FireWire (IEEE-1394) interface card. Although Macintoshes commonly have such capabilities already, a FireWire connection is not always a standard feature in Windows PCs. Installing such a card is usually no more complicated than opening the computer and slipping the card into a free slot. Windows XP automatically recognizes the card and installs the software, or prompts you to insert a disk containing support software for the card.

You might want to make a few changes to your computer's software configuration, too. Upgrade to Windows XP if you're using Windows 98 or Windows Me, because the latest version of Windows makes working with digital images a lot simpler in many ways, such as the automated transfer of images to your computer, and built-in Windows Movie Maker software.

Use the Windows Control Panel's Power Options panel, shown in Figure 2.6, to reset power-saving options that might interfere with your video capture and editing operations. If your Control Panel doesn't show the Power Options icon, double-click the Performance and Maintenance icon and you'll find it nested underneath. Then, reset the four Power Schemes options to Never. If you click the Save As button, you can store these settings under a name like Video Editing and use them only when working on videos, allowing the default power-saving schemes to operate at other times.

FIGURE 2.6 Turn off Windows XP's power-saving features to avoid interruptions.

Video Capture Capabilities

Lots of computers and their video cards have video "out" capabilities that let you redirect the computer's video output to an external monitor, VCR, or other destination. This option is most commonly in the form of an S-Video socket.

Video input to a computer is not particularly tricky, but it's also not exactly a standard feature from the computer's standpoint. That's because there are two different kinds of video that you'll be working

with, and each type is imported into your computer in a different way. Depending on the source for your video, it may be in analog or digital format, and your computer needs to be able to accept both.

Digital video is easy to transfer; you can link your source directly to the computer. However, to transfer analog video (that produced by VCRs, older VHS-compatible camcorders, and some other video sources) to your computer for editing and assembly into a finished production are video "in" features, on your computer, commonly called video capture.

You might even be using a digital video source, such as a television DVD player that does not have a provision for digital output. In that case, the only way you can get your video from the DVD player to your computer is through the non-digital video output your player uses to send video and audio to your television.

To understand how the two types of video can be transferred to your computer, it will be helpful to explain the difference between analog and digital video in more detail.

Analog Video

Analog video is that old, familiar form of video that we've all been watching on TV since we were kids, and, more recently, on our computer screens. Like its digital counterpart, analog video is made up of thousands of tiny dots (which may be round or rectangular) arranged in lines on the screen. Color video consists of clusters of red, green, and blue dots that our eyes merge together to form all the colors we can see. This video is called analog because the brightness of each dot can be varied continuously from black (no light at all) to white (the maximum amount of light) and every gradation in between. It's a little like an analog watch's sweep second hand that moves continuously through an entire 360 degrees each minute, compared to a digital watch that displays 01, 02, 03, 04, and so forth, but never any value in between.

Analog video itself comes in three varieties—NTSC, PAL, and SECAM—and your equipment must be compatible with the version used in your area. NTSC (which stands for National Television System

Committee, or, as wags would say, Never Twice the Same Color) is used in North America, some South American countries like Nicaragua and Peru, as well as many Asian countries such as Japan, Taiwan, and the Philippines.

NTSC is common in countries that use 60 Hz (cycles per second) electrical current, and produces video with roughly 720 x 534 pixel resolution (often 708 x 480 in practice) at 30 frames per second. Televisions, VCRs, DVD players, camcorders, and other video devices sold and used in the United States all work with NTSC signals.

The wide use of NTSC may change many years down the road when digital/high-definition television becomes the standard and NTSC broadcasting is phased out, but that will happen a long time from now. Digital TV allows for six different high-definition (HDTV) formats and 12 standard definition (SDTV) formats with up to 1920 x 1080 pixels of resolution. HDTV complicates things a bit, but it is beyond the scope of this book, in any case.

PAL and SECAM are the two 50 Hz video formats, used virtually everywhere else in the world, including most of Europe and Africa, and some countries in Asia. PAL dominates Europe and Africa, with SECAM used in France, Middle Eastern countries, and former Eastern Block nations like Russia. A very few countries, such as Monaco and Saudi Arabia, are blessed with both systems. Both PAL and SECAM are capable of reproducing up to 625 lines of resolution, compared to the 534 (theoretical) and 525 to 480 (actual) vertical resolution of NTSC.

For most living in the U.S., the NTSC/PAL/SECAM question becomes contentious only when an NTSC user tries to play back videos created with one of the other systems. There are video devices that can be switched back and forth from one broadcast system and current frequency to another, but they are not common in the United States.

You'll find analog video today coming from several sources. Standard VHS-compatible recorders and camcorders produce NTSC video (or PAL/SECAM video in those countries where those formats are used). Your television system probably uses analog video, too. DVD players read digital information from the disk, but usually convert it to analog form for display on analog-only television sets.

Digital still cameras that can capture video clips generate analog video in any of several computer-friendly formats (such as AVI or MPEG, which will be discussed in Chapter 4). Despite the growing popularity of digital video, analog video still accounts for a large percentage of all the video we use and see.

Your computer can't handle analog video without help from some special hardware. To get analog video into your computer you'll need a video capture module, which can be a separate component, but is often built into upscale video cards.

Video capture modules can also be external devices that plug into a FireWire or USB port. If using a USB version, you'll want one with the faster USB 2.0 connection, and will need to make sure your computer also supports USB 2.0 and not just the older, slower, USB 1.1 version.

Your best option may be an external video capture module built into a DVD writer, like the HP DVD Movie Writer DC3000. This latter configuration is especially convenient; just connect your video source to the DVD writer, which is in turn linked to your computer and may be used to record your finished videos. If you're copying an existing video directly to a DVD with no editing involved, you may be able to perform the transfer in one step.

If you're using a video capture device installed inside your computer, look for one that has all the input and output ports built into a separate component called a breakout box. You plug the box into the capture card's port on the back of your computer, and then make your audio and video connections to the box itself. That's a lot more convenient than crawling around behind your computer when you need to hook up or unhook something, and virtually as convenient as using an entirely external device like the HP DC3000.

Digital Video

The latest trend is towards fully digital video (DV). That's video that's already been converted to the digital format native to computers, DVDs, and digital video editing programs. You'll find digital video in dig-

ital camcorders, digital cable TV boxes, DVD players, and, soon, fully digital television receivers.

Digital video has some significant advantages, not the least of which is that its quality is light years ahead of what's possible with most analog video systems. Because the system is digital, the information it contains is represented by binary 1s and 0s that can't be lost or corrupted or fade when you make a copy. Indeed, digital video can include error correction codes that help verify that the digital information is, in fact, precisely as it should be.

In contrast, analog video contains information that can be lost in "noise" produced in the electrical system of the recording or playback system, or even in the tape itself. Each time you make a copy of an analog tape, some information is lost because of this noise. And, as we've seen, analog video must be converted to digital form before the computer can work with it.

Because the digital video is already in computer format, you don't need a capture device to convert it from analog form. All you need is a connector to link your digital video source, such as a camcorder, to your computer. Usually, that's a FireWire (IEEE-1394) connector. I'll explain a little more about digital video in the following sections.

Selecting a Video Source

The video clips you'll be working with have to come from somewhere, and usually your source will be a VCR, camcorder, or digital camcorder. You might also have some video available that have already been imported into your computer as Windows video clips with .AVI, .MPG, or .WMV extensions (you'll learn about these formats in Chapter 4). Your video source might also be a DVD, although, as you'll learn in the next chapter, your options for capturing DVD video can be limited because of copyright considerations.

Because you probably already own a VCR and will use that to transfer existing VHS tapes, your real choices probably are among the

various kinds of camcorders for the action you capture live. If you already own a camcorder, you'll want to use that to start.

Don't be surprised if, after you've been working with video productions for awhile, you find that you've outgrown your current camcorder and begin looking for a new one with more features and advanced capabilities. It comes with the territory. As your skills grow, the things you want to do with your camcorder become more sophisticated, too, and the urge to upgrade is natural.

The next section lists the various camcorder formats. I'm listing all the common options that have been available over the last decade or so, because many of you may be using older equipment or have the opportunity to pick up used gear at a good price. But realistically, modern digital video equipment is just about the only option, and usually the only offering that most vendors provide.

Full-Size VHS

Some of the earliest camcorders used full-sized half-inch VHS videotapes, and many of these devices are still used today for a good reason: their standard VHS tapes are compatible with the VCRs found in virtually every household. When you're done shooting you can just remove the tape from the camcorder and pop it into your home VCR and view it on your television. Or, you can link the camcorder to the VCR with a cable and make a copy by playing back the tape on the camcorder as you record on the VCR. Connect the camcorder or VCR to your computer, and you can transfer the tape using an analog video capture device.

Of course, this convenience comes at a cost. VHS resolution is typically very poor, on the order of 240/250 lines/pixels of resolution vertically, about half of what NTSC televisions can display. Audio quality can be poor as well, making VHS a poor choice for recording your next music video. The quality of the image deteriorates each time you make a copy onto another VHS tape, too.

When compared to the quality considerations, the other drawbacks of VHS might seem minor, but they do exist. For example, full-

size VHS camcorders are typically huge by today's standards, and must be slung across your shoulder to support their weight during shooting. You'll look more like a television news camera operator than an individual out grabbing a few video clips, and will thus find it difficult to grab video unobtrusively.

On the plus side, used VHS camcorders can be picked up very cheaply, and they're inexpensive to operate. They use videotapes that cost a dollar or two and can record from two hours to six hours or more, so you can shoot to your heart's content. A full-sized VHS camcorder might be a good birthday gift for a youngster who wants to be the next Steven Spielberg. You can set up a child with a camcorder, VCR, and an analog capture card for his or her computer for a few hundred dollars. Better chip in for a tripod, too, as a full-sized camcorder may be a little unwieldy for younger people (or even adults)!

Compact VHS/VHS-C

Camcorder vendors initially answered the demand for a less bulky camcorder by inventing the "compact" VHS format, which uses smaller VHS tape cassettes, measuring about 2.32 x 3.6 inches, and less than an inch thick. This smaller size allows designing much more compact camcorders, reducing them from shoulder-mounted to hand-held dimensions. You'll need an adapter to play a VHS-C tape in a standard VHS recorder.

The smaller tapes have more limited recording times, of course, varying from 30 to about 90 minutes, and cost more than standard VHS tapes on a per-minute basis. The relatively poor video and audio quality of VHS applies to the VHS-C format as well. Still, VHS-C cameras can be purchased inexpensively, are more portable than their full-sized siblings, and can be an option for video producers on a tight budget.

A variation known as SVHS-C is also available. So-called "Super VHS" compact camcorders provide higher quality with 400 vertical lines, but their tapes can be played back only on a SVHS camcorder or SVHS VCR (again, using an adapter). You can record and play standard VHS-C tapes with these camcorders (at the lower resolution of

VHS-C), but ordinary VHS-C camcorders cannot play tapes recorded using SVHS settings. If your low budget can afford an SVHS-C camcorder and SVHS VCR, you'll be happier with the results you get.

8mm/Hi8

The video equipment vendors' next move was to introduce camcorders that used an even smaller videotape format called 8mm (because the tape is only 8mm wide, about two-thirds the width of a standard 1/2-inch VHS tape). The tape cassette itself, shown in Figure 2.7, is roughly 2.25 x 3.5 inches and about half an inch thick, and fits in camcorders that comfortably fit in your hand.

FIGURE 2.7 The 8mm/Hi8 tape cassette is compact and allows designing small camcorders.

The standard 8mm format provides video quality no better than standard VHS, but the later Hi8 version bumps that up to SVHS levels at 400 lines of vertical resolution. Sound quality is pretty good, roughly that of a HiFi VHS VCR. You can record two hours of video on a standard 8mm cassette at the standard play (SP) setting, or up to four hours with some camcorders that support a slower "long play" (LP) speed.

Because they are so widely used, 8mm tapes can be fairly inexpensive, costing only a few dollars if you buy them in convenient "three packs" or other bundles.

The chief drawback is that an 8mm/Hi8 tape cannot be viewed on a standard VHS player, and no adapters are available. Transferring the video to a VHS recorder (preferably one capable of the higher quality SVHS format) still costs you sharpness and sound quality. If you use a camcorder of this type, your best bet is to copy the tape to your computer, where additional copies and edits can be made without further quality loss.

Digital 8

Combine the small size of an 8mm/Hi8 video tape with digital technology and you end up with the Digital 8 format. Camcorders designed around this format are compact and easy to carry, and really do combine the advantages of 8mm and the digital world, as well as some of the disadvantages.

For example, these camcorders can use inexpensive 8mm or Hi8 tapes, and are physically about the same size as their analog counterparts. They can even play back (but not record) analog 8mm and Hi8 tapes you've previously recorded, so if you decide to replace your old analog 8mm camcorder you can still view or transfer the tapes you've already made. You can also continue to record on that cache of blank 8mm tapes you accumulated.

Digital 8 tapes cannot be played directly on a VHS recorder; the camcorders include standard AV connections like those found on 8mm/Hi8 camcorders to transfer or play back videos on VHS devices.

Like all digital camcorders, Digital 8 models produce superior video resolution, approaching 500 lines, which is about 20 percent better than Hi8 or SVHS. Sound quality is great, roughly the same as audio CDs. However, because Digital 8 puts so much more information on the tape, recording times are shorter. A two-hour Hi8 cassette can store one hour of Digital 8 sound and video.

As with other digital formats, you can transfer digital video directly to a computer using a FireWire connection. Unfortunately, if you want to transfer previously recorded 8mm analog video to your computer, the FireWire link won't work, as these camcorders cannot convert analog video to digital. You'll have to use the standard AV connections on the camcorder and an analog video capture device on your computer.

MiniDV

Digital 8 is something of a hybrid format, of course, using the older 8mm cassette tapes to record digital video. MiniDV tape cassettes, on the other hand, are a bit tinier at 2.6 x 1.9 x 0.47 inches, and the tape itself is only 6mm wide. Designed specifically for digital recording, these tapes allow creating extremely small video cameras. Some camcorders can fit in the palm of your hand. Yet, the resolution and sound are the same as Digital 8.

MiniDV cameras usually have two recording speeds: SP (standard play) and LP (long play), which allow recording for 60 and 90 minutes, respectively. Some MiniDV cameras can capture still frames, too, allowing the device to double as a low-resolution digital still camera.

As with all digital formats, transfer to your VCR or TV is through AV connectors, and to your computer using the FireWire port.

Other Formats

Vendors are not finished experimenting with additional tape formats, most of which are, as you might guess, incompatible with each other. In addition to the formats discussed, you'll find camcorders that use ultracompact MicroDV and MicroMV cassettes save in a special video format called MPEG-2. You'll also find very expensive, supposedly professional models based on MiniDV with names like DVCAM and DVCPro. These use more rugged tapes and have higher quality, but are too costly for amateur and consumer video applications.

Some camcorders use flash memory cards, including Secure Digital and Memory Stick cards, like those found in digital cameras, to save still pictures and lower quality video.

A few camcorders record onto Mini DVD-R and DVD-RAM disks. While these may be viewable on home DVD players, they provide relatively short recording times and may be difficult to edit because not many software applications support them.

Choosing Your Camcorder

Once you've sorted out which video format you're going to use, it's time to select the actual camcorder that's best for you. If you're buying a used camcorder, any of the formats described may work. Should you be in the market for a new camcorder, you'll want to give strong consideration to a digital model, for all the reasons outlined earlier in this chapter. This next section will list some of the features to look for. A few of them, such as type of scanning, are a bit techie in nature and, unless you have some special needs, you probably don't have to worry about the more esoteric features available.

Optical Zoom

One important feature to consider is the amount of zoom, or magnification, you can get using the camcorder's lens alone. The higher the zoom ratio, the more magnification provided, and the closer your camera appears to be from your subject. For example, a 10X zoom lens will make an object that is 100 feet away appear as if it were only 10 feet from your camera, as you can see in Figures 2.8 and 2.9. That's a great capability for sports or for any shooting in which you can't get close to your subject. Your camcorder should have an optical zoom ratio of at least 10X to 25X.

FIGURE 2.8 Even when you're seated next to the dugout, the pitcher is more than 100 feet away from your camcorder...

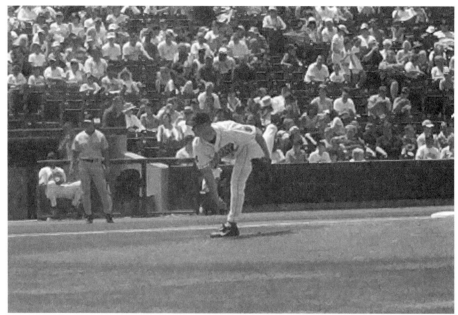

FIGURE 2.9 ...but a 10X optical zoom brings you 90 percent closer for this action shot.

Digital Zoom

You may think a 25X zoom is nothing special, because you see digital camcorders advertised with 100X or 200X zooms all the time. Unfortunately, those extra high numbers aren't produced by the optical system of your lens. Extremely high zoom ratios are achieved digitally, simply by blowing up the central portion of your image and cropping everything else out. Digital zoom uses fewer pixels to fill the frame so, as you might guess, the results aren't as sharp. You should reserve digital zoom for special applications and discount it entirely when choosing a camcorder.

Type of Sensor

If you're like most consumers, you don't want to hear much about sensors, so I'll keep this discussion brief. Most camcorders, especially the most inexpensive models, use a single sensor (called a charge-coupled device or CCD) to capture an image. More expensive models use three separate CCDs, one each for the primary colors of red, green, and blue, to provide a higher quality image. Such camcorders can be a lot more expensive, but if you need the best quality you should consider a three-chip/three CCD model.

Battery Type

The robustness of your battery determines how long you can record video before your camera poops out. Camcorders generally use a special rechargeable battery made for that camera or camera line, but you can often purchase replacement batteries from vendors other than the one that made your camera. Both nickel-metal-hydride (NiMH) and lithium-ion batteries are used with camcorders, but the latter last longer and are more versatile.

You'll want to investigate which kind of battery your camcorder uses, and how much it costs. Eventually, batteries lose their ability to receive or retain a charge, so sometime down the road you'll be buying a replacement. In addition, it's often a good idea to have several batteries as spares to use when your camcorder's current power source is depleted.

Although camcorders can use AC power as an alternative, most of the time you won't want to be tethered to a wall socket. When evaluating batteries that can be used with a particular camcorder, use the capacity (given in milli-ampere hours) to gauge how long a particular battery will last compared to another. A 3600 mAh battery will power a particular camcorder roughly twice as long as an 1800 mAh battery for the same model.

Different cameras slurp juice at different rates, so this comparison is valid only for batteries of the same type that will be used on the same model camera. A 2000 mAh battery for a miserly camcorder with few power-draining features may last a lot longer than a 3000 mAh battery mounted on a different camcorder with, say, a big zoom lens and an extra-bright LCD viewfinder.

Resolution

Resolution is how much detail the camcorder can theoretically capture, limited at the top end by the maximum resolution of the video system used (e.g., 525 vertical lines for NTSC video and 625 vertical lines for PAL/SECAM video systems). Some vendors also describe resolution in terms of number of pixels captured. A camcorder capable of 1,100,000 total pixel resolution may be further described as having 690,000 pixels effective resolution. The former figure is how many pixels the sensor has, while the latter reflects how many pixels are actually captured.

If you're shopping for digital camcorders, you won't find a lot of difference in the claimed resolution between models, but it's still good to know what these figures mean.

Microphones and Sound

Video is only half the picture, so to speak. To produce good clips you'll also want good sound. Digital cameras use a process called Pulse Code Modulation (PCM) to grab sound that is virtually as good as audio CDs, using either 12-bits or 16-bits of information to capture that sound. As with anything digital, the more bits the better, but for most

video applications it doesn't make much difference whether your camcorder uses 12-bit PCM or 16-bit PCM.

Instead, keep in mind that the quality of the microphone and its placement are likely to have a much more dramatic impact on your sound quality. Camcorders have a microphone built in to the front of the unit, of course, and that microphone can serve for many types of shooting.

However, even though well-shielded from extraneous noise, the built-in microphone is excellently positioned to pick up the breathing (or coughing) of the camera operator, internal noises of the camera itself, and other sounds that might obscure the audio emanating from your intended subject. For serious videography, you'll want the option of using an external microphone, especially since these add-on sound grabbers can easily provide even better quality than the built-in variety.

Camcorders frequently include a standard mini-jack for plugging in an external microphone, like the one shown in Figure 2.10. Even better is a 3-pin XLR connector, which is used for higher quality microphones, public address systems, and professional applications. Having an XLR connector on your camcorder is a plus, although you'll find them primarily on professional-grade equipment. You can purchase an adapter that will let you plug a microphone with an XLR connector into the conventional microphone jack of most camcorders, however.

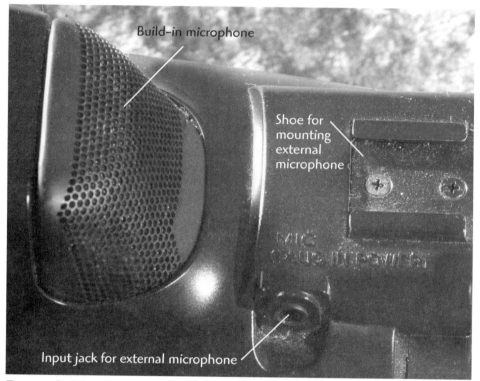

FIGURE 2.10 Instead of relying solely on the camcorder's built-in mike, use the connectors for attaching an external microphone for better sound quality.

You can choose from a variety of external microphone types, including lavalieres that clip to the clothing of that talking head you're shooting, handheld units you can poke in somebody's face if you're fond of "gotcha" journalism, and mikes that can be mounted on booms over the heads or off to the side of your subjects, out of the picture area.

Microphones are available with various coverage areas, too, so you can limit the directions that the recorded sound comes from. Omnidirectional mikes are sensitive to sound coming from any direction, and are a good choice when you can place the device in the center of the action, so to speak. Cardioid mikes are most sensitive to sound coming from directly in front of them, as for interviews. Bi-directional mikes pick up sound from either side of the microphone, but not in front of or behind it.

Light Source

Some camcorders include a built-in light source that can illuminate your subject or fill in the shadows. However, such lights are frequently too weak to do much good, drain your batteries quickly, or provide harsh, glaring effects. You're usually better off using the available light or relying on additional external light sources. Unless you have a special reason for an on-camera light source (say, you do a lot of spelunking or want to use the light as a flash for still photos), don't worry much about this feature. Instead, plan on buying some simple movie lights when it comes time to dress up your productions.

Manual Controls

Most video is taken on the run, so to speak, so automatic features like autofocus and autoexposure are not only welcome, but also essential. However, as you develop your video skills, you might want to create some special effects, such as an extra-bright or extra-dark look to set a mood. Optional manual controls give you that capability.

You can even steal from the master cinematographers, if you want. Start out a scene with the foreground blurry and out of focus, and the background very sharp, then manually focus on an object in the fore-ground, making it suddenly take on importance as the blurriness fades.

Other manual controls will let you create additional special effects in the camera as you shoot. Managing the controls while capturing video can be tricky, but it's worth the effort to take your clips beyond the ordinary.

Still Photography

Camcorders generally don't make very good still cameras, but it's still nice to be able to capture a photo here and there. Some models have a still photo option, and probably use a digital memory card to store those photos. With one of these cameras, you might be able to leave your still camera at home some of the time.

Web Video Capture

Video clips taken for display on Web pages don't have to be of the same high quality as the clips you capture for your video extravaganzas.

Indeed, extra quality translates into larger file sizes that may be cumbersome to download from a Web page, or that might display in a jerky manner over slow connections or on slower computers operated by visitors to your Web page. Your camcorder might have a "Web" clip option that lets you capture video at a lower resolution, such as 320 x 240 pixels, and slower frame rates, down to 10–15 frames per second (compared to the 30 frames per second used for NTSC video). These clips are often good enough for Web display, and download quickly, to boot. If you have need of video for Web display, look for this feature.

Night Vision

The solid-state sensors used in digital cameras are extremely sensitive to infra-red illumination, so much so that many cameras use a device called a "hot mirror" to filter out this non-visible form of light. Under very dark conditions, particularly at night, infra-red may be virtually the only light available to shoot by, so a few cameras flip the infra-red filter out of the way and call it a "night shot" capability. It's useful for security purposes, or maybe spy capers and a few applications such as photography of nocturnal animals, but unless you have a special interest in such work, this is a feature you shouldn't place high on your list of priorities.

Special Effects

Some cameras incorporate special effects features that you can apply while shooting. Most of the time, activating the effects as you work can be distracting, and the results you get won't be as good as those you can apply using virtually any editing software on your computer. If your camcorder comes with special effects, you're probably smart to pretend they aren't even there.

Scanning

As you know, video cameras produce images by scanning one line at a time very quickly, and repeat the process so that the video we watch consists of a series of frames (similar to motion picture frames) that our eyes merge into a continuous moving image. For various technical reasons, all conventional broadcast video scans each frame in two passes:

first for the odd-numbered lines and then for the even-numbered lines. These two sets of lines are merged to form what is called an "interlaced" image. Some HDTV formats and computer monitors display moving images with a single, non-interlaced pass, but for general-purpose video, interlacing is the norm.

Interlacing works pretty well, even though, with fast-moving objects, the difference in position between scans can create an odd look, as if horizontal slices were taken out of the subject. To solve this problem, some higher-end camcorders use noninterlaced scanning (called, in this case, progressive scan), so that each frame is scanned entirely in one step. Progressive scanning also improves the quality of the still image captured, too, so some camcorders use this mode for making still pictures.

Unless you shoot a lot of sports, auto racing, or other fast-moving subjects, the type of scan probably won't be important to you, but I wanted to explain this option just in case it's of value.

That's about all you need to know to assemble your video studio. A camcorder, capture device (if required), a few add-ons like external lights and microphone, and a gnarly computer equipped with the right software are all you need. I'll describe the software in the next chapter, when we work through all the steps needed to transfer your video.

chapter

3

Transferring Video to Your Computer

In this chapter...

✔ **Why Transfer Your Tape Library?**

✔ **Selecting Movies and Footage for Transfer**

✔ **What About Commercial Movies and DVDs?**

✔ **Preparing to Transfer**

✔ **Capturing Video**

✔ **Working with Wizards**

You've got tons of movies and clips already on tape. You probably enjoy viewing them on your television. But what will you do in the future when the current generation of VCRs has gone the way of the dinosaur? And what would you do if some disaster struck your home (such as a precocious two-year old who wonders what's inside those funny plastic boxes)?

Why not transfer your precious videos to DVD for posterity or ease of viewing? Having your videos stored away on compact DVDs out of harm's way is reason enough to make the transfer. But, computer access to your movies is only the start.

Once you've transferred your films to your computer, the fun really begins. You can edit your videos, create compilations of your best sequences, add special effects, and make copies for anyone who has a DVD player.

Best of all, transfer is easy. This chapter shows you all the steps required to transfer your VHS or 8mm tapes (and a few other video sources) to your computer, and thence on to DVD.

Why Transfer Your Tape Library?

Until digital video became practical for the average consumer, assembling an archive of personal movies and videos was a nightmare of clutter, inconvenience, and risk. A film or tape library takes up a lot of room and is difficult to organize. Finding the exact clip you want to view can be tricky. Tapes and film are easily damaged during normal viewing, and can be stolen, lost, or destroyed. When you consider how much we enjoy our personal movies and tapes, these limitations and dangers are serious drawbacks.

Movies on film are the absolute worst offenders. Back in the days when Super 8 was popular, each movie was returned from the processing lab on a tiny reel that held only a few minutes of action. You may still have some old Super 8 movies sitting around. If you don't want to keep threading one film after another onto the projector, it's mandatory to splice them all together into one long reel using messy techniques involving razor-blade cutters and glue solvents (or adhesive tape splices or ultrasonic welding).

Even strung together onto 400-foot reels, film takes a lot of space. To view the films, you need to set up a projector, which itself threatens to chew up your film each time it runs through the teeth of the sprockets, assuming that the splices don't break. Film can be permanently damaged by a little too much heat or a little too much moisture, and tends to fade alarmingly even if you take very good care of it. It's a blessing that home movies on film faded into oblivion several decades ago, even though many of us older folk still have piles of film reels up in the attic. (This happens to be one of the absolute worst places to store them, by the way.)

Film is one movie media that isn't easy to transfer to digital format. If you have old films you want transferred, your best bet is to ask around at your camera store and locate a professional who can do the transfer for you.

Videotapes are much easier to view and transfer, but have problems of their own. If your tape library happens to reside on Betamax tapes, you're in trouble right off the bat, because Betamax tape players haven't been manufactured for many years. Should your old Betamax VCR still be in working condition, it's probably a great idea to transfer your collection to DVD before it dies.

Of course, VHS recorder/players are still widely sold, but that won't always be the case. DVD is starting to replace VHS in many homes. Retailers and rental outlets have sharply reduced the number of prerecorded VHS tapes they offer. The majority of home users don't tape television shows very often, so many VCRs spend most of their time collecting dust. When DVD recorders and personal video recorder technologies like TiVo become more common, the death knell will sound for VHS. In ten years, your collection of VHS tapes might be as obsolete as Betamax is today.

Transferring your collection becomes an even better idea when you realize how easily videotapes are damaged. Who hasn't recorded a new clip on top of an old one that you meant to keep? A precious memory can become just that—only a memory—when you overwrite it because the original tape was inadequately labeled.

Older VCRs, especially, are prone to "eating" tapes. That's bad enough when the tape was a commercial movie you purchased or rented, because you can always go out and buy a new copy. But a snarled tape can be especially painful if it's a personal clip representing a lifetime milestone that can't be repeated. No store can sell you a copy of that wedding video that was damaged, or that you accidentally used to tape the Super Bowl.

Tapes can be damaged in other ways, too. Although more rugged than film, tapes can be made unplayable by water or heat. The magnetic coating on tapes can gradually wear off or change from exposure to magnetic fields. It's even possible for the electrical signal recorded on a tape to fade over time. It's possible to make a backup copy of a videotape, but the copy will not be as good as the original, and any successive generations duplicated from the copy will be even worse.

There are many reasons for transferring your movies to DVD. Here's a summary:

Protection. We've already seen that transferring movies to DVD provides protection for your valuable clips. DVDs are much more rugged than either film or tape, and can be easily duplicated. You can keep a spare copy of each disk in a fireproof safe or off-site, say, at a friend or relative's house.

Future compatibility. Conventional analog videotape is on its way out. There's no telling how long even the newer digital tape formats will be around. As pervasive as MiniDV is today, it could vanish quickly when the newer storage formats that are surely coming appear. Vendors have already announced digital memory cards that hold 8 gigabytes of information. With a little more capacity and much lower prices, cards capable of storing an hour or two of high-resolution digital video will be possible. Your older tapes, even the newer digital variety, will be obsolete.

No such fate is likely for DVD in the near or distant future, because the technology is still in its infancy. Current 4.7G DVDs will be augmented (not replaced) by 8G versions in the next few months, and the technology is already mapped out for DVDs that can hold 16G or more. As newer and better DVD storage is introduced, the original versions

will still be playable on future DVD players. It's not likely that DVD will be replaced by memory cards for permanent storage, as rewritable digital cards will never cost less than write-once DVDs. The DVDs you make today should be viewable 10 or 20 years from now, even if the basic technology is vastly improved.

Beyond the 20 year mark, if even more advanced technologies replace DVD, it should be easy to transfer your DVDs to the new medium. Because DVDs are already in data-friendly digital format and so widely used (even today), vendors of the replacement technologies will undoubtedly include provisions for migrating to them from DVD.

Ease of viewing. DVDs are more convenient to view. Certainly, a VCR connected to your television is convenient to use, but DVDs offer a lot more. You're not limited to viewing your movies on your television. If you have a computer with a DVD player, you can watch them at your workstation. Most new laptops have DVD players, too, so you can take your movies on the road and view them anywhere you like: in conference rooms, hotel rooms, or on an airplane.

It gets better. Videotapes must be viewed from beginning to end, and fast-forward or fast-reverse don't help you move to the exact clip you want to view very easily. Unless you've memorized counter numbers (and are viewing the tape on the exact machine used when you jotted down those numbers), finding a specific place in a videotape involves a great deal of trial and error. In contrast, you can easily divide your own home movies into "chapters" that can be selected from a standard DVD menu that you create yourself when the disk is designed.

Distribution. Videotapes are literally one of a kind. Copies are never as good as the original, and are time-consuming to produce. If you need a dozen copies of a one-hour tape, unless you have access to a tape duplication facility, you can count on spending at least 12 hours making your duplicates (and you'll need a pair of VCRs, too).

DVD copies, on the other hand, are indistinguishable from the originals. You can make as many duplicates as you like at a cost of only a dollar or two for a DVD+R/-R disk. Dupes are fast and easy to make, too. Just insert the original in your DVD burner and load the duplication

software. Specify how many copies you want, and the software will make an exact image of the disk on your hard drive, then burn each duplicate as you feed blanks into the burner. Depending on how much information is on your original DVD, the process can take a few minutes to a few hours, all without the tedium of loading and rewinding tapes.

Editing and enhancement. The ability to enhance your original videos is one of the best reasons to make transfers. Once the clips have been copied to your hard drive, you are free to extract sequences and place them in any order. You can add transitions like dissolves or fades between sequences or create text titles. Special effects are easy, too.

Video transfers give you the power to take your films beyond the mundane and transform them into something special. Whether you're a budding film director who wants to gain experience, a business user who is seeking more professional-looking videos, or simply a home videographer who would like to dress up your camcorder efforts, digital video is a perfect tool. You'll learn more about editing video in Chapter 4.

Selecting Movies and Footage for Transfer

It's tempting to simply take all your videos and transfer them *en masse* to DVD. In some cases, that's not a bad idea. If your current collection of videos is small, you might as well transfer all of them to DVD for archival purposes before you begin the process of editing. If you decide on the spur of the moment that a production you're working on needs a clip from another tape, you won't need to hunt down the tape and make the transfer; the clip will already have been copied to DVD.

Or, if you're particularly nervous about the possibility of losing one of your tapes, it might make sense to transfer even a large collection all at once to create a more permanent version. If the footage is particularly valuable, you might even want to make a copy of each raw DVD to store elsewhere. After all the tapes have been safely transferred, you can begin the task of editing and assembling with an unworried mind.

For most of us, neither situation applies, and so you'll probably be transferring your videos a few at a time. There are several criteria to use for selecting which tapes to transfer first.

Current projects. Perhaps you have an immediate project in mind, such as creating a compilation tape showing highlights from your kid's soccer career. Or, a birthday is coming up and you'd like to produce a "this is your life" production about a specific person. Maybe you'd like to create a blooper reel of funny moments caught on tape. If you have specific clips in mind, you might want to transfer the tapes containing those clips first. You can wade through the tapes that contain the clips you need and either transfer the entire tape to your computer, or copy only the portions you require for your production. This is a good approach if your tapes are well-organized so you can find the clips you want quickly and have certain ones that you need right now.

Categories. Sometimes it makes sense to transfer tapes according to particular categories. You could transfer all your tapes of vacations at one time, or select only those dealing with sports. Maybe you have all the school plays and pageants on separate tapes and would like to build a collection of them for later editing. If you tend to use each tape for a single event or type of event, transferring according to subject matter and categories can be a good strategy. On the other hand, if you tend to use one tape all year long until it fills up (and thus have visits to the beach followed by shots at a Halloween party followed by snowboarding escapades), this approach might not work.

Last in, first out. It's natural to be most interested in the thing you were working on most recently. Moreover, your video skills probably improved as you shot more footage. So, it's entirely possible that the clips that you're most interested in working with are those you shot most recently. In that case, you'll probably want to transfer your newest videos first.

Chronological order. At times we might want to start with the oldest movies and transfer your videos in chronological order. In some cases, the oldest videos are those you haven't looked at in awhile, and therefore hold a lot of nostalgic interest. Start transferring from the very beginning of your collection and work your way through. This

approach may even help you as you organize your transferred clips into some semblance of order. Reverse chronological order can work, too, if you want to transfer your latest videos and work your way backwards.

What About Commercial Movies and DVDs?

So far, we've concentrated on videos you made yourself, because that's the type of movie transfer of most interest to the average consumer. However, there might be some cases when you want to transfer a movie you purchased on tape or DVD. Perhaps your movie is in Beta format and your Beta VCR is on its last legs. Or, you'd like to use a couple of clips from a favorite movie to accent your own non-commercial production. Maybe you're planning on phasing out your VCR entirely, but don't want to lose your collection of vintage Hollywood classics.

There's good news and bad news on this front. The good news is that court decisions have uniformly upheld your right to make backup copies of media that you already own. You can't make duplicates of copyrighted material for your family or friends, but you can make an extra copy for yourself if you feel you need one. Reusing parts of commercial films in personal productions is on shakier ground, even if used for parodies, so you should try this at your own risk (and be sure not to make copies or try to distribute your finished productions)!

The bad news is that legal duplication is becoming more difficult to accomplish. Many commercial VHS tapes have copy protection features built in. Copying from DVD is certain to be difficult, even with special software. Many transfer programs are equipped to recognize copyrighted material and will stop dead in their tracks if you try. My advice is not to bother trying to copy commercial movies and DVDs. Unless you have a special need for such copies, it's generally not worth the fuss and bother.

Preparing to Transfer

Once you've decided which movies to transfer to your computer or DVD, it's time to get set up. The next sections will take you through the initial steps. You'll learn how to prepare your computer, make the connections, and load the software you need to start the transfer process.

Prepare Your Computer

The first thing to do is make sure your computer is ready for video transfer. You learned about the hardware you need, including amount of memory, hard disk space, and processor speed in Chapters 1 and 2. You upgraded your operating system, if necessary, and turned off power-saving features that could interrupt your video transfer. However, there are still a few things that can be done. I'll provide a quick checklist.

Defragment Your Hard Drive

Your computer is constantly creating files, erasing old files, and writing new ones to your hard disk. The space freed up when an obsolete file is removed is rarely exactly the same size as the next file to be written to that space. So, your computer may place part of the new file in the old space, then put the rest somewhere else. As you use your hard disk, there is a tendency for all the files to be scattered helter-skelter on your drive, written piecemeal wherever there is space. That process is called fragmentation. After awhile, your hard disk platter may begin to resemble a patchwork quilt, something like the simplified (and fanciful) representation shown in Figure 3.1.

FIGURE 3.1 When files are scattered all over your hard drive, its sectors become a patchwork of partial file fragments.

It's not as bad as it sounds. Your computer's operating system easily keeps track of where all the pieces of each file reside and can jump from one location to another to collect all of them quite rapidly. Today's computers and hard drives are so fast that you'll scarcely notice any delay, even if your hard drive is seriously fragmented.

However, that delay can affect video transfers, because the process moves so quickly that even a minor delay can slow things down and

spoil a perfect transfer. It's even theoretically possible for a severely fragmented disk to affect playback.

Things will go more smoothly if your hard drive is defragmented, so the existing files are arranged so that all the pieces reside consecutively on the disk, and the remaining spaces are as continuous as possible. Defragmenting is accomplished using a special software tool that copies each file to a temporary location on your hard drive, and then copies it back to a semi-permanent locale when the process creates a space large enough to hold the entire file.

If your hard disk is almost full, defragmenting can take a very long time, as there are not many free locations to use as a temporary home for your file fragments. Defragmenting a hard drive that is only, say 25 percent full, can still take an hour or more if many files are fragmented.

Windows includes a tool called Defragmenter, shown in Figure 3.2, which you might find at Start>All Programs>Accessories>System Tools>Disk Defragmenter, or possibly another location. Utilities like Norton SystemWorks also include a defragmenter that can be run as needed, or set to automatically defragment your hard drive a little at a time during idle moments.

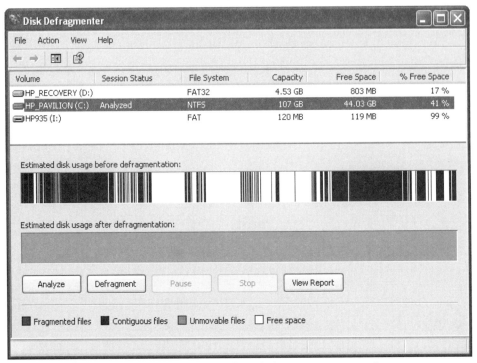

FIGURE 3.2 Windows XP includes a free defragmentation tool.

To clean up your hard drive with Defragmenter, click the Analyze button first to evaluate just how badly your disk needs tidying. The utility will return a report like the one shown in Figure 3.3, along with a recommendation. If Defragmenter suggests fixing the problem, click the Defragment button and let the utility get to work. You can continue to use your computer while defragmentation is underway, but the process will work to completion more quickly if you let Defragmenter work when the computer is otherwise not being used. If my hard drive is in poor shape, I usually let Defragmenter do its stuff while I'm away from my desk for a couple of hours.

FIGURE 3.3 *Analysis will show if your hard drive needs to be defragmented.*

Check Free Space

You'll need enough free space on your hard drive to store the files being transferred, even if you're writing them directly to DVD. However, even direct-to-DVD transfers use your hard disk drive as storage, so you'll want to have as much hard disk space as possible. I can't emphasize that enough. Remember the good old days when it was possible to store files on a floppy disk? Video files can consume as much hard disk space as two floppy disks, every second! A 60-minute videotape can occupy as much as 12G of hard disk space in its raw form (it will com-

press down to a much more reasonable size when transferred to DVD, however).

If that weren't enough to give your hard disk drive a workout, keep in mind that the computer needs three or four times as much additional space for temporary files during the transfer and editing than it does for the raw converted clip. So, if you're planning to transfer an hour-long video to your computer and then edit it, 50G of space is not too much to have on hand. The final production will be much smaller, of course, but you'll require a lot of free space on your hard drive as you work on a video.

You can view the amount of space remaining on your hard drive by choosing Start>My Computer and then right clicking on the drive's icon and choosing Properties from the menu that pops up. It will look like the one shown in Figure 3.4. If you fear that a lot of space is being wasted, click the Disk Cleanup button, which will empty your Recycle Bin, which retains files long after you've deleted them (until you empty the Recycle Bin, in fact). Disk Cleanup will also provide the option for removing temporary Internet files, such as Web pages or pictures that your browser stores on your hard drive in case you revisit the same page soon. Figure 3.5 shows the Disk Cleanup dialog box.

If you do run low on disk space, even with the most rigorous cleanup of your existing drive, remember that inexpensive external hard drives are available that plug right into the USB or FireWire port of your computer, making expansion of your storage capabilities very easy.

FIGURE 3.4 Check out the Properties box to see how much hard disk space you have remaining.

FIGURE 3.5 Disk Cleanup will remove unneeded files for you.

Close Extra Programs

Even if you have a very fast computer, indeed, you'll find that the demands of running other programs during the transfer can slow down your system enough to impact video transfer. Because I have a lot of memory and tend to work on many things at once, I usually have lots of programs running on my computer at all times. These always include at least a couple of components of Microsoft Office, such as Word and Excel, a Web browser, my favorite MP3 player, Photoshop (so I can edit an image on a moment's notice), and two different email programs (one for personal email, and one for business email).

In addition, Windows XP is always running a clutch of programs unknown to the average user. If you're wondering exactly what programs are running at any given time, press Ctrl+Alt+Del to access the Windows Task Manager. Click the Applications tab to view the programs you've launched yourself, as shown in Figure 3.6. Then click the Processes tab and scroll down the long list of other programs that are loaded and ready to run when the operating system decides it needs them. You shouldn't shut down anything from the Processes tab, but you might want to review the list of programs shown in the Applications tab and shut down the ones you can live without during video transfer. It's best to close the application from the program itself, rather than use the Task Manager, especially if you want to avoid losing changes in any files that might be currently open.

Closing extra programs can also free up RAM, giving your computer and its transfer program that much more to work with as your videos are converted.

FIGURE 3.6 Task Manager will show you exactly what applications you have launched.

Connect Your Video Source

Once you're satisfied that your computer is ready for video transfer, the next step is to connect your video source, such as a VCR or camcorder, to the computer. There are a variety of ways to do this, depending on whether you're transferring analog or digital video. I'll describe both of them next.

Connecting Analog Sources

As I described in Chapter 2, analog video must be converted to digital form before it can reside on your computer's hard disk or be copied to a DVD. You've already learned that this magic is accomplished using video capture hardware that can be built into your PC's video card, reside on a separate capture card in your computer, or be located in an external capture device such as the one included with the HP DVD Movie Writer DC3000. Once you have that hardware, you still need to connect your VCR or camcorder to the capture device. Analog video devices can link up in one of four different ways.

Composite video/audio. Composite video connectors are most commonly RCA jacks like the one shown at left in Figure 3.7. The jack accepts an RCA-style cable. The video connection is usually color-coded yellow. The two jacks coded red and white are for left and right stereo audio channels. If your camcorder has only yellow and white jacks, the audio connector provides only monaural output. You'll need a Y-shaped adapter like the one shown in Figure 3.8 to feed the monaural signal to the stereo inputs of your capture device.

FIGURE 3.7 Composite video/audio use three RCA jacks color-coded yellow, red, and white.

Figure 3.8 A Y-shaped adapter will let you feed a monaural signal to a stereo input, or send a stereo signal to a device that accepts only monaural input.

S-Video. S-Video output provides a higher quality video output, compared to composite video, and should be preferred if your video source offers both. You'll find S-video output on newer camcorders, DVD players, and some VCRs. S-Video connectors may have four or seven pins, but there is no standard for the use of the three center pins, so most devices use only the outer four. A few Dell computers use the additional three pins for audio, but, generally, you'll still have to use your camcorder's red/white RCA audio jacks to connect to your analog video capture device. You can learn more about S-Video at http://www.svideo-rca.com. Figure 3.9 shows the arrangement of both four-pin and seven-pin S-Video connectors.

FIGURE 3.9 S-Video connectors come in both four-pin and seven-pin varieties, but in most cases only the outer four pins are used.

Component video. Some costly professional video devices use component video connections, carrying the video signal over three connectors that are coded red, green, and blue. You'll need a capture device that accepts component video to use this type of connection, if your video source has that option.

Video converters. An alternative to the conventional analog video capture device is the video converters available from several vendors. These external devices have inputs for the signals from your analog camcorder or VCR, and a FireWire connector that directs the converted signal to the FireWire port of your computer.

Remember that after you've connected your analog device's video output to a converter or capture component; you must also connect the audio output, usually by means of RCA cables connected to the red/white RCA jacks, or, with some camcorders, through a 3.5mm mini-stereo plug that splits into two RCA plugs, as shown in Figure 3.10.

FIGURE 3.10 Some components, such as computer sound cards, use a 3.5mm mini-stereo plug for audio. You can use an adapter like this one to connect to a miniplug jack.

Connecting Digital Sources

Linking your computer to your digital camcorder is a lot easier. All you need to do is plug a cable into the FireWire port of your camcorder and connect the other end to any of the FireWire ports on your computer. Some camcorders use USB instead of or in addition to FireWire, but, if you have a choice, use the FireWire connector. If you don't have a FireWire port, you can usually add one with an inexpensive card that plugs into your computer.

The FireWire port on your computer has slots for six pins, three on each side of the connector, as shown at the top in Figure 3.11. Your camcorder's FireWire port probably has four pins, all arrayed on one side, as you can see at the bottom in the same figure. Your camcorder should be furnished with a four-pin to six-pin FireWire cable.

FIGURE 3.11 FireWire connectors come in both six-pin varieties (for your computer) and four-pin versions (for your camcorder or other component).

You don't need to switch off your computer to connect the camcorder. Just plug it in. If this is the first time you've connected the camcorder, Windows may pop up a dialog box or offer to install the device. If you need to install software so the computer can recognize your camcorder, you can do it at this time.

Once linked, you're ready to transfer video through your capture software. You may find that your computer can actually control your digital camera over the linkup, so you can start playback, rewind to a particular point in the tape, or pause using the software controls.

Capturing Video

Now you're ready to go. You can capture video, save it to your hard drive, and, if you like, archive it to DVD. You can even edit your movies to enhance them. I'll explain the last three steps in more detail in Chapter 4. For now, we'll look at the steps involved in capturing video after you've gotten your computer ready and connected your camcorder.

Run Your Capture Software

Your camcorder may be furnished with software that allows capturing video. This software may have only limited features and not provide much in the way of editing functions. Alternatively, you can use the video-editing software of your choice, because all of them have capture features built right in. HP products intended for video capture

include several useful programs. These range from ArcSoft ShowBiz Video Editor and ArcSoft ShowBiz DVD (in models with a DVD-writer), to Microsoft Windows MovieMaker 2.0, which is furnished free with Windows XP.

Windows Movie Maker includes three main "tasks" in the column at the far left of the window shown in Figure 3.12. You can start out by clicking Capture Video first, and then choosing whether you want to capture from a video device, or import video, pictures, or audio that you've already captured. Once you've assembled the clips you want to use, you can click Edit Movie and Finish Movie to polish off your production. We'll look at editing and final production in Chapter 4.

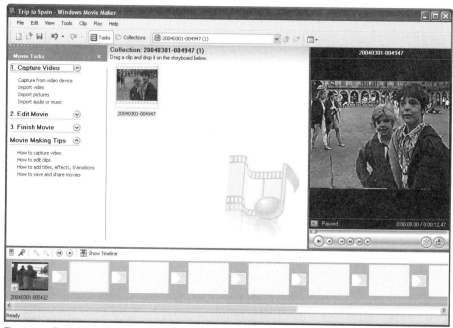

FIGURE 3.12 Windows Movie Maker is supplied free with Windows XP.

More advanced programs, like the ShowBiz Video/DVD editors included with many HP products, are just as easy to use as Windows Movie Maker, and offer many more options.

Once you're connected and have loaded the ShowBiz software, shown in Figure 3.13 with several video clips already loaded and ready

for editing, you may have to make a few settings adjustments, but in most cases the correct default values will already be loaded for you.

FIGURE 3.13 ShowBiz has a clean, easy-to-use interface. Most of the default settings will work fine.

For example, in Figure 3.14 you can see that ShowBiz has automatically detected the HP DVD Movie Writer DC3000 as the video input source. If your system happens to have more than one video source, the additional devices will appear in the drop-down Video Device List. A frame size of 720 x 480 and frame rate of 30 frames per second have already been selected for you. Unless you need less resolution or a slower frame rate (say for a video that will be displayed on the Web), you won't need to change these.

FIGURE 3.14 The most frequently used options have been selected for you.

The Settings button in ShowBiz (or an Options button or menu choice in other programs) produces a set of options you can change. Again, unless you have special needs, you can usually ignore these. For example, in Figure 3.15 you can change the method used to encode and compress the video as it's captured, but the default choice, MPEG-2, is the most compatible and works fine in nearly all cases. There's another option to change the resolution, and buttons to choose whether input should come from the S-Video port or Composite Video port of your capture device. The correct options have been selected automatically. You can safely ignore settings such as bit rate and bit-rate mode.

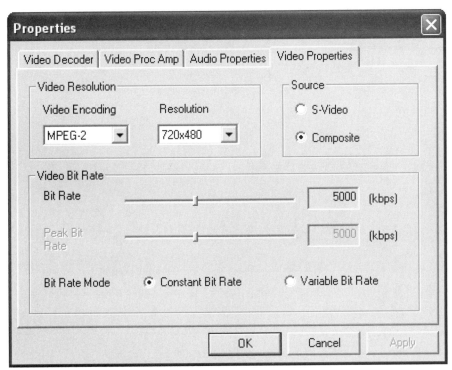

FIGURE 3.15 You'll rarely need to change the video properties settings.

Other options, like those shown in Figure 3.16, appear in the Preferences menu and are applied globally to all videos you transfer until you change them. ShowBiz lets you specify whether the incoming video is NTSC or PAL, and whether files should be saved in interlaced mode (for best display on a television) or in non-interlaced ("progressive") mode for best viewing on a computer screen. You probably won't even have to change these basic preferences. They are set by default to the values most commonly used.

FIGURE 3.16 Type of scanning is likely to be the only preference you change, for optimizing your captures for the type of system they'll be viewed on.

One handy feature that you'll want to learn to use is the scene detection mode, shown in Figure 3.17. When you transfer your movies to DVDs, the software can create menu choices reflecting individual scenes on the DVD, just like you'll find on commercial disks. Having your video bookmarked with scenes makes it easy to jump to the exact place you want using your DVD player's controls.

Your capture software can automatically detect scene changes, usually by detecting when the subject matter of the captured video is modified significantly. A sensitivity slider can determine how loosely or strictly the automatic scene feature defines scenes. A better choice might be to use manual scene detection. In that mode, you watch the video as it is being captured and send a signal to the software (usually by pressing the space bar or some other key) when a scene should be bookmarked.

The video capture software you use may have additional options, but most of the time you won't need to use them.

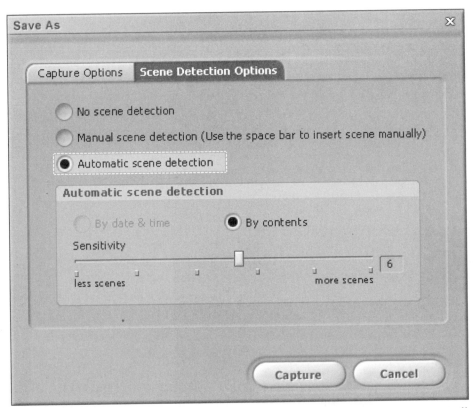

FIGURE 3.17 Choose automatic or manual scene detection, or no scenes at all.

When you're ready to begin capturing video, click the Capture button. A preview window like the one shown in Figure 3.18 appears, and capture begins. A display in the lower right corner of the screen shows the current file size for your captured video, the elapsed time for the clip you've grabbed so far, the amount of free space left on your hard drive, and the amount of recordable time remaining.

FIGURE 3.18 Video capture is quick and easy.

You can continue capturing a single video for as long as your hard disk holds out, or capture each tape in sections. Grabbing a little of the video at a time can be useful if the tape contains many different kinds of scenes (which is typical) rather than one long sequence. For example, if you shot a few minutes of video in each city you visited on a trip to Europe, you'd probably want to capture all the footage for individual cities separately so you could edit that city's scenes without having to hunt through a long video for them. On the other hand, if you shot your child's class play as one extended sequence, you might want to divide it only between scenes to avoid inserting interruptions in your production.

That's the great part about transferring video to your computer: the flexibility at your fingertips. You can grab as much or as little as you want, or go back and recapture sections if you decide you want a longer sequence in each file.

Working with Wizards

If you're in a hurry, or simply want to do nothing more than transfer a video to a DVD, using one of the wizards furnished with most editing or capture programs may suit you to a T. These automated programs have few options, and do little except the one thing they are designed to do: transfer video directly to your computer or DVD. They might look like the one shown in Figure 3.19, included with one version of Showbiz.

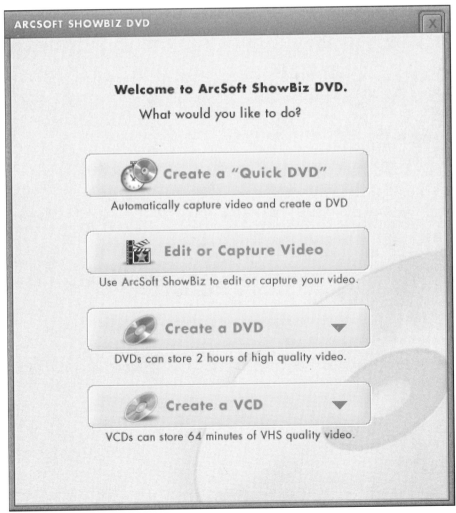

FIGURE 3.19 Wizards are a fast and easy way to transfer video.

One of the easiest to use is the HP Video Transfer Wizard, furnished with the DC3000 Movie Writer. When you activate it, the wizard shows you how to do everything from connect up your equipment to save the captured video to DVD. Figure 3.20 shows the first screen in the five-step wizard's display.

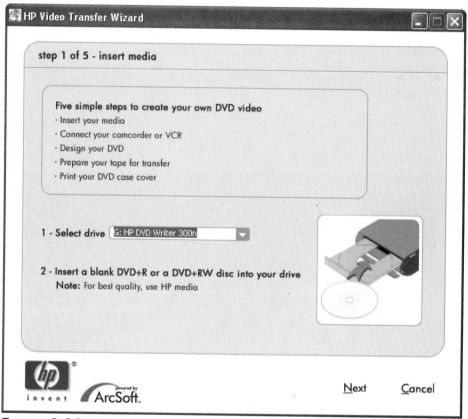

FIGURE 3.20 The first step is to insert a blank DVD+R or DVD+RW disk in the CD burner.

The next screen (Figure 3.21) provides a picture that shows you how to connect your camcorder or VCR to the Movie Writer. After that, you're given an opportunity to enter a title for your movie and choose a background. These (shown in Figure 3.22) will appear on the opening menu when your movie is shown using your DVD player.

FIGURE 3.21 Connect up your equipment according to the instructions.

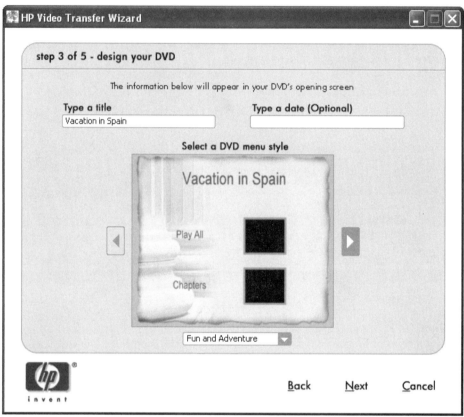

FIGURE 3.22 Add a title and background if you like.

Finally, you're told to advance the tape in your camcorder to the position you want to start the transfer. You can set a maximum time limit on the capture, so the transfer will stop automatically at that point. You can use this feature to start unattended transfers that will capture only as much of the video as you specify. For example, if you're transferring a 120-minute Hi8 tape, but want only the first 30 minutes (or, perhaps, only the first 30 minutes have been recorded and the rest of the tape is blank), you can set that upper time limit, start the transfer, and walk away. The capture will stop automatically when the time limit is reached. Figure 3.23 shows this final set-up screen. When you're ready to begin capture, click the Transfer button and press the Play control on your camcorder or VCR at the same time.

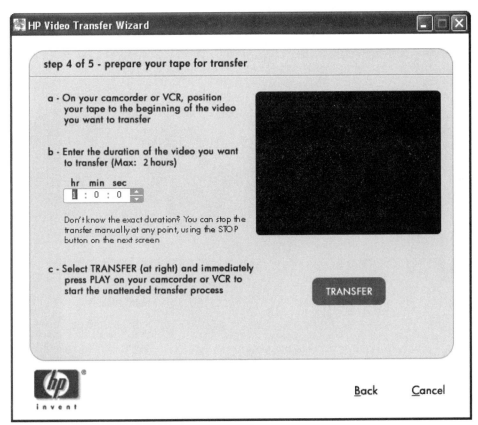

FIGURE 3.23 You can start the transfer from this screen.

The wizard then starts capturing the video, stores it in a temporary file on your hard disk, creates a menu for the DVD, and then burns the DVD. You can go do something else, returning to your computer only to monitor the status screen, shown in Figure 3.24, from time to time.

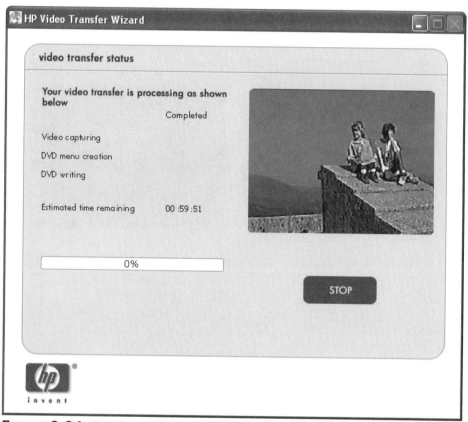

FIGURE 3.24 This status screen shows the progress of the transfer.

That's about everything you need to know to begin transferring video to your computer. If you think video capture techniques are easy and fun, wait until you see what you can do at the editing stage. That's what we'll be covering in the next chapter. You'll learn how to divide your masterpiece up into individual scenes, edit them, add special effects and transitions, and do a lot more that turns an amateur home movie into a professional-looking production.

4

Editing Your Videos

In this chapter...

Once you've transferred your video to your computer, there's more fun in store. You can edit your clips in cool ways, adding special effects, transitions, music, and other enhancements. Even simple changes can transform a long and rambling video into a taut, engaging movie that will be a pleasure to watch.

T his chapter will get you started in the wonderful world of video editing, introducing you to some of the kinds of projects you can create, and the tools you'll need to create them. You'll find that once you've gained a little experience, editing can be quick and easy; or, if your movie-making ambitions run high, you can become completely immersed in the process, if you like.

Wherefore Art Thou Editing?

Creative editing is a little like serving as a director of a Shakespeare play. All the characters and performances are already there, ready for you to refine and mold into a finished production. You can add a little stage direction, if you like, to make things more interesting, and increase the excitement a notch with some special effects. Address your audience directly, not with soliloquies, but with narration or text titles. Highlight your best performers, and trim the parts of those who have a smaller role in the action. After all, the play's the thing!

You don't need to be assembling a masterwork to benefit editing, however. There are lots of reasons why some judicious trimming and rearranging can improve your videos. Here are a few of them:

Increase entertainment value. Andy Warhol frequently made long, unedited films, such as *Empire* (24 hours of nothing but the Empire State Building) and *Sleep* (a six-hour epic showing a man sleeping), but the importance of his cinematic output lies in Warhol's avant-garde techniques, intensity, and outright strangeness rather than the odd length of some of his productions.

Those of us with an artistic vision that's a little more conventional must use careful editing to make our videos watchable. The ease of pointing a camera and just letting it run lets us capture everything that happens, but viewers are unlikely to be willing to sit through hours of raw, unedited footage. Careful selection of the best parts and arranging them into a pleasing order can make even haphazard shooting worth viewing.

Anyone who's bothered to watch the "Deleted Scenes" segments among the special features of a commercial DVD will agree that most of those scenes were deleted for a very good reason. A professional director's "first cut" edit of a film may be hours longer than the final release, even though some (seemingly) priceless footage must be removed. That's the approach you should take if you want your videos to be watchable: edit them down to include only what's necessary, and nothing more.

Combine related clips. As you create videos, you'll accumulate lots of different clips shot at different times that are related to one another in different ways. Perhaps you have sequences taken over the years of a beloved family pet, or have filmed the practical joke hijinx of a friend. Maybe you've informally grabbed clips of all the new product introductions at your office. Or, you've surreptitiously filmed the annual company picnic with a thought towards creating a highlight reel for display at a future gathering. All these clips can be extracted from their original footage, edited, and combined to make a fresh, new production.

The relationships that the individual clips share can exist only in your imagination. You might want a compilation video of all the caverns your family has visited on vacation. Perhaps you'd like to compile a blooper reel taken from rehearsals at your drama club. If you shoot video at motor sports events, you might enjoy putting together all the most spectacular action.

Digital editing is a way to combine these separate clips in new ways.

Add special effects and transitions. Movies that already sparkle with life can be made even better with the addition of special effects and transitions between scenes (such as dissolves, fade outs, and so forth). These add-ons tend to make your productions look a little more professional, and can serve an artistic purpose as well. For example, a fade-out from one scene followed by a fade-in to the next implies a passage of time. Special color effects can create a mood. Careful editing can spice up your productions quickly and easily.

Add music and sound effects. Movies from Casablanca to American Graffiti to Pulp Fiction simply wouldn't be the same without background music to set the tone.

You can blend music in with live action in such a way that the natural sounds already there aren't obscured. Or, if your video happens to be mostly silent (say, you've photographed a scenic mountain panorama and the only sounds are of the wind whistling), you can liven things up with your favorite sounds.

Tell a story. Many home videos are just collections of clips of various interesting things as they happened, more or less at random. There's nothing wrong with that, and it's possible to have a lot of fun viewing well-edited sequences that each stand on their own. However, more advanced video fans soon graduate to planning productions that tell a story of some sort. Editing can help you collect the clips you need and assemble them in the order needed to tell that story.

The story can be as simple as "Our 2004 Vacation," with clips of the family getting ready for the trip, traveling from destination to destination, and participating in activities at each location. Or, your story could be a mini-biography of someone's life. If you're especially motivated, you can prepare a script for an original play, collect props, build sets, assemble costumes, rehearse, and then film the whole production. One of the best things about working with video is that it's inexpensive to capture the same scene over and over until it's done right. Or, you can choose the best "takes" from a selection of run-throughs and use them to assemble the finished product.

Simple story-telling with video and editing tools can become a passion, and once you've tried it you might find that movie-making has become a favorite hobby (or even more than just a hobby!).

Basic Editing Terminology

All digital video editing software works in pretty much the same way, using similar tools, working screens, and menus, so I'll describe the basics of editing in general terms that apply to just about any editing application, but will use ArcSoft ShowBiz as an example. ShowBiz is supplied with many HP computers and other products.

Here are some of the basic terms you need to be familiar with to edit video:

Projects. A video production is termed a *project*, and consists of all the elements used to assemble the finished production for showing, including videos, audio, the special effects, and other components. You can share bits and pieces among different projects, but each project comprises just one finished video.

Clips. Clips are individual components of a production, each individually manipulated, ordered, and then combined to complete a project. In addition to video clips, there are also *audio* clips, which can consist of music, sound effects, or audio narration that is applied voice-over fashion, and even *still photo* clips. Because this chapter focuses on video editing, for the most part when I use the term clip by itself I am referring to a *video* clip (usually a video clip that also contains sound). When I mean audio-only clip I'll use the full name *audio clip*, and when I am referring to a still image, I'll call it a *photo*.

Storyboard. A storyboard is like a rough sketch of your movie, where you place individual clips in the order they will be presented, comic-strip style. If you've ever viewed the Chapter Selection menu of a commercial DVD, you'll know exactly what a scene-by-scene storyboard looks like. The storyboard pane of video editors shows a thumbnail image of the first frame of the video clip, making it easy to visualize the content you've lined up.

Timeline. A timeline is a little like a storyboard, in that it shows thumbnail images of individual clips in the order they've been arranged. However, a timeline includes a ruler that shows the elapsed time allotted for each clip, so you can see the relationships between them. Shorter clips take up less space on the timeline ruler, and longer clips take up more space.

Frames and timecodes. Frames are the individual images that, when viewed consecutively, make up your video. There are approximately 30 frames per second in an NTSC video. The number isn't exactly 30 because the NTSC video system drops roughly one frame per minute, so most 60-segment clips contain 1799 frames instead of 1800 (30 x

60). The dropped frame allows the electronic system to squeeze in a little extra information needed for color reproduction.

Ordinarily, you'd never even notice the dropped frame (just as you don't notice the leap-seconds scientists add to the length of the year every now and then). However, video editing programs use an *hours:minutes:seconds:frames* system (called *timecodes)* to number each and every frame in a video, and those dropped frames have to be accounted for. If you're involved enough in video editing to pay close attention to timecodes, you'll want to know why the numbering of some frames (usually those at the beginning of each minute) can be slightly different from what you might expect.

Encoding. This is a process of converting video files into a smaller, compressed format so that they don't take up quite as much space. Even a DVD won't hold several hours of video unless the raw sequences are squeezed down into a more efficient format. The specific software modules that *compress* and *decompress* video are called *codecs.*

Making Movies

I'm going to take you through each of the steps needed to edit a series of clips into a finished movie. You've already learned about one step, transferring and digitizing video so you can work with it on your computer, but we'll start there anyway, because there's a little more to say. After that, we'll move briskly on to all the other steps.

Open Your Project

The first step in creating a movie is to launch a new project and give it a name. Generally, you'll find a New Project choice in your image editor's File menu. You can create the project from scratch or, if you want to reuse the work you've done on another project, you can load that project into the editor and save it under a new name. Reusing projects is a good strategy when you want to create a variation of an existing pro-

duction. Teachers, for example, may want one version of a classroom project for parents, one for school administrators, and one for the kids.

Acquiring Your Media

Next, you'll want to add the clips you plan to work with to your project. As I noted earlier in this chapter, the clips you use to create your masterpiece aren't necessarily all video clips. You can incorporate other types of images and sound into your productions. These all fall under the umbrella term, *media*. The first step in making your movie is to acquire the media you are going to use, and make them available to your video editing program. You'll acquire these kinds of media:

Video. You learned about transferring video from tapes in Chapter 3. You may also use video acquired from other sources in your productions. These clips could easily be so-called *stock footage*, which consists of video, often supplied in digital form on DVDs or CDs, as a bonus feature of your editing program.

Your video editor might well have come with a "content" disk containing these clips. You can also purchase stock footage from suppliers who cater to home video enthusiasts like yourself. The company supplying the clips will grant you various levels of rights to reuse the footage in your own productions. For example, you might be given unrestricted use, which means you can pretty much do anything you like with it. Or, you might be allowed to use the video only for personal, non-professional productions. It's also possible to be granted free use of video for both amateur and professional applications with the exception that you're not allowed to resell it as stock footage.

Perhaps you've transferred some video from DVDs you own, or friends have given you their own footage to include. As long as you have permission to use the clips, all these video sources can make excellent fodder for your productions.

Audio. You'll be working with the audio that accompanies the video clips you transferred, but you might also want to use audio from other sources. These can include MP3s you've downloaded or made from CDs, recordings you made with your own tape recorder and micro-

phone, or commercial background music and sound effects intended for use in video productions. (These audio clips are a kind of "stock" footage, too, and carry their own rights and restrictions; make sure you understand exactly what uses are permitted.)

If audio doesn't already exist in digital form, it can be captured using recorder software like the Sound Recorder built into Windows XP, or "ripped" from CDs using popular MP3 software.

Still photos. There are lots of times when you'll want to incorporate still photos in your movies. For example, you might want a photo, with text added, in your titles at the beginning of the movie, or as credits at the end. You can create these stills using a digital camera, or capture them using a scanner. Many video-editing programs include an Acquire module that lets you import still images directly into the program from one of these sources. You can read more about digital photography and scanners in Chapters 5 through 9 of this book.

To use any of these media, you need to add them to your video editor's album or clip browser, like the one shown in Figure 4.1, where they will appear as thumbnails. Once loaded into the browsing area, you can review the clips or drag them onto the storyboard for inclusion in the production. If you change your mind, just delete a clip from the storyboard. It will remain in the browser/album for you to restore to the storyboard later if you like.

FIGURE 4.1 To start your project, acquire your media and add them to the browsing area.

Adding Clips to the Storyboard

The next step is to add clips from your media album or browser to the storyboard in the order in which you want them to appear, as shown in Figure 4.2. This step can be as simple as dragging the clip from the browser onto the storyboard.

As you click on a clip in the browser, the software will display information about the particular clip, such as its name, the size of the clip file, and information about what kind of format it is stored in.

Formats include variations on the MPEG format (such as MPEG-1 or MPEG-2), different types of Windows video formats (including AVI or WMV), audio formats like MP3 or WAV, and still photo formats such as JPEG or TIF. It's not really necessary to know the finer points of the differences between these formats when you're assembling your

video. If your video editor can import a particular format, it's suitable for use with your production. The time to be selective about the file format of the video is when you're storing the finished movie permanently on your hard disk, DVD, or CD, because you want your effort to be as compatible as possible with the software and hardware that will be used to view it.

As you add clips to the storyboard, you can rearrange them or remove them at any time. You can preview any clip by selecting it in the browser/album or on the storyboard, and clicking the Play button under the video editor's preview window, shown at upper right in Figure 4.2.

FIGURE 4.2 Select a highlighted clip from the browser (upper left) or storyboard (bottom) and view in the preview window (upper right).

Enhancing Your Clips

When you select a clip that's been dragged to the storyboard, video editors like Showbiz usually let you make some minor enhancements, using the controls you can see in the center of the window in Figure 4.2. You can adjust the volume, improve the brightness and/or contrast, change the overall color (hue) of the clip, or modify the richness (saturation) of the colors. The image quality modifications are pretty much the same as you can make with still images, so if you want to learn more about brightness, contrast, hue, or saturation, check out Chapter 7, which deals with editing photos.

If you don't like the changes you've made, you can remove them by clicking the Restore, Reset, or Cancel buttons provided by your video editor.

Creating Transitions

One of the hallmarks of a professional-looking video production is the transitions between scenes. With many video editors, the easiest place to add transitions is in the storyboard. You can add transitions before or after you've adjusted the length of each clip (more on that later in this chapter), or change the transitions at any time.

The usual way to add a transition is to drag an icon representing the kind of transition you want from a transition album or library to an icon placed between two clips in the storyboard. You can see the transition icons between the first few clips in Figure 4.3. The video editor software automatically applies the transition when it merges the two clips.

FIGURE 4.3 The icons before the first clip, and between the first/second and second/third clips, represent transitions that have been added.

Anyone who grew up since the advent of movies and television (which includes just about anyone with an age that's not in triple digits) has seen transitional effects added to film and video hundreds of thousands of times. You're probably even familiar with some of the lingo, such as dissolves, wipes, or slides. Now that you're a movie producer, it's time to get a little more cozy with some of the effects you can use. The transitions available in your video editor will fall into several common categories.

Cut. A cut is practically no transition at all. The video goes directly from one scene to the next. You might not even notice the non-transition. Movies use cuts constantly, say, when the hero of an action flick unleashes a round-house kick at the bad guy and the image immediately changes to a reaction shot of the villain's face. Used carefully to link very short shots, cuts can be an effective transition.

Cuts can be jarring, too, when the context of the two linked shots is very different. If one scene shows an idyllic daylit tropical beach scene, and the video immediately cuts to a night-time urban shot, the result can be confusing or disturbing. Such *jump cuts* can be used artistically when you want to create a discordant effect, but most of the time you'll want to avoid them.

Wipe. A wipe transition occurs when the scene that follows gradually moves across the frame, obscuring the original scene, like a sponge or squeegee wiping across a pane of glass. If you can imagine a window-shade gradually being pulled down over a window, with the shade being the new scene and the window representing the original scene, you can visualize what a wipe looks like. Figure 4.4 shows a scene featuring one cat (at left) wiping into the previous scene of a different cat.

FIGURE 4.4 The scene at left is moving into the frame from left to right, wiping out the previous scene.

However, wipes can occur using many different orientations or shapes. The "window-shade" can start at the bottom and move to the top, or at either side of the frame. Wipes can start at one or more corners of the frame and move inward, or in the center and move out-

ward. Professional editing equipment provides hundreds of variations on the wipe, and most video editing software for PCs includes a dozen versions, so you can constantly switch to something new and fresh.

Wipes can work together in interesting ways, too. Perhaps one short scene wipes into the next one from left to right, and then the scene following that wipes in from right to left. You can apply wipes gradually, or use a quick wipe to keep the pace moving. As you can see, this kind of transition can do more than simply ease the move from one scene to the next.

Slides. A slide works a lot like a wipe, but with some variations. For example, a slide can have multiple segments so, say, the new scene starts at both the top and bottom of the frame and wipes toward the center. Or, the top half and bottom half of a frame can wipe over the original scene from different directions. One cool slide effect is to gradually shrink the original scene down to a tiny spot, then enlarge the next scene from that spot until it fills the frame, as shown in Figure 4.5.

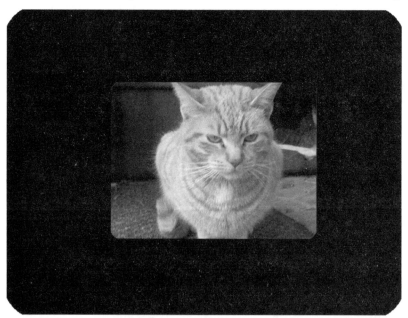

FIGURE 4.5 In this slide transition, the original scene shrinks down to a tiny spot, which then grows to full size again, revealing the next scene.

Fades and dissolves. These transitions gradually make the original scene more and more transparent, while the next scene, which starts out transparent, becomes gradually opaque. The traditional fade-out/ fade-in transition has been augmented by more sophisticated versions, such as the dissolve, in which the two scenes fade in and out in a "grainy" manner, with one seeming to dissolve into the other. The "fade-out" and "fade- in" can also occur using lines, dots, checkerboards, or other patterns that seem to eat away at the original scene, revealing the new scene underneath, as shown in Figure 4.6.

FIGURE 4.6 With a dissolve, the original scene seems to be eaten away, revealing the next scene "underneath."

Fancy transitions. Electronics and computers have made it relatively easy to use all kinds of motion and other effects during transitions. The new scene may appear as a rectangle seen from an edge-on perspective, and the shape gradually twists in three-dimensional space until it fills the frame, as shown in Figure 4.7. Or, the old scene may appear to roll up from one corner, like a decal being peeled off a window, revealing the next scene underneath. You'll see this kind of transition used on

television a lot (and almost never in motion pictures), and you can use them if you want a lively, high-tech video feeling.

Once you've mastered all the different kinds of transitions your video editor offers, you'll want to experiment with them to see what kind of artistic effects they offer. Play around with the duration of your transitions, especially, so you can determine whether a long, leisurely wipe or a fast dissolve is best for your particular scenes.

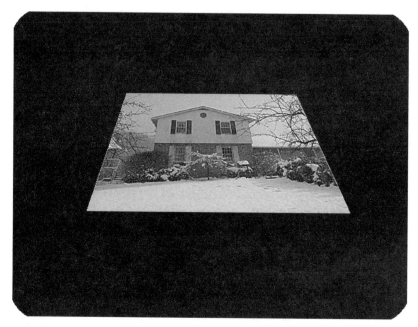

FIGURE 4.7 Some transitions may swirl your scene around, twist it, or show it at a strange angle before finishing up with the normal frame orientation.

Adding Text

Text is a valuable addition to most productions, if only for the opening titles or closing credits. However, you can also use text as subtitles or to provide funny comments. Text can also make an effective and informative transition, as anyone who's watched the scene-setting titles between shots on the *Frasier* television show can attest.

Although you can use text applied to still photos that you drop onto your storyboard in appropriate places, you'll find more flexibility using

the text capabilities of your video editor. You can choose from simple and fancy text types, superimpose the text over a video clip of your choice, and use the video editor's transition effects to wipe, fade, dissolve, or slide the text onto the screen. You can specify exactly how long to display the text, too, so if you want a title to appear only at the beginning of your opening sequence, then fade away, you can do that. Figure 4.8 shows an example of title text.

FIGURE 4.8 Add text to make your own titles.

Using Special Effects

Another enhancement you can make to your video is the addition of special effects. These can include filters to add texture, changes in frame orientation, and other effects, depending on the capabilities of your particular video editor. Here are some of the kinds of effects you can add, usually by dragging the effect onto a clip in the timeline:

Filters. These operate like the filters used with still photo editors (see Chapter 7 for more details on those), to create interesting patterns and textures to your clips. Add raindrops, create a negative (great for horror films!), produce wild false color solarizations, or accentuate the edges of your images. These kinds of effects are great for title or credit sequences, but can be carefully mixed into other parts of your video, too, if you don't overdo them. Figure 4.9 shows a clip with a special effect added.

FIGURE 4.9 *Special effects can spice up your videos.*

Orientation. These effects change the viewpoint of your clip, turning the image on its side, upside down, reversing it as with a mirror, or producing a reflection. You can probably think of some artistic uses for these effects, but, for the most part, they are simply just a lot of fun to apply.

Television effects. These mimic some of the electronic looks a television effects generator can create, such as breaking your image into multiple tiny versions of itself, wrapping the image around a cube, or mimicking the effects of a horizontal hold malfunction.

Crop effects. These effects display your clip as if it were being viewed through a cutout, such as a keyhole, star-shape, or letterbox-style

frame. Everything outside the cookie-cutter cropping boundary is masked with a black background. Use these to emphasize certain portions of your frame, or for special theme effects, like Valentine's Day, as you can see in Figure 4.10.

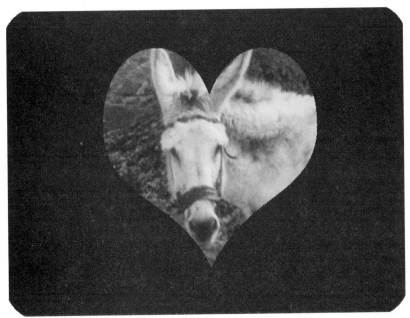

FIGURE 4.10 Use a cut-out crop to highlight a loved one or special pet.

Banners. These are overlays plopped onto your video, and serve much the same purpose as the logos your television station places in a lower corner of the screen (for example, "Action 8 News") to remind you what you're watching.

Special frames. This kind of effect places a frame (sometimes a silly one) around your clip, so that the video appears as if it were displayed on a billboard, on the side of an advertising blimp, on a movie marquee, the scoreboard at the ballpark, or some other location. There are lots of cute things you can do with this feature.

Working with Timelines

The timeline is where you do your trimming of clips and mix your audio. A typical timeline is shown in Figure 4.11. The key components are these:

Timeline ruler. This shows the elapsed time in seconds, from 00:00:00 seconds to the actual length of the clip. You always know the exact point being edited by its position on the timeline ruler.

Zoom control. Use the zoom controls to enlarge or reduce the amount of time shown on the timeline. Zoom in to view only a few minutes or seconds worth of video. Zoom out to view a large chunk of the production (or even the whole thing) at once.

Position. This is a vertical bar that shows the position of the frame currently being displayed and edited. You can move this indicator like a slider to advance or rewind the edit point.

Text track. This track shows the position and duration of any text you may have superimposed, along with the transitions that lead into or out of the text.

Video track. The video track shows the visual and audio portions of a video clip, with the duration indicated by the width shown on the timeline.

Multiple audio tracks. Any additional audio tracks, such as background music or special sound effects, that you have added will appear on one or more audio tracks in the timeline.

As you highlight any of these tracks in the timeline, controls appear that let you adjust the intensity, volume, and other characteristics.

FIGURE 4.11 The timeline includes all the tracks used for your video, and shows the duration of each clip.

Trimming Your Video

An important part of any editing venture is to trim out parts of your clips that are extraneous, dull, or otherwise not essential to telling your story. This step is carried out from the timeline view.

The most common way to trim a video is to view a clip in the preview window until you reach a point where you want to trim. Then, click the Pause button. Right-click on the clip and select Split from the menu that pops up. The clip will be split into two sections: the part that's already played, and the portion after that point, as shown in Figure 4.12.

FIGURE 4.12 Once split, a clip will have two or more sections.

If you return to the storyboard view, you'll see that the split video now occupies two positions in the storyboard, as in Figure 4.13. You've created a new pair of clips consisting of the two parts of the original sequence.

At the storyboard you can delete the portion you don't want, move it to another location in the production, or even add a transition between it and the sequence that follows it. You can also delete clips you no longer need from the timeline view. Splitting clips into smaller chunks gives you a lot of flexibility in trimming and reordering what were originally longer sequences.

That's why it's not essential that you divide up your videos into smaller clips when making the original transfer. Even if you have a video that's one long 30-minute clip, you can split it up into smaller sequences of a few seconds or whatever length you desire, and then continue editing from there.

FIGURE 4.13 A split clip becomes two different thumbnails on the storyboard. You can move each sequence independently and add transitions.

Exporting Video

At any time during the editing process, you can save your project to store all the changes and enhancements you've made. When the production nears completion, you can export the project as a video file that can be viewed outside the video editor itself, using any viewing software (such as Windows Media Player). Your destinations for your finished video can include your hard disk, email, or copying back to your digital video camcorder or VHS tape.

Exporting to Hard Disk

When you save to your hard disk, you can choose from several different file formats. The format you choose will depend on how much you want to squeeze down (compress) the file, and the quality that you need. Remember that higher quality equals larger file size when choosing a format. Format options are likely to range from AVI to MPEG.

Options

When saving your files, you'll have some choices to make, as shown in Figure 4.14. These include:

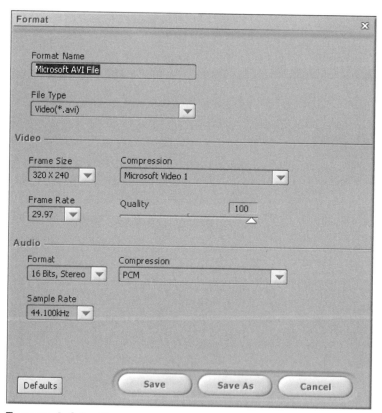

FIGURE 4.14 Choose your options when exporting a production to your hard disk.

Frame size. You can select a frame size from 320 x 240 pixels up to 800 x 600 pixels or more. Use the smaller sizes to save space and for

applications where you don't need a large frame size, such as for Web-based display. Intermediate sizes, up to 704/720 x 480, can display full screen on televisions. The largest sizes, from 800 x 600 pixels and up, are best for display on a computer monitor. If you use a large frame size, make sure your video production is sharp enough to withstand such a large blow-up.

Frame rate: The standard NTSC frame rate is 29.97 frames per second (once dropped frames are figured in), but you can also select lower frame rates, down to 10 frames per second. Lower rates will produce jerkier motion, but will make the file size for a given duration. That is, a particular movie at 10 fps will be roughly one-third the size of the same production at 29.97 frames per second.

Compression/decompression algorithm. One of the questionably wondrous things about video displayed on Windows computers is that there are so many mathematical formulas used to compress the video files (to save space on your hard disk and when transferring over the Internet) and to decompress them again for viewing. These compression/decompression algorithms are known as *codecs* for short. Keep in mind that anyone viewing your video must have the same codec installed on his or her computer. Some of the common codecs, such as Microsoft Video 1, or one of the various Intel Indeo algorithms, are safe choices. When you're starting out, there's little reason to prefer one codec over another, so opting for the basic Microsoft Video 1 codec is a good idea.

When videos are viewed on a computer connected to the Internet, some viewers will automatically try to download the right codec if it isn't already installed. As you gain experience with video, you'll learn which codecs do the best job for your particular productions.

Quality. Like JPEG compression for still images (see Chapter 7 for more on this), video compression can be adjusted for less squeezing (and larger file sizes) or greater squeezing (and smaller file sizes). You can set this control using a Quality slider in most editing programs. Most of the time you'll want to use the lower quality settings only when small file size is critical, as for videos that will be viewed over the Internet.

Audio format. You can choose 16-bit stereo sound for the best quality (and largest file sizes), or drop down to 8-bit audio in monaural for lowest sound quality (and smallest file size).

Audio compression. As with the video portion of your program, you can choose an algorithm for compressing the sound. Most of the time you can choose pulse code modulation (PCM), which is used for audio CDs, DV camcorders, and other digital sound devices, and not bother with other options.

Sample rate. The simplest way to express this parameter is to describe it as the number of slices the audio track is divided into each second. The more samples per second, the higher the sound quality. Use the default 44.100 kiloHertz (thousand cycles per second) for music, or select a lower sample rate, such as 22.050 kHz, if sound quality isn't important or your audio track consists primarily of voice.

Video Format

Another option is the video file type. When you select a specific video format, you may find that some of the other options listed above are restricted or modified by that format. For example, when you use the QuickTime MOV format, the frame sizes, codecs, and even audio compression schemes are different from those available for AVI. You can choose from:

AVI. Audio Video Interleave is an older Microsoft Windows file format. It's compatible with many different applications, and is a good choice if quality and file size are not over-riding concerns. All the options listed earlier are generally available when you choose AVI.

WMV. The Windows Media Video format is a newer video format, particularly suitable for playing over the Web. Indeed, instead of choosing all the options described in the previous section, your video editor may simply ask you to select a destination or connection, such as Web display at dial-up speeds, or NTSC over broadband links. If you have friends who own a Macintosh and want to send them your videos, a Windows Media Video viewer is available for that platform, too.

MPEG. MPEG is a more sophisticated file format that comes in several different varieties, quality levels, and compression ratios. MPEG is

your best bet when you want excellent quality, good compression, and fairly small file sizes.

There are four different breeds of MPEG file, only three of which are used for video (the other version, MPEG-3, is used for audio only, and we know it as MP3). MPEG-1 is the original type of MPEG file, and is limited to very small frame sizes (352 x 240 pixels). MPEG-2 is used for DVD movies, and, as you might expect, provides higher quality. MPEG-4 is the latest version of the standard and is still in the development stages, so you won't find many applications that support it.

QuickTime. QuickTime's MOV format was developed for Macintosh computers, but has been adapted for Windows PCs as well. Because of its Mac origins, the codecs and compression schemes used for QuickTime output are quite different from those for other Windows-friendly formats. You'll generally have to use the QuickTime viewer to watch your productions, too.

Exporting to Digital Video or VHS

There are many reasons why you might want to export your edited production back out to a tape device, such as your digital video camcorder or a VHS tape recorder. For example, you might want to have the video on tape to send to someone who has a digital video tape player or VCR, but doesn't have a DVD player or computer to view your movie in its finished digital format.

Exporting back out to video is easy, and almost the reverse of the capture process described in Chapter 3. You don't need a special digital to analog converter to export to VHS (even though you needed an analog/digital capture device for the reverse process), because your computer is already set up to create an analog video from your video production.

To copy your computer video to a VHS recorder, connect your video card's S-Video or RCA composite video out jack to the S-Video or RCA video in jack of the VCR. If you have a mismatch (one component has only S-Video, say, while the other has only RCA composite),

you can use an inexpensive converter like the ones you'll find at http://svideo-rca.com.

Then connect your computer's sound card output to the red/white audio in RCA jacks of your VCR. You can review how to make this linkup in Chapter 3. When you're connected, start your VCR recording at the same time you start to play the video on your computer.

Exporting to a DV camcorder is even easier, because you need only to connect your computer and the camcorder with a FireWire (or USB) cable, and you can usually control the camcorder right from your computer screen, as shown in Figure 4.15.

FIGURE 4.15 Control your camcorder right from your video-editing software.

Exporting to Email

Some video editors let you route your edited videos directly to an email client, and send the production as an attachment. Your choices for this option may include:

Email client. These include AOL, Outlook, Outlook Express, Eudora, Forte Agent, Netscape Messenger, and others.

File format. Choose Windows Media Format for most recipients, or QuickTime if you know the recipient uses a Mac.

Frame size. Videos sent by email should be as small as possible, so you'll want to select either 160 x 120 pixels, or 320 x 240 pixels, tops.

Compression. Use the best quality choice if both you and the recipient have fast Internet connections (or you're both willing to wait awhile for the video to transfer). Select the highest compression/lowest quality setting if your movie is a long one, or a slow Internet connection will be used at either end.

Exporting to a DVD

One of the most popular destinations for your edited digital video will be to a DVD, particularly if you own a DVD burner and you want to share the production with anyone who has a DVD player.

When you export to a DVD, you have a little extra (but enjoyable) work ahead of you. Your video editor will let you set up a menu like the ones included with commercial DVDs, as shown in Figure 4.16. You can divide the production into scenes and chapters, choose images to use as thumbnails to represent the scenes, add backgrounds and titles to your menus, and include text of your choice.

The procedure varies from one video editor to another, but once you've designed your DVD, all you need to do is insert a blank disk and click the Record button.

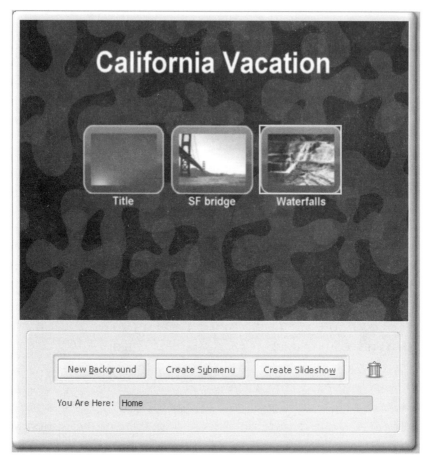

FIGURE 4.16 Your DVDs can include chapter selection and custom backgrounds, just like the DVDs you rent at the video store.

If you want to export your movie to disk but don't have a DVD burner, most editing programs will let you create a hybrid disk on an ordinary CD-ROM, called a VCD (Video CD) or SVCD (super-VCD). You can create these using an ordinary CD writer, and view them on DVD players that support the VCD format (most newer DVD players do). As you might expect, the lower capacity of CD-ROMs means that VCDs can hold no more than 60 minutes of video, at a quality that's quite a bit less than what you'd expect from a "real" DVD. SVCDs are a little better in quality, but support no more than 20 minutes of video. Still, this option is a good stop-gap for those anxious to

get started making movies, but who haven't yet sprung for a DVD burner.

That's about all you need to know to get started editing your films and creating video files and DVDs you can play back on your computer, VCR, or DVD player. It's easy, fun, and a great way to share your ideas, creative efforts, and memories with friends, relatives, and colleagues.

5

Choosing a Digital Camera

In this chapter...

Are you in the market for a digital camera? If you don't already own a digital camera, you probably will be searching for a pixel grabber in the near future, because digital cameras are the latest rage. In fact, don't be surprised if you end up with several digital cameras—one for you and additional cameras for other members of the family.

In any case, digital cameras aren't a lifetime investment. They're more like automobiles and personal computers. You buy a new car, PC, or digital camera now, enjoy using it immensely, and then, a few years down the road you replace it with an even better model with more features.

In the case of a digital camera, that's part of the fun: finding new things to do as you and your equipment grow in sophistication the longer you spend becoming adept at photography.

Although today's digital camera won't be your last, you'll still want to make a wise decision so that you can enjoy your purchase as long as possible. You'll find the information you need to make a smart buy in this chapter. I'll show you how to define your expectations and needs, choose the best camera category, and select a model that has all the features you need now and down the road.

No matter what type of digital camera buyer you are—veteran, beginner, or someone who hasn't dipped a toe into the digital waters yet—this chapter will help you. It will assist anyone who is considering the purchase of a digital camera decide what kind of features are essential, whether the acquisition is likely to be next month or next year. This basic introduction to digital cameras includes information on how to narrow down the features you really need for digital photography, so you can purchase a model that's easy to operate, but has features that can keep pace with your growing skills.

Last year, digital cameras outsold conventional film cameras for the first time—by a hefty percentage, according to some sources—and Hewlett-Packard cameras for both point-and-shoot and photo-enthusiast photographers were particularly popular. You may have purchased your first digital camera before you ever bought this book. If so, that's great; you already have everything you need to get started taking dazzling pictures.

Or, perhaps you're the type who likes to learn everything he or she can before making a purchase. You may be reading this chapter to make sure that the digital camera selection you make is a wise one, and that your camera will suit your needs for a very long time. In either case, if you're interested enough in photography to buy this book, you'll want to own a digital camera and need this information.

You'll encounter some terms in this chapter that may not be entirely familiar to you, such as resolution, megapixels (MPs), and zoom. I'll provide quickie definitions for each of these the first time they are used.

What Do You Hope to Do?

The question, "what am I going to do?" is even more important than "what can I afford?" That's because you'll find inexpensive models that are easy to use and that produce excellent image quality, as well as digital cameras in the same price range that are difficult to operate and produce less than stellar pictures. At the other end of the scale, a very expensive camera may not give you the best photos and it may be so complicated to use that you'll never figure out how to take the pictures you want. So, neither a limited budget nor unlimited funds needs have the sole impact on what kind of camera. Knowing what your expectations are is more important.

Will You Be Fine-Tuning or Manipulating Your Photos?

As you'll learn in Chapter 7, editing your own digital photos can be easy and a lot of fun. Some people buy digital cameras expressly because they want to play "funhouse" games with their images to produce fantasy images, like the one shown in Figure 5.1, which couldn't possibly exist in real life.

FIGURE 5.1 If you plan to play with your photos in an image editor, you'll get the most flexibility if you have lots of megapixels to play with.

Or, perhaps you want to modify pictures for business or hobby applications. Anyone who plans to edit pictures probably wants a digital camera that can capture a lot of detail, has options for customizing the photos as they are taken, and that can accept versatile accessories, such as add-on lenses.

Other digital photographers don't want or need to edit their images. Indeed, they don't even want to learn how to fiddle with their pictures. Perhaps you need to take tons of pictures of home exteriors and interiors for a real estate firm. You want good, sharp pictures, not artsy photos. Or, you might be snapping pictures of items for your eBay auctions, and will be doing nothing more than cropping your images. Perhaps you require some pictures for your Web page.

If that's the case, you don't need a high-end camera with extra sharpness and the manual features that will lead to pictures worthy of extensive image editing. An intermediate or basic camera may do the

job for you. We'll look at the kinds of features you'll find within various camera categories later in this chapter.

Do You Need Lots of Megapixels?

Megapixels are one measurement of how much detail a digital camera can capture, in millions of pixels. Each picture element, or pixel, represents one tiny bit of information in a digital photo. The more megapixels a camera can capture, the sharper its pictures and the higher its resolution (the ability of the camera to capture more detail or pixels).

Anyone who wants to display large prints (in digital photography, that's 8 x 10 inches or larger) or crop small sections out of images needs relatively high resolutions, on the order of 4 to 6 megapixels (millions of pixels) or higher. If this kind of picture makes up the bulk of your work, until recently you would have considered a conventional film camera to do the job. That's no longer necessarily the case, because digital cameras at reasonable prices have improved so dramatically. When you're thinking of making 11 x 14-inch or larger prints, or crop very small portions of images, film can still work well, even though film cameras, by and large, are on their way out.

However, if big prints and small crops are only part of your overall picture mix, a digital camera with less than the maximum possible resolution can still work for you. Just purchase the highest resolution you can afford and take pictures very, very carefully, so that the largest amount of your picture area will be usable, and no pixels wasted.

Do You Like to Experiment?

Some digital cameras are designed strictly for point-and-shoot ease: you press the button and the camera does the rest. Many digital photographers are discovering that pointing and shooting are only half the fun of imaging. If you're a dedicated photo fan, or think you might become one, you'll want a digital camera with the flexibility to let you take control when you want to. That usually means manual features or options for helping to select the shutter speed, lens opening, or other

settings. You'll also want enough zoom (image sizing) capability to provide different perspectives, and enough storage options to keep you from running out of digital "film" at inopportune times.

How Long Do You Plan to Keep the Camera?

The president of a major power tool company once remarked, "Most of our customers don't come to us because they want a one-half horsepower 3/8-inch reversible drill. They want holes." Similarly, many digital camera buyers aren't looking for a shiny new gadget: they want pictures. Once they acquire a camera that does the job for them, they're not likely to upgrade until they develop an important job their current model can't handle. For those users, the digital camera they buy today may serve them very well for several years.

In the opposite camp are photo fanatics who always must have the very latest model with the very latest features. They are the equivalent of the car-buyers of 20 or 30 years ago who used to trade in their automobile for a new model every year.

Such well-heeled photographers are not often disappointed by the constant parade of new hardware in the digital photography realm. New, less expensive, more flexible models are rolled out every month or two. You'll always find new gear to drool over, because digital photography is improving at a relentless pace.

If you don't plan to upgrade, you should get a camera that does the job for you at a price you can afford. You might as well spend a little bit extra for a megapixel or two or a slightly better lens, because you'll be keeping the camera for a long time. You won't want to go overboard, but you won't want to scrimp, either.

If you like to upgrade frequently, on the other hand, you'll want to keep in mind that you'll be duplicating your investment in the near future, and your old camera will be worth more as a hand-me-down to another user than as a trade-in. Don't spend $1500 for a digital camera today if you'll be unhappy and unable to afford the upgrade next year when models with better lenses and higher resolution cost half as much. If your desires are large but your pocketbook is limited, you may

want to scale back your purchase to make those inevitable frequent upgrades feasible. The good news is that many sophisticated digital cameras can be purchased for $500 or less.

Is Size a Consideration?

Some digital cameras, like the one shown in Figure 5.2, are small enough to slip into a purse, briefcase, or jacket pocket. Others may be so large that you'll hesitate to take them with you at all times. Remember, the best picture you never took is the one that slipped by you on that occasion when you left your camera at home. If size is important to you, you'll want the smallest camera that has the features you really need to take those pictures you want.

FIGURE 5.2 Some digital cameras are small enough to fit in your pocket, but still have all the features you need.

Pick a Category

Digital cameras can be found in one of four or five different categories that are defined by what the cameras can do, how many megapixels of resolution they have, their degree of automation, and how much manual control they give the creative photographer. The lines are a little blurry. For example, you can find 5 megapixel cameras for as little as $350 or as much as $1000: expensive, highly automated cameras with few manual controls and inexpensive cameras that let you (at your option) make many settings yourself. However, your dream system will probably fall somewhere in these categories:

Basic Point-and-Shoot Models

Point-and-shoot means just that. You point the camera at the subject you want to capture, frame it in the viewfinder, and press a shutter release button to take the picture. The only controls you may need to operate are zoom buttons to enlarge or reduce the size of the image.

With point-and-shoot cameras, focusing will either be fixed or automatic, because the lenses on digital cameras are capable of providing sharp focus over a very large range. It's likely that the flash unit can be set to fire automatically, only when it's needed, without your needing to think about it or do anything special. The correct exposure will also be determined automatically.

While there still may be a few 1.2 megapixel cameras available with, say 1280 x 960 pixel resolution (roughly the same number of pixels as the average computer video monitor), it's more common to find point-and-shoot cameras with at least 2.1 megapixels of resolution (1636 x 1236 pixels) to 3.1 megapixels (2048 x 1536).

Figure 5.3 shows a typical model in this category, shown with the dock that can be used to link it directly to your computer.

FIGURE 5.3 Point-and-shoot cameras make picture-taking incredibly easy, and produce clear, sharp images.

Intermediate Models

Most digital cameras fall into this category, numerically, because this category of camera meets the needs of the vast majority of all picture takers. They fall into the 4- to 5-megapixel range (at the time I write this; you can probably add a megapixel or two to the range during the life of this book). All will have zoom lenses, and the option of some manual settings for exposure or focus to provide greater control.

However, the real advantage of these more advanced cameras are the automated features that, at the same time, let you customize your photos in creative ways. For example, a typical camera will have a half-dozen or more scene modes to choose from. These modes might include portrait photography, sports, nighttime photography, or other choices. Select one to "tell" your digital camera what kind of picture you're taking, and it will automatically choose the best exposure and focus settings for you.

Such cameras will also boast cool features like a "burst" mode that lets you snap off three or four pictures in a row quickly, to better photograph sports or a fleeting expression on the face of a loved one. You'll also find video capture capabilities so you can grab mini-movies, more zoom lens range to bring distant objects closer, and maybe a couple of options to let you tweak your photographs, say to make colors richer. You can even expect some useful close-up capabilities.

Figure 5.4 shows a popular intermediate model camera.

FIGURE 5.4 Intermediate cameras add lots of features that let you fine-tune your photography.

Advanced Models

Spend a little more, and you'll find a growing selection of cameras with even more resolution (5 megapixels or more), a longer zoom range, more manual control options, and other goodies. Generally, although

these cameras are much more sophisticated, they still can be easy to use once you've mastered all the options and controls. You'll find them liberally studded with multi-function buttons and dials, lots of modes, dozens of menus, and thick manuals. If you need the features these cameras boast, prepare to spend some time learning to use them.

For example, you can expect zoom lenses that can magnify an image as much as eight times, a pop-up flash unit, and a larger variety of mode and flash settings. Automated exposure and focus will be more sophisticated, too, with features like the HP Adaptive Lighting feature, which digitally analyzes an image and brightens only darker areas, such as those in backlit scenes, providing a fill flash effect without electronic flash.

Also available are burst modes that can fire off six shots or more in a few seconds, and clever features like a two-shot self-timer option that takes a second picture three seconds after the first, and an electronic viewfinder. I'll explain more about these options later in the chapter.

These cameras, like some of their less costly siblings, also may be able to use an optional camera dock that you can leave permanently connected to your computer. HP's implementation of this feature, for example, is Instant Share, which allows routing photos for printing or Web-based sharing with the press of a single button, charging your batteries, and printing directly to compatible HP printers using a cable. Figure 5.5 shows a typical advanced camera.

FIGURE 5.5 Advanced features have sophisticated features like burst mode and electronic viewfinders, giving you extra picture-taking versatility.

Prosumer Models

At the $1000–$2000 level, you'll find cameras best suited for photo fanatics, semi-professional photographers, and even a few pros who need an inexpensive second digital camera. If you really need one of these, you can add a couple of million pixels to your resolution, a few pounds to the weight you'll be lugging around, and virtually every important feature known to humankind. Most of the readers of this book will be happiest with an intermediate to advanced camera, but it's interesting to know about this more esoteric variety of digital machine.

Not all of these are designed from the ground up for digital photography, so the downside is that some transformations of 35mm SLRs

into the digital realm are clumsy. For example, because the sensors are smaller than the size of the standard 35mm film frame, a given lens may enlarge the image more than you'd expect. A lens that provides a wide field of view on a 35mm film camera frequently becomes a short telephoto, and normal and telephoto lenses become even longer when mounted on a digital camera. Dedicated hobbyists who need something this advanced will take these differences in stride.

Professional Models

For $3000 to $30,000 or so, you can get yourself a camera that is an almost exact counterpart of the professional film camera, but with a much, much higher price tag. You don't need me to outline the features and advantages of these beasts. If you need and can afford one, you already have that information. I've used various examples in this category off and on since 1995. The scary part is that one $30,000 model loaned to me in the mid-1990s had less resolution than you'll find in a Hewlett-Packard intermediate or advanced digital camera today.

Fortunately, pros don't see this kind of equipment as an investment as much as an expenditure. What's a $30,000 camera when your client has a multi-million-dollar advertising budget?

Selecting Features

Once you've decided whether you want a basic point-and-shoot digital camera, a mainstream intermediate model, or perhaps even an advanced camera, you'll want to choose the specific features you'll be looking for. The chief options to take into account are resolution, lens requirements, storage options, exposure controls, and type of viewfinder.

You Say You Want a Resolution?

A digital camera's solid-state sensor captures the image information that is transformed into a digital picture. The sensor consists of a grid,

or array, of light-sensitive sites on a solid-state wafer, with an overlay of colored filters, as shown in Figure 5.6, that allows each location on the sensor to receive only one color of light, either red, green, or blue. (Some sensors operate in a slightly different manner, but most do work this way.) The figure shows only a small section of a representation of a sensor; in a real sensor there would be millions of these light-sensitive photosites, producing megapixels of information.

FIGURE 5.6 *This shows part of a sensor, which is laid out as an array of red-, green-, and blue-sensitive photosites.*

Any discussion of digital cameras always seems to focus on the number of megapixels a given camera can capture, as if resolution were the only important feature. Indeed, megapixels worm their way into even the briefest description of a camera: one unit is a 2-megapixel (or MP) snapshooter; another is a 5-MP camera, ignoring, in both cases, such equally important features as type of zoom lens or ability to focus closely. There's no fighting the fuss over megapixels, because they are important, so you might as well relax, learn exactly what's going on, and then choose your resolution with all the facts at hand.

COLOR PLATE 1 With a dissolve, the original scene seems to be eaten away, revealing the next scene "underneath." (Figure 4.6)

COLOR PLATE 2 Add text to make your own titles. (Figure 4.8)

COLOR PLATE 3 Special effects can spice up your videos. (Figure 4.9)

COLOR PLATE 4 If you plan to play with your photos in an image editor, you'll get the most flexibility if you have lots of megapixels to play with. (Figure 5.1)

COLOR PLATE 5 This 5-megapixel version has a lot more sharpness and detail.
(Figure 5.8)

COLOR PLATE 6 Living so close to an amusement park, these are hardly wild geese! (Figure 6.1)

COLOR PLATE 7 Crop the image tightly to exclude the neighboring park, and the geese could be swimming on a secluded pond. (Figure 6.2)

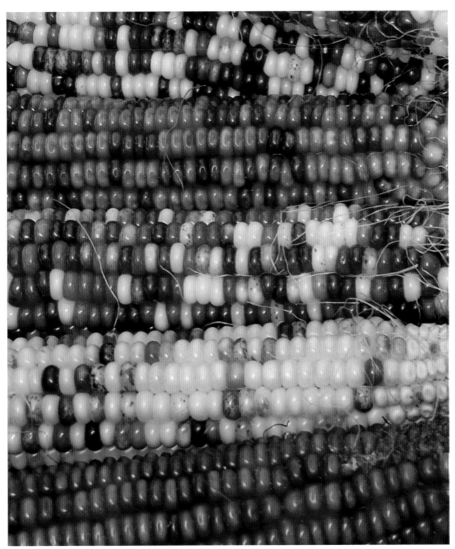

COLOR PLATE 8 Crop your picture tightly to emphasize the rich tones and texture of the Indian corn. (Figure 6.8)

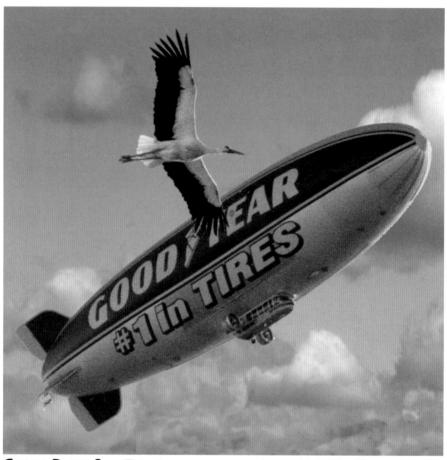

COLOR PLATE 9 This picture never existed in real life. The blimp, clouds, and stork were all combined digitally in an image editor. (Figure 6.9)

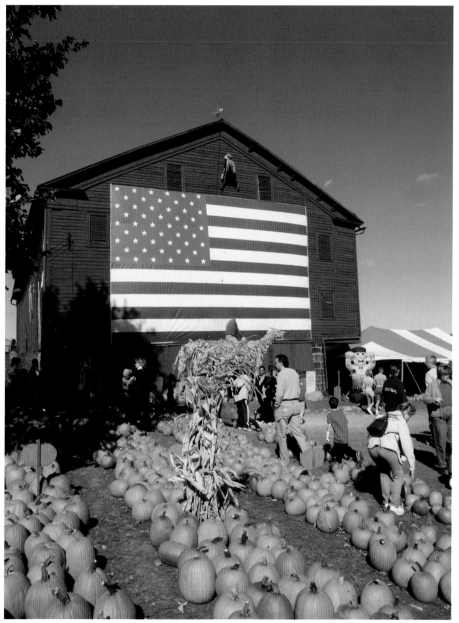

COLOR PLATE 10 Your compositions should have a distinct center of interest, such as the American flag and the rows of pumpkins that seem to point to the side of the barn. (Figure 6.11)

COLOR PLATE 11 Placing the center of interest at the intersection of the imaginary points that divide the picture into thirds makes for a pleasing composition. (Figure 6.14)

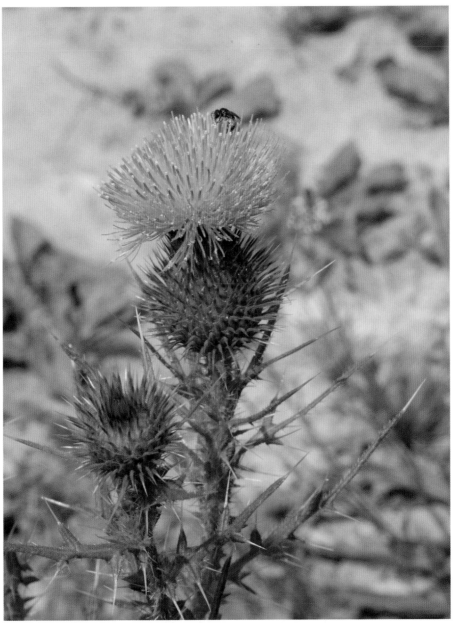

COLOR PLATE 12 Close-ups often have the main center of interest close to the center of the photo. (Figure 6.20)

COLOR PLATE 13 Lights bounced off white cardboard produced this soft illumination. (Figure 6.22)

COLOR PLATE 14 Twist an image into a whirlpool using typical special effects found in image editors. (Figure 7.13)

COLOR PLATE 15 Special effects add a distinctive look to each version of this photo of a Chinese temple lion. (Figure 7.14)

COLOR PLATE 16 Color balance controls let you modify colors by moving sliders. (Figure 7.17)

COLOR PLATE 17 Filters can add texture (left) or a soft diffuse glow (right). (Figure 7.25)

COLOR PLATE 18 You can assemble your favorite pictures into a screen saver slide show. (Figure 8.4)

COLOR PLATE 19 When details are lost in the shadows, as in the example at left, a scanner with a wider dynamic range can reveal the hidden information, as in the version shown at right. (Figure 9.6)

COLOR PLATE 20 Custom print sizes, like this 5 x 10-inch print, are a snap when you print your own pictures. (Figure 10.2)

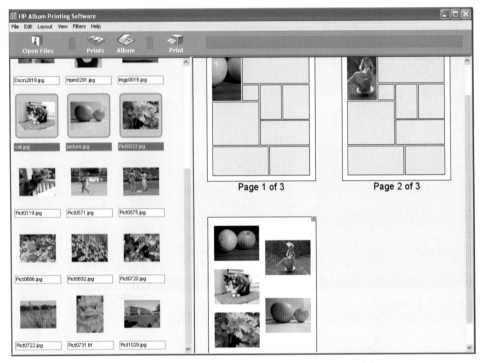

COLOR PLATE 21 HP Album printing software helps you organize your photos.
(Figure 10.11)

In truth, the number of pixels a camera can capture affects the sharpness of your final image. Pictures taken with a 5-MP camera will generally have more detail and will look sharper than the same subjects taken with a 2-MP camera. The quality of the sensor and the sharpness of the lens are also important, but megapixels are a number that's easy to latch onto. Of course, in practice it may be difficult to tell the difference. Figure 5.7 was taken with a 1-MP camera, and then enlarged to the same size as the picture shown in Figure 5.8, which was taken with a 5-MP camera. While the difference between the two is apparent on the computer screen, when both are printed in this book (or output to your inkjet printer as 4 x 6-inch prints), they may be hard to tell apart.

FIGURE 5.7 This picture taken with a 1-megapixel camera doesn't look bad...

FIGURE 5.8 ...but this 5-megapixel version has a lot more sharpness and detail.

Today, even the least expensive digital cameras have 2 megapixels of resolution (actually, many cell phones with snapshooting capabilities built in can capture 2-MP images). Cameras in the 3.2–3.3 megapixel range have enjoyed renewed popularity of late, with vendors like HP offering extra-compact models at low prices that nevertheless have more resolution than top-of-the-line models of only a few years ago.

At the same time, the 4- and 5-megapixel resolutions have become almost standard for many intermediate and advanced models. You'll find simple point-and-shoot digital cameras as well as more sophisticated shooters at this same resolution "sweet spot." At 5 MPs, digital cameras truly match the quality possible with film cameras, even when you want to make 5 x 7-inch or 8 x 10-inch enlargements.

Unless you plan to make very big enlargements, or crop tiny sections out of your digital camera images, models with 4- to 6-megapixels will probably meet your needs very well indeed. While lower-cost 8-megapixel (or more) cameras are starting to appear, they are usually overkill for the average picture taker.

You can establish how much resolution you require by estimating how many of your photos will fall into one of these categories:

Web workouts. These include most pictures for Web pages or online auctions; photos that won't be cropped very much, and pictures that won't be printed in large sizes. If all your photos are of this type, you may be able to get away with a camera with as little as 2 megapixels of resolution.

Cropped images. If you often need to trim out unwanted portions of your pictures or will be making somewhat larger prints, you'll need a higher-resolution camera with resolution on the order of 3.2 megapixels. The extra resolution will give you the flexibility you need to crop freely and still make good-looking enlargements of 5 x 7 inches or more.

Big prints. Should you often get carried away with cropping, or want to make lots of prints that are 8 x 10 inches or larger, you'll need a higher resolution camera, in the 4–6-megapixel range.

You'll find that many cameras offer a choice of resolutions other than the maximum possible with that camera, so you can match your megapixels with the task at hand. For example, if you are taking a series of pictures for use on a Web page, you can set your 5-MP camera to shoot at 3-MP or 2-MP. You'll find that shooting lower resolution pictures produces smaller image files, so you can store more photos on your camera's digital memory card.

It's common to tuck away resolution options in a menu that you can summon at the press of a button and view on your digital camera's LCD screen. The choices are usually listed in actual pixel dimensions, rather than number of megapixels. The exact dimensions can vary from camera to camera, but they will be something on the order of 2608 x 1952 (5.2 MP), 2140 x 1560 (3.2 MP), 1636 x 1236 (2 MP), and 1296 x 976 (1.2 MP).

There's a second measurement that affects image quality and that often confuses beginner (or veteran!) digital photographers. That measurement is called, variously, Quality, Image Quality, or Compression, depending on the terminology used by the vendor. The actual settings are usually referred to by names such as Good, Better, and Best, or star ratings (one star, two stars, three stars), which is what Hewlett-Packard does. Other vendors may use terms like Standard, Fine, Superfine, or Ultrafine.

Although the terms are descriptive and provide a good description of the relative quality differences between the settings, it's important to know that they are entirely independent of the resolution/megapixel setting you choose. The Good, Better, Best, and similar terminology actually reflect how much your image is "squeezed" or compressed in order to fit as many as possible on your digital memory card. In order to squish the images down to a smaller and more manageable size, your digital camera converts them to a format called JPEG, which takes, say, a 5-MP image and reduces it 10X to 15X. Thanks to this image compression, a memory card that might fill up after a dozen shots can easily hold 50 or more photos.

To work this magic, the camera analyzes each image carefully and discards some visual information that is deemed less important. A lot of extra detail in that clear blue sky or that grassy meadow may be sacrificed, because you probably will never notice that it's missing.

At the Best setting, the image is bright and clear, and looks, to the eye, as sharp as a tack. Use the Better setting, and you may notice some details have been lost when you make enlargements. The Good setting might be good enough for small prints and only minimal cropping. Make a huge enlargement of a photo that was saved using a high amount of compression, and you may get a "block" effect, as shown in Figure 5.9, in a blow-up of a photo of a cat's eye, taken using the Good setting.

FIGURE 5.9 Enlarging an image that has been heavily compressed can produce a blocky look.

Any of these Quality or Compression choices can be applied to any of your camera's resolution settings, so you can select a combination of the two that's best suited for your application.

This kind of image-squeezing is called lossy compression, because some information is lost. Some digital cameras have an optional setting that uses a format called TIFF, which is called lossless, because it doesn't discard any image information. However, TIFF files are much larger, so only a few of them will fit on a typical memory card. The increase in image quality is often so slight that most digital photogra-

phers use TIFF only when they absolutely must have the ultimate in image quality. Most of the time, the Best setting provides all the sharpness you really need.

Your Digital Lens

You want to get sharp, clear images from your digital camera, but grabbing millions of pixels is only the first step. A good, sharp lens, which captures and focuses the light from your scene onto your sensor, is also a must. Your digital camera's lens affects the quality of your images as well as the kinds of pictures you can take. What really counts is the quality of the lens, the amount of light it can transmit (the more the better), its focusing range (how close you can be to your subject), and the amount of magnification (or zooming) that the lens provides. Following are some of the terms you should be familiar with.

Lens aperture. The lens aperture is the opening that admits light to the digital camera's sensor. A wider aperture allows more light to reach the sensor, so you can take good photos under dimmer conditions. A smaller opening allows less light to reach the sensor, which may be necessary under very bright lighting conditions, such as at the beach. Your lens uses an iris-like feature to provide different-sized lens openings, termed f-stops, to adjust the exposure under a variety of situations.

Figure 5.10 shows a simplified representation of how lens openings are changed in a digital camera, with a wide-open f-stop at left and a "stopped down" setting at right. Generally, a lens with a larger maximum aperture is preferable to one with a smaller aperture, but in practice you'll notice the difference only when shooting in very low light levels. If you're a photo fan, you'll be interested in this spec; otherwise, you shouldn't spend too much time researching the maximum lens openings of the digital cameras you're evaluating.

FIGURE 5.10 Different-sized lens openings admit different amounts of light to the sensor.

Zoom lens. A zoom lens is a convenience for making an image larger or smaller without needing to move from your shooting position. That's a special help when you're shooting sports (and can't move from your seat or other location) or scenics (when moving even a little bit may back you up against the wall of a monument, or send you toppling over a cliff).

Just about all digital cameras have a zoom lens. Some have skimpy, but useful zoom ratios, such as 2:1 to 3:1 (producing an image that is two or three times as large). Hewlett-Packard digital cameras have zoom ratios up to 8:1, which provides a powerful telephoto effect, indeed.

The difference in magnification can be dramatic. Figure 5.11 shows an image taken with a digital camera's wide-angle setting; the box drawn around the tip of one of the plants represents the image area when the same lens is zoomed 4X to its maximum telephoto setting.

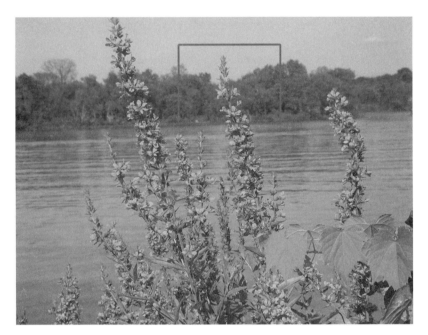

FIGURE 5.11 The whole picture was taken at the wide-angle zoom setting. The small box represents the area that could be included using the 4X telephoto setting.

Digital cameras generally increase and decrease magnification using the lens's optical zoom feature, in which the elements of the lens are moved to produce more or less magnification. Many digital cameras also feature digital zoom, in which additional magnification is produced simply by enlarging part of the center of the image. Digital zoom is often less sharp than optical zoom, so you'll want to use this feature with caution.

If you've used 35mm film cameras, you're probably familiar with the use of lens focal length as a measure of how much magnification the lens produces. That is, with a 35mm camera, a lens with a focal length of 28mm is considered "wide" while one with a focal length of 105mm is considered a "telephoto" lens. Such absolute focal length figures don't apply in the digital camera realm. That's because the amount of magnification a particular lens produces is related to the size of the solid-state sensor used to capture the image, and different digital cameras use different sensors. For that reason, digital camera "focal

lengths" are usually given using the equivalent value for a 35mm film camera. A digital camera with a lens that zooms from 7.6mm to 22.8mm (in real terms) would be given as equivalent to a 37mm to 111mm zoom on a conventional 35mm film camera. Using these equivalent figures makes it easier to compare lens range on an apples-to-apples basis.

Focus range. If you'll be doing a lot of table-top or close-up photography, particularly of detailed subject matter like the flower shown in Figure 5.12, make sure the cameras you're considering have a close-up setting. Close-up photography is typically the ability to focus from a few feet to as little as 12 inches to one inch from the front of the camera lens. Photo buffs use terms like magnification and enlargement ratios. For example, a 1:1 image (one in which the object photographed is the same size on the film or sensor as it is in real life), is considered "life size."

Keep in mind that the closer you get, the more important an easily viewed LCD display (that screen on the back of your camera) becomes, because you'll be using that LCD to focus, or to evaluate how well the image is focused. You'll also want automatic focusing, if available. Inexpensive cameras may not be able to focus close, which isn't an overwhelming drawback because their lenses usually provide sharp focus of everything within a normal shooting distance of a few feet to infinity anyway. Intermediate and advanced cameras have sophisticated automatic focus capabilities that focus for you.

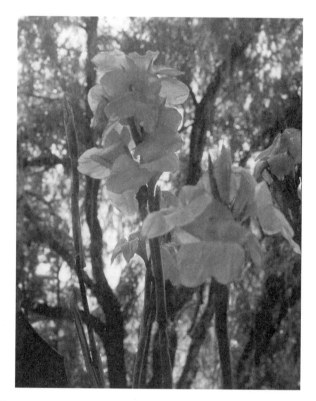

FIGURE 5.12 The ability to focus close lets you take detailed pictures of flowers and other small subjects.

Lens attachments. Serious photography can often be enhanced with accessories attached to the front of the lens, such as filters, special-effects devices, close-up lenses, or lens hoods. If you need these options, look for a digital camera with a lens equipped to accept them. The ability to use add-ons in standard screw-thread sizes is a plus, because a wider variety of such accessories is available at reasonable prices. Some cameras require an adapter, like the one shown attached to the wide-angle adapter in Figure 5.13.

FIGURE 5.13 Add-on lens attachments, like this wide–angle adapter for one Hewlett-Packard model, increase the versatility of your digital camera.

Exposure Controls

All digital camera lenses with variable apertures (that is, with different f-stops available) adjust themselves for the proper exposure automatically. The only exceptions are some very inexpensive models with lenses that cannot be adjusted for exposure at all. Serious photo-hobbyists and professionals may also want the option found in higher-end cameras of setting the lens manually to provide special effects or more precise exposure. These controls come in several forms:

Plus/minus or over/under exposure controls. With these, often known as EV (Exposure Value) settings, you can use a little more or a little less exposure than the amount determined by your camera's built-in light meter.

Aperture-preferred exposure. With aperture-preferred exposure, you set the lens opening, and the camera's exposure system will automatically choose the correct shutter speed for you. This is an excellent choice when you want to use a particular f-stop, such as the widest

setting (to allow the background to blur) or the smallest setting (to provide the largest range of sharp focus).

Shutter-preferred exposure. This is the opposite of aperture-preferred exposure. You set the shutter speed, and the camera will choose the f-stop. Use this option when you want the shortest shutter speed possible (to stop action) or a long shutter speed (to blur your subject, perhaps for creative reasons).

Programmed exposure. Most digital cameras have scene modes for sports, night photography, landscapes, or other common situations. These modes have been fine-tuned to provide the best exposure under the situations they were designed for.

Manual exposure. Manual mode, found in some intermediate and advanced cameras, lets you set any shutter speed or aperture combination you want. You can seriously underexpose a photo to produce a darker effect, or to create a silhouette look, or overexposure to make an image lighter. You can even completely muff the exposure and ruin a picture entirely if you're not careful, so manual exposure should be used with caution.

As you're learning, exposure involves more than lens settings, of course. Exposure is also determined by the amount of time the sensor is exposed to light (the equivalent of a film camera's shutter speed) and the intensity of the light (which can vary greatly when you're using an external source, such as an electronic flash unit). Digital cameras all have automatic exposure features for both flash and non-flash photography, but some are more flexible than others.

Beyond the basic exposure options, there are other considerations you'll want to take into account. For example, digital cameras differ in their ability to take pictures in low light without flash. Some sensors are more sensitive than others, so they can grab pictures in dimmer lighting, which can be important in environments where flash is frowned upon or not allowed (such as museums or concerts).

Digital camera sensitivity is measured using something called ISO (International Standards Organization) ratings such as ISO 100, ISO 200, and ISO 400. The higher the number, the more sensitive the sensor. Your camera may let you specify the ISO setting to increase sensi-

tivity. Or, your camera may change the ISO setting for you automatically, depending on the scene mode you've chosen. Dial in the "night exposure" option and your digital camera may automatically bump up the sensitivity to let you take pictures with shutter speeds that are fast enough to stop some blurring that occurs from a shaky hand. With many cameras, upping the ISO setting also increases the amount of noise (a type of digital grain or fuzziness) in your pictures, so you'll want to keep this in mind if you take pictures at night or in dim light.

You'll want to make sure your digital camera's exposure modes are flexible enough to handle demanding situations, such as subjects that are lit primarily from the rear (called "backlighting"). In such situations, you may want your camera to be able to compensate automatically for backlighting, or let you press a button manually to correct the exposure for this type of subject matter. The best cameras have those scene modes I've mentioned before, which let you choose exposure for various types of situations.

Some cameras let you choose how the light is measured. Digital cameras may average all the light in a scene to determine exposure, or may choose various areas from a matrix of sections of the image, or even let you choose to meter from a specific "spot" area of the subject matter.

Flash features are also part of the overall exposure scheme of things. Some cameras may have a fixed flash range, from, say, 2 to 9 or 12 feet, or include special settings for wide-angle or telephoto shots. You might be able to turn the flash off entirely, or specify that it provides only "fill" light to illuminate shadows, which is useful to soften high-contrast daylight pictures (although the latest HP cameras can provide "fill flash" for you electronically). You'll usually find a "red-eye" setting for your flash that triggers a brief pre-flash that helps minimize the devilish red glow that eyes can pick up during flash shots (or the yellow or green glow sometimes seen in animal eyes).

You might even want the option of attaching an external flash, although this feature is generally found only in the most advanced digital cameras.

Viewfinders

You won't have many options for viewfinders. Virtually all digital cameras today have both an optical viewfinder, which can be used to quickly frame an image, and an LCD display screen on the back of the camera for more precise composition and picture review. The top-of-the-line Hewlett-Packard digital cameras offer a third option: an electronic viewfinder, which is an LCD display that shows (more or less) exactly what the lens sees, through an eyepiece.

Before buying a camera, you'll want to confirm that its back-mounted LCD display is visible in bright daylight, and whether it is large enough to see picture details, focus, and lighting.

You'll probably use your digital camera's optical viewfinder (or electronic viewfinder if your camera has one) to compose pictures, so make sure it's bright and clear and accurately represents what the sensor sees as closely as possible. An optical viewfinder that isn't especially accurate can cause you to clip off part of an image when you're taking a close-up picture. In such cases, you may want to stick to the LCD display.

Storage Options

You won't be choosing a digital camera based on the kind of memory card it uses, but your storage options are still important. Today, all digital cameras use one of the popular memory card devices, such as Compact Flash or, in the case of HP cameras, the versatile Secure Data memory card. You may find that the card furnished with your camera doesn't hold as many pictures as you typically take in a session, so one of your first add-on purchases may be for a larger card in the 128MB to 256MB range. Prices for digital cards are dropping all the time, so even larger cards of 512MB or more capacity are becoming well within the budgets of amateur photographers.

The larger the memory card you have, the better. You'll also need some way to transfer photos from your memory card or camera to your computer. One easy way is to remove the card and plug it into a

card reader slot, such as the slots built right into many Hewlett-Packard computers. External card readers that plug into a USB port of your computer are also available.

Digital cameras also can link directly to your computer through a USB cable, or through a docking cradle like the HP Photosmart 8881 digital camera dock.

Such docking devices let you drop the camera in the cradle, which may be permanently connected to your computer, and quickly transfer pictures to your computer, print them, or send them by email. The dock also recharges your camera's batteries while it's connected, too.

Other Features

Other features can be important, depending on your needs. For example, some digital cameras let you add a voice message to annotate your images with a few seconds of sound. Others may let you record short video clips at 640 x 480-pixel resolution. Many have video outputs so you can view your pictures on a TV screen without transferring them to a computer. This is great for previews, and can turn your camera into a portable slide projector! If you shoot many pictures, the ability to choose from cheap alkaline batteries, which you can pick up anywhere in a pinch, to more economical high-capacity rechargeable batteries will be important.

Burst modes, which let you snap off a handful of pictures consecutively in "motor drive" mode, are great for sports photography and other fast-moving applications.

6

Going Beyond Point-and-Shoot

In the last chapter you learned about the features of digital cameras, and how to choose the pixel grabber that will work best for you. Now it's time to put your digital camera to work. In this chapter you're going to learn how to take great pictures of a variety of types, including sports, close-ups, and people pictures.

It doesn't matter whether you have a point-and-shoot camera or an advanced model designed for photo enthusiasts. All you need to take pleasing images is a digital camera and some tips that will let you compose and create compelling photographs. The hardware you use is only a means to the ends; your eye, imagination, and an understanding of what makes a picture good are the real keys to photo creativity.

Making (vs. Taking) a Photograph

There are several elements that make a picture good. One group of these elements is the technical aspects. Is the picture properly exposed, in sharp focus (where it's supposed to be sharp), and with a pleasing range of tones? Is there unwanted blurriness caused by the camera or subject moving while the picture was taken? Are the colors suitably accurate?

You might have noticed that I qualified most of those statements, because creative photography sometimes calls for pictures that are underexposed or overexposed in order to produce a desired dark or washed-out effect. Other times you might want some blurriness to obscure unwanted detail, or to add a feeling of motion to an action photograph.

The definition of accurate color, too, can vary depending on what you hope to accomplish with a photograph. A reddish sunset or blueish snow scene might have the exact color cast you're looking for, whereas a blueish sunset and reddish snow scene might not. Most rules about sharpness, focus, blurriness, and color can be broken if the effect is one you intentionally want to produce. But most of the time you'd rather have a sharp, well-focused, properly color-balanced image.

Generally, these technical aspects can be handled for you by your digital camera's automated features. Unless you change settings to vary from a technically perfect image, the camera will do its best to

provide sharp, clear, realistic images. A small percentage of the time the picture-taking environment will be beyond the camera's ability to compensate, and that's where your judgment comes in. You can correct the color, tell the camera how to calculate exposure, or manually tweak focus, either to produce an image that's closer to perfect, or one that's skewed one way or another in a creative way.

Learning to make the technical aspects of picture-making work for you is one of the tasks you take on when you decide to move beyond simple point-and-shoot photography.

Another group of elements under your control are those that concern the content of the photo. What subjects do you choose to include in the photograph? How close do you stand, or what zoom lens setting do you use? What's the best angle: eye-level, up high, down low, or from one side or another? Many of these aspects of arranging the content of your images come under the broad heading of composition. You'll find that good composition is at least as important as good technique. The next section will explain a little about good composition, and how to achieve it.

Four Basic Ways to Change an Image

The first thing to learn is four basic ways to change the content of your pictures. Most other aspects of organizing an image are variations on these concepts. They are simple to understand, but you may have to work to keep them in mind constantly as you compose your photographs.

Including and Excluding

The first general decision you must make is to decide what objects to include or exclude from your photograph. Good pictures include only the subjects needed to make the picture a good one. If you want a photograph of your home to highlight its shrubbery and plantings, you won't want to include extra things like neighboring houses, trees, automobiles in the driveway, kids' toys, and so forth. Or, when photograph-

ing a bridal party, you might want to frame the picture to include only the bride and groom for a special portrait of the couple. The elements you include or exclude from a photograph can have a dramatic effect on your photograph. For example, Figure 6.1 shows a group of geese swimming across a lake that borders a theme park. The nearby park immediately labels these geese as "tame." By excluding the park from the image, as in Figure 6.2, the geese might easily be seen as wild geese on a secluded waterway. (Or maybe not, but at least the birds would seem to be more plausibly in their natural habitat.)

Decisions about including/excluding affect other aspects of making a picture that I'll describe shortly, such as framing and balancing an image.

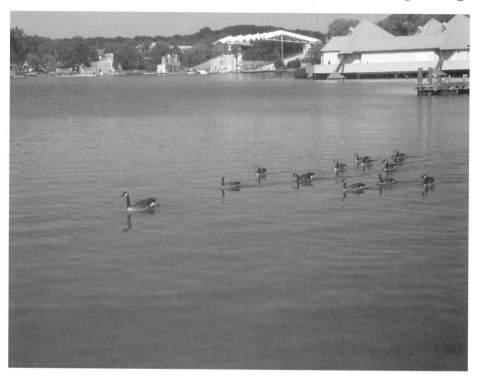

FIGURE 6.1 Living so close to an amusement park, these are hardly wild geese!

FIGURE 6.2 Crop the image tightly to exclude the neighboring park, and the geese could be swimming on a secluded pond.

Moving the Figures or Objects

Sometimes you change the composition by moving the subjects around a bit. Who hasn't tried to make a group photo more interesting by asking everyone to squeeze a little closer together, or by moving the taller folk to the end of the line or the back of the group? If you're photographing still lives, flowers, or your train collection, you might have moved an object to produce a more interesting arrangement.

You'll discover there are many picture-taking situations in which it's entirely practical to move things around to better suit your image, or, even, as an experiment to see what might look better. Posing, which involves arranging body parts like arms, legs, and faces in interesting ways, is a way of applying the ability to move things around in your picture. If you're working with inanimate objects or very patient people, and have the time to spend, you'll be able to create interesting compositions with ease simply by moving things from one place to another. Figure 6.3 shows a photo of some flowers, but, unfortunately, some extra petals at the corners and bottom of the picture are distracting. Moving them aside for the photo in Figure 6.4 produced a better-looking picture.

FIGURE 6.3 The extraneous petals at the top corners and bottom of the picture are distracting.

FIGURE 6.4 Moving the distracting foliage produces a much cleaner composition.

Changing Your Viewpoint

The viewpoint you choose is another way to change the way an image looks. You can change your angle or perspective by moving yourself and your camera from side to side, up or down, or to a different location. This kind of change works even if your subject matter itself is not easily moved.

For example, the Great Pyramid of Khufu has squatted stolidly on the same 14 acres of Egyptian sand for roughly 4600 years, and isn't likely to move a bit to the right or left to better suit your photographic composition. Whether you're shooting monuments, buildings, scenery, or stubborn humans, you'll encounter situations where your viewpoint must be changed to get an arrangement you like.

At times, you might not want to move subject matter that could be relocated, simply because doing so would change the way your subject relates to its environment. If a street vendor's cart obscures your view of his face, you might not want to ask him to move away from the cart. It would be a better idea to change your camera angle so the cart and vendor both are shown clearly. Often, you'll find that even if you could move a figure or object in your picture, the better choice is to leave your subject matter unmolested and adjust your point of view instead.

You may want to stoop to get a lower angle, climb up a bluff or mount a ladder to achieve an aerial view, or step back, forward, or to one side, as was done for Figures 6.5 and 6.6. Changing your point of view has the added benefit of providing a new look to an image. A head-on, eye-level picture is often not as interesting as one taken from a novel elevation or unusual angle.

Digital Photography

FIGURE 6.5 That tree blocks the view of the home.

FIGURE 6.6 Move a dozen feet to the right for an unobstructed view.

Zooming/Cropping

A composition can be changed dramatically by adjusting the framing of your image, either by zooming in or out, to increase or decrease magnification, or by cropping the picture within your image editing program. This kind of framing (as distinguished from arranging your subject matter within a frame) can often be done most effectively after the picture is taken, through judicious cropping. However, because digital images can't be enlarged infinitely without the pixels becoming intrusive, you'll want to keep the zoom setting in mind when composing the original shot, to minimize the amount of cropping that has to be done.

Zooming can also become a compositional tool when you use it to increase or decrease the amount of an image that is in focus. Because less of your subject will be in focus with a telephoto picture, zooming in can isolate your subject, making it appear sharp while other elements

are blurred. Conversely, a wide-angle perspective can put everything in focus from foreground to background, if that's what you want.

Figure 6.7 shows some Indian corn, but doesn't provide a close-up view of its interesting texture. There's no need to go back and retake the photo—just rotate the image and crop tightly, as shown in Figure 6.8!

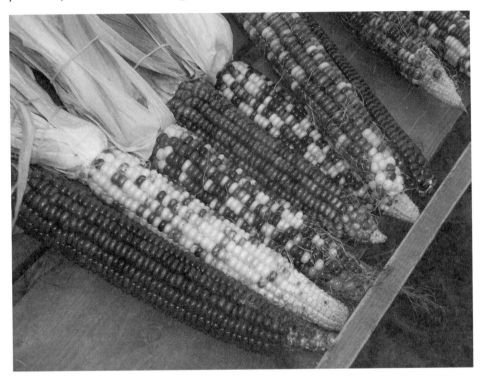

FIGURE 6.7 This Indian corn makes an interesting photo...

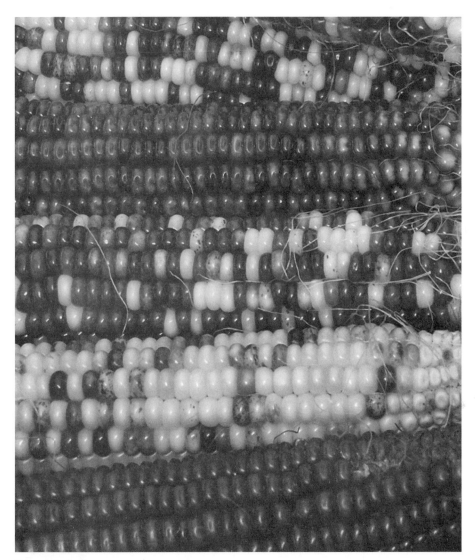

FIGURE 6.8 ...especially if the picture is rotated and cropped tightly to emphasize the tones and texture.

Digital Retouching

National Geographic Magazine actually did find a way to relocate the Great Pyramid from its traditional home on the Giza plateau, kicking off a famous controversy in the process. The magazine's artists used

digital retouching techniques to squeeze two pyramids together to create a tighter vertical composition that better suited the magazine's February 1982 cover. Those who held the magazine in esteem for its highly detailed and accurate photography were outraged. If nearly perfect digital composites could be made (ordinary photo-retouching is relatively easy to detect by an expert) could we really say that "Seeing is believing?" Would it ever again be possible to trust our "unbiased" press? A strict code of conduct for photojournalism has since been adopted and the public seems less concerned about photo manipulation today. For those who aren't professional journalists, digital retouching is an entirely appropriate and useful tool for creating pleasing compositions.

Figure 6.9 isn't a perfect composite, but it wasn't meant to be. It shows that if you have several elements you'd like to combine into one picture you can perform the magic within an image editor.

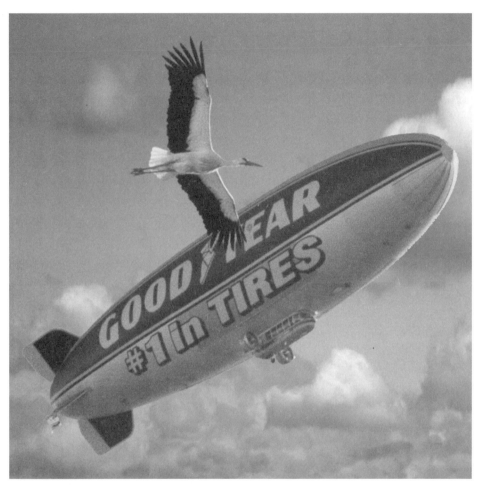

FIGURE 6.9 This picture never existed in real life. The blimp, clouds, and stork were all combined digitally in an image editor.

Guidelines for Good Composition

Good composition can happen by accident, but most good pictures are carefully composed by the photographer. The first step is to learn the guidelines for good composition. I avoid calling them "rules," because one of the best ways to use guidelines is to know when to step outside their boundaries without hesitation. Rules, on the other hand, are

seemingly rigid tenets that we have qualms about breaking. Indeed, some of the very best photos are compelling because they go beyond our normal expectations by breaking artificial rules.

You might want to think of these guidelines as techniques that you can choose to apply, or not apply, to any particular picture-taking situation. There are six universal techniques that you'll find detailed in every book, article, or course on composition (although not always under precisely the same names). I'll describe them briefly here, then spend some time showing you how each of them operates.

Simplicity

Simplicity is the art of reducing your picture to only the elements that are needed to illustrate your idea. By avoiding extraneous subject matter, you can eliminate confusion and draw attention to the most important part of your picture.

The Concept of Thirds

Placing interesting objects at a position located about one-third from the top, bottom, or either side of your picture makes your images more interesting than ones that place the center of attention dead-center (as most amateurs tend to do).

Lines

Objects in your pictures can be arranged in straight or curving lines that lead the eye to the center of interest, often in appealing ways.

Balance

We enjoy looking at photographs that are evenly balanced with interesting objects on both sides, rather than everything located on one side or another and nothing at all on the other side.

Framing

In this sense, framing is not the boundaries of your picture but, rather, elements in a photograph that tend to create a frame-within-the-frame to highlight the center of interest.

Fusion/Separation

When creating photographs, it's important to insure that two unrelated objects don't merge in a way we didn't intend, as in the classic example of the tree growing out of the top of someone's head.

Lighting

Effective use of lighting is another element of composition. Light itself can change the way your compositions look, or even become part of the composition itself.

Creating a Composition

Compositions are, by and large, created by the photographer, although great-looking arrangements of subjects can be stumbled across at almost anytime. Even in those cases the photographer needs to recognize the good compositions and do anything needed to refine them and capture the image. Here are some steps to follow in creating pleasing compositions.

Visualize Your Concept

The first step in creating a picture is to conceptualize your photo by planning what kind of picture you intend to take. By that, I don't mean you need to sit down and map out an outline of your intent before every snap. But you should have a good idea of what kind of picture you're looking for (a romantic portrait, action photo, or tight close-up picture); know its final destination, whether that's a Web page or a

framed print on your piano top; have an idea about the intended audience, such as family members or clients; and consider whether you have an underlying message such as "Our best vacation!" You need to know what you hope to accomplish before you can work on the other elements of your composition.

Zeroing in on Your Subject

Next, you decide what's the most important subject in your picture, so your viewers don't have to wonder what they're supposed to be looking at. You can even include several lesser centers of interest to add richness and encourage exploration of your image, but there should be only one main center that immediately attracts the eye. Think of Da Vinci's *The Last Supper*. There are four groups of Apostles that each form their own little tableaux, but the main focus is always on the gentleman seated at the center of the table.

The center of interest should be the most eye-catching object in the photograph; it may be the largest, the brightest, or most unusual item within your frame. As much as you love your spouse, including a circus clown in the photo will insure that the clown's face will grab all the attention. Gaudy colors, bright objects, large masses, and unusual or unique subjects all fight for our attention, even if they are located in the background in a presumably secondary position. Your desired center of attention should have one of these eye-catching attributes, or, at least, shouldn't be competing with subject matter that does.

FIGURE 6.10 This picture has no center of interest, so the viewer's eye doesn't know what part of the image to concentrate on.

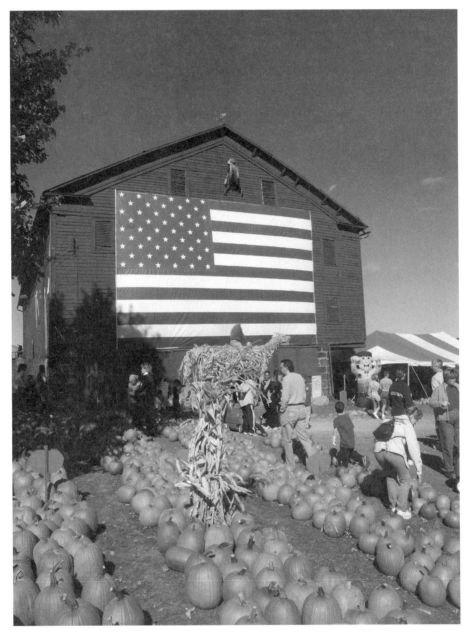

FIGURE 6.11 This picture taken a few seconds later has a distinct center of interest, the American flag, as well as rows of pumpkins that seem to "point" to the side of the barn.

Remove Distracting Objects

Choose plain, uncomplicated backgrounds, and crop out unimportant subject matter by moving closer, stepping back, or using your zoom lens. Remember that a wide-angle look emphasizes the foreground, adds sky area in outdoor pictures, and increases the feeling of depth and space. Moving closer adds a feeling of intimacy while emphasizing the texture and details of your subject. A step back might be a good move for a scenic photo, and a step forward a good move for a portrait.

Remember that with a digital camera, careful cropping when you take the picture means less trimming in your photo editor, and less resolution lost to unnecessary enlargement. Finally, when eliminating "unimportant" aspects of a subject, make sure you really and truly don't need the portion you're cropping. For example, if you're cropping part of a car, make sure the part that remains is recognizable as a car and not a lumpy glob that viewers will waste time trying to identify. And don't cut off people's heads!

Select an Orientation

One way to eliminate extra subject matter is to choose the correct orientation for your picture, either vertical or horizontal. Beginners often shoot everything with the camera held horizontally, which is not the best way to take pictures of tall buildings, trees, and other vertically oriented subjects. Such an orientation also wastes pixels, because you're including lots of detail at either side of your subject that you really don't need.

On the other hand, landscapes, group photos, and auto races are among the subjects that are logically pictured in horizontal mode. While there are a few subjects that look good in a square format, most of the time you'll want a horizontal or landscape orientation. Figures 6–12 and 6–13 provide examples.

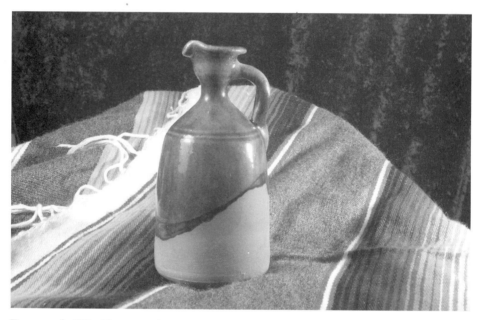

FIGURE 6.12 This still life might be captured in horizontal orientation if you wanted to show the fabric.

FIGURE 6.13 If the emphasis is on the jug, a vertical composition works much better.

The Concept of Thirds

You'll see the idea of dividing your images into thirds referred to as the Rule of Thirds quite a bit, and I'm almost willing to admit that it is, in fact, a "rule." It really is a good idea to arrange your pictures using this guideline much of the time, and when you depart from it, it's a great idea to know exactly why you did so.

That's because things that are centered in the frame tend to look fixed and static, while objects located to one side or the other imply movement, because they have somewhere in the frame to serve as an imaginary destination.

The Rule of Thirds works like this: use your imagination to divide your picture area with two horizontal lines and two vertical lines, each placed one-third of the distance from the borders of the image, as shown in Figure 6.14. The intersections of these imaginary lines represent four different points where you might want to place your center of interest. The point you choose depends on your subject matter and how you want it portrayed. Secondary objects placed at any of the other three points will also be arranged in a pleasing way.

Horizons, for example, are often best located at the upper third of the picture, unless you want to emphasize the sky by having it occupy the entire upper two-thirds of the image. Tall buildings may look best if they are assigned to the right or left thirds of a vertical composition. Figure 6.14 shows a scene arranged into thirds. Notice how the horizon is roughly a third of the way from the bottom, and the important structures of the castle all fall at the intersections of the imaginary lines.

Of course, if your subject is an animal, a vehicle, or anything else with a definable "front end," it should be arranged in a horizontal composition so that the front is facing into the picture. If not, your viewer will wonder what your subject is looking at, or where the animal is going. Add a little space in front of potentially fast-moving objects so it doesn't appear as if the thing is just about to dash from view.

You'll find that close-up pictures are frequently an exception to the rule. You'll find several close-up photos later in this chapter in which the

subject is placed squarely in the center. That works, because in this kind of picture the focus is intended to be solely on the main subject, and other portions of the picture are to be ignored.

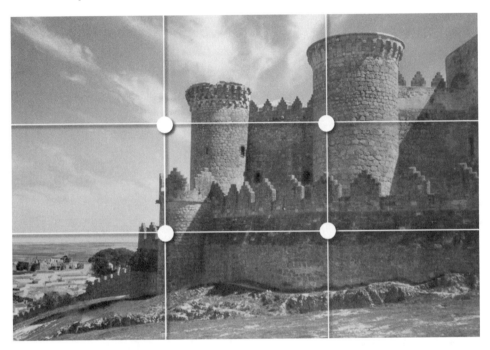

FIGURE 6.14 Placing the center of interest at the intersection of the imaginary points that divide the picture into thirds makes for a pleasing composition.

Using Lines

Viewers find an image more enjoyable if there is an easy path for their eyes to follow to the center of interest. Strong vertical lines lead the eye up and down through an image. Robust horizontal lines cast our eyes from side to side. Repetitive lines form interesting patterns. Diagonal lines conduct our gaze along a more gentle path, and curved lines are the most pleasing of all. Lines in your photograph can be obvious, such as fences or the horizon, or more subtle, like a skyline or the curve of a flamingo's neck. Lines might even be implied, as by a collection of windmills that retreat into the distance.

As you compose your images, you'll want to look for natural lines in your subject matter and take advantage of them. You can move around, change your viewpoint, or even relocate cooperative subjects somewhat to create the lines that will enhance your photos.

Lines can be arranged into simple geometric shapes to create better compositions. Notice how the lines of the tire tracks in the snow in Figure 6.15 lead your eye through the picture towards the horizon. The lines join the subjects together and create a unity that wouldn't be there if they were all standing in random positions.

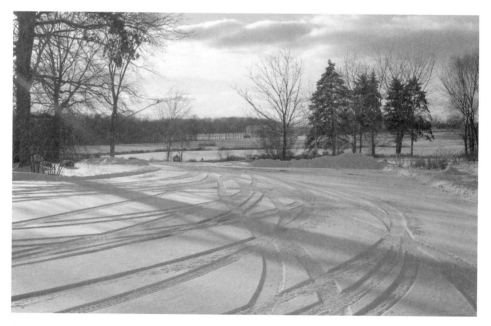

FIGURE 6.15 The lines of the tire tracks in the snow lead the eye through this composition.

Balance

Balance is the arrangement of shapes, colors, brightness, and darkness so they complement each other, giving the photograph an even, rather than lopsided, look. Balance can be equal or symmetrical, with equivalent subject matter on each side of the image; or asymmetrical with a

larger, brighter, or more colorful object on one side balanced by a smaller, less bright, or less colorful object on the other.

In Figure 6.16, the diagonal line of pumpkins that progresses through the center from lower left to upper right is the main subject. The secondary lines of pumpkins on either side provide some balance, and also frame the main subject.

FIGURE 6.16 The pumpkins on either side of the photo provide some balance, even though the emphasis is on the diagonal line of pumpkins that cuts through the middle of the picture.

Framing

Framing is a technique of using objects in the foreground to create an imaginary picture frame around the subject. A frame concentrates our gaze on the center of interest that it contains, plus adds a three-dimensional feeling. A frame can also be used to give you additional information about the subject, such as its surroundings or environment.

You'll need to use your creativity to look around your subject to find areas that can be used to frame your subject. Windows, doorways, trees, surrounding buildings, and arches are obvious frames. Figure 6.17 shows a classic "environmental" frame, with an arch over the road used to frame the castle in the background. Frames don't have to be perfect or complete geometric shapes.

Generally, your frame should be in the foreground, but with a bit of ingenuity you can get away with using a background object as a framing device.

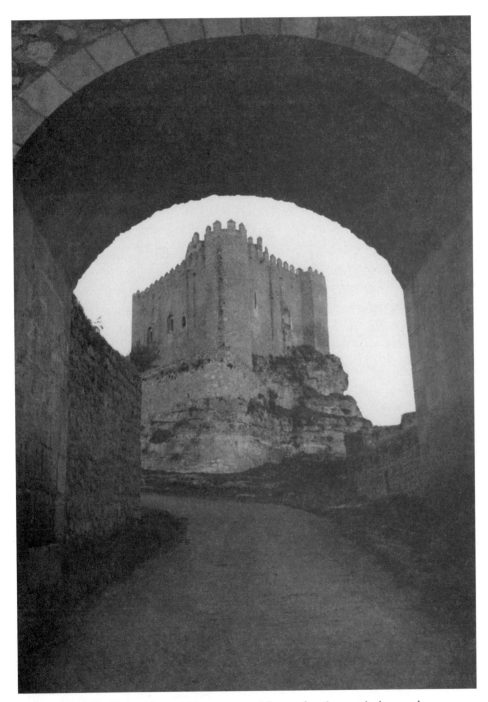

FIGURE 6.17 The arch provides a natural frame for the castle beyond.

Fusion/Separation

Our vision is three-dimensional, but photographs are inherently flat, even though we do our best to give them a semblance of depth. So, while that pole holding up the volleyball net at your company picnic didn't appear to be obtrusive to the eye, it appeared to be growing directly out of the head of your boss in the final picture. Or, you cut off the top of his head on purpose to minimize that bald pate. But now it appears like his head is attached directly to the top of the picture.

You always need to examine your subject through the viewfinder carefully to make sure you haven't fused two objects that shouldn't be merged, and have provided a comfortable amount of separation between them. When you encounter this problem, correct it by changing your viewpoint, moving your subject, or by using selective focus to blur that objectionable background.

Indeed, choosing a good background is an important part of com-posing any photograph. Avoid busy, gaudy, or bright backgrounds that will draw attention from your subject. Indoors, you might want to use a plain wall or a seamless background for a portrait or, perhaps, position your subject in front of a wall of books that lends a dignified air to the picture. Outdoors, take advantage of trees, grass, skies rich with fluffy clouds, or textured walls. Remember how strong lines can lead the eye, and look for them in your backgrounds to avoid distracting the viewer from your intended center of interest.

Figure 6.18 shows what happens when your background is not only cluttered, but indistinguishable from the objects in the foreground. The flowers all seem to fuse together. The same flowers were pictured in Figure 6.4, but with a plainer background that avoided the unwanted merger.

FIGURE 6.18 All the flowers in this photo seem to fuse together because the angle chosen was poor.

Lighting

Lighting and its use in composition is a complex subject. There have been many books written about lighting alone. Later in this chapter you'll find a discussion of how lighting can be used with portraiture, and all the techniques described there apply to other types of subjects

as well. However, portraits are the situations in which you're likely to have the most control, so I'm going to use that kind of photography to explain lighting in a little more detail.

Photographic Cornucopia

Now that you know more about composing your pictures, it's time to look at some of the popular kinds of picture-taking that you'll want to explore. This next section provides an introduction to some of the most popular photographic genres.

Close-Ups

If you want to explore your digital camera's capabilities methodically, close-up photography can let you use your image grabber to capture a whole new world that exists right under your nose. Whether you're shooting pictures outdoors or in your home, macro photography is fun.

Of all the various categories of photography that you can explore with a digital camera, close-up photography of small objects (or tiny living creatures) is one of the best matches for an electronic camera's capabilities. This is one arena in which digital cameras better the average film camera in several respects. Digital cameras include an LCD display that makes it easy to frame your photos precisely. You can view your finished picture in seconds, and reshoot if you're not satisfied. Most digital cameras focus a lot closer than the average snap-shooting film camera, too.

Close-up photography is inexpensive, because you don't need to travel to an exotic location to find exotic subjects. You'll find a whole new world of images in your back yard or attic. Because close-ups are generally taken with a lot of forethought, such pictures are a perfect venue for exercising your creativity. Close-ups are perfect for many hobbies, too, such as coin or stamp collecting, nature, flower cultivation and arranging, needlework, or other avocations.

You can shoot on location or at home. A home setting for close-up photography needn't be elaborate. You can gather a few components and use them around your kitchen or dining room table, if you like. All you need is a plain background, such as a cloth or piece of poster board, some supports to hold your background and camera (such as a tripod or light stands), and perhaps a few lights you can use to illuminate your subject clearly.

For lighting equipment, you can use existing light (the light that's already there, whether you're indoors or outdoors). You can manipulate this light (using reflectors or other gadgets), so you're not strictly limited to what's at hand. Or you can use the flash unit built into your digital camera alone or augmented by additional and "slave" flash units if you're getting fancy. Other good choices are photoflood lights, high-intensity lamps, or any similar lamps you choose to set up. Strictly speaking, you could also use light emitted by the subject itself, but unless you're photographing a candle or a lightning bug, that's not the usual situation.

Arrange Your Subject and Background

The first step is to arrange your subject and its background. If you're shooting in a mini-studio, set up the background on a table or other surface with enough space in front of the setup to let you get close with your camera and tripod (if you're using a tripod). Arrange your subject at the angle you want, making sure it won't tip over or move unexpectedly. Bits of modeling clay can be used to fix many items to the shooting surface (remember that some kinds of clay may contain oils that will stain cloth or paper).

If you're shooting on location, police the area and remove any dead branches, leaves, rocks, extraneous fauna, or anything else you don't want to appear in your photo. Now is the time to simplify your background. Look closely for dirt that can be cleaned away to improve your photo. You might find that a natural setting may be the best background, as shown in Figure 6.19.

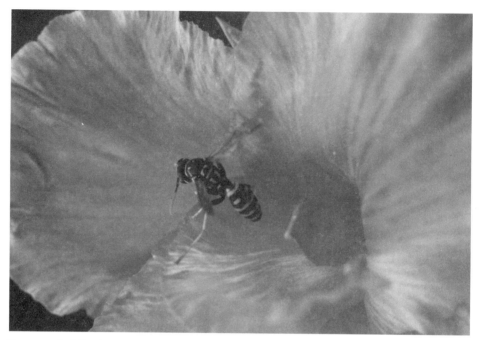

FIGURE 6.19 Natural backgrounds usually look the most realistic when photographing insects.

Set Up Your Camera

If you're using a tripod, adjust the length of the legs so they provide most of the elevation you need. The center pole should be used to fine-tune the height of the camera; if you set the legs too short and have to crank the center column way up, the tripod will be top-heavy and less stable.

Arrange the tripod and camera so you can use the tripod's swivel head to get the angles you want. If you have trouble getting close enough because the tripod's legs get in the way, don't be afraid to reverse the center pole and shoot down on your subject.

Deploy Your Lights

If you're shooting at home, you'll probably want to use at least two lights to illuminate your subject from both sides. Shine the lights directly onto your subject, or bounce the light off a reflector like those described earlier in this chapter. Make sure there is some light on the background to separate your subject from its surroundings.

You may have to get creative with lighting on location. If you're not using external lights, take advantage of reflectors to bounce additional light into the shadows, and light-blocking objects to create softer shadows from direct sunlight or illumination.

As you light your scene, remember that anything you can do to increase the amount of light available will let your camera take a picture at a smaller aperture, which increases depth-of-field (the range in which everything in the picture is sharp).

Frame Your Photograph

With everything in place, it's time to actually compose your photo. Here are some of the things to consider. Choose an appropriate zoom setting (focal length) for your picture. Some digital cameras offer close focusing only at particular focal lengths (that is, they focus closely at medium to telephoto settings, but not at the wide-angle setting), so your choice may be limited. Remember that wide-angle settings can add apparent distortion to your image, making things that are closer to the lens appear much larger than they normally look. This effect is most pronounced with close-ups. A normal or short telephoto zoom setting may produce a more natural look.

Next, frame your picture to exclude extraneous subject matter. Get in tight to produce a photo that will require a minimum of enlargement and will be as sharp as possible. As I noted earlier, close-up pictures are often an exception to the rule about arranging your subjects off-center. Many good macro photos have the main subject smack in the middle of the frame, or only slightly off-center, as shown in Figure 6.20.

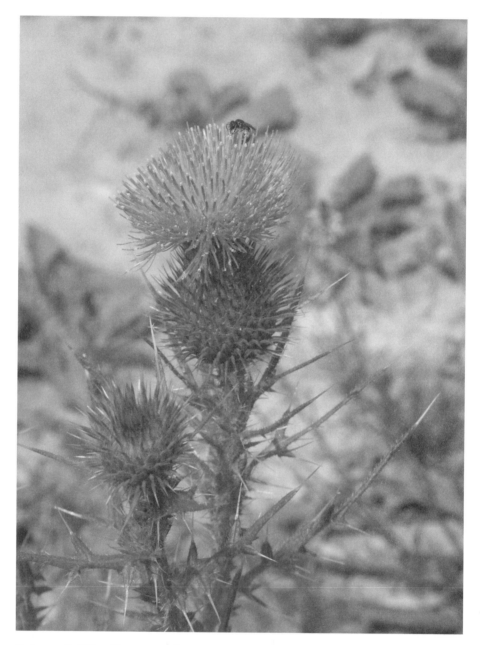

FIGURE 6.20 Close-ups often have the main center of interest close to the center of the photo.

Watch your camera's focus indicator, which may be an LED light near the viewfinder that glows green (or some other color) when the image is in focus. Use your camera's LCD display to evaluate your framing, composition, and focus. The optical viewfinder of your digital camera won't show you exactly what you are going to get, and may indeed cut off part of the picture area.

Many digital cameras have a connector that allows displaying the camera's output on a TV screen. You may even have forgotten you have this capability. Your indoor studio can include a TV or monitor to use in previewing your shot. Even a 20-inch color TV will provide a picture that is larger and easier to view than your camera's 2-inch LCD display. Close-up photography is a perfect application for this feature. You can use the TV to review your pictures as you take them, too.

Take the Photo

When you're ready to take the picture, use your digital camera's "focus lock," which freezes the focus at the current point when you partially depress the shutter release. If your subject is inanimate and you're using a tripod, consider using your digital camera's self-timer feature to trip the shutter after a delay of a few seconds. Even if you press the shutter release carefully, you may shake the camera a little. Wait a few seconds after you hear the camera's shutter click (assuming you've turned on your digital camera's electronic shutter sound), or watch for the blinking of the red LED that indicates the camera is storing an image on the memory card, before doing anything, until you are sure your camera is not making a lengthy exposure or time exposure. That click might have been the shutter opening, and the camera may still be capturing the picture.

Finally, review your photo immediately on your camera's LCD display (or that big TV you set up) to check for unwanted reflections.

Scanners for Close-Ups

If you own a scanner, you already have one of the best close-up accessories you could ask for. Scanners are designed and built for grabbing

images of things that are only a fraction of an inch from the device's sensor. Many scanners work great as capture devices for flat items and some kinds of three-dimensional objects, such as stamps, coins, toy soldiers, small dolls, your butterfly collection, and similar items. Scanners have considerably more resolution than digital cameras at macro distances, so your results will be crisp and sharp. Figure 6.21, produced for an eBay auction, didn't involve a camera at all. The toy locomotive was placed on the bed of an HP scanner, and grabbed that way.

FIGURE 6.21 *No camera is required for some kinds of close-ups when you have a flatbed scanner.*

People

Pictures of people are more than simply a way of capturing human nature in still images. Photographs of humans in action or at rest are a way of documenting history and preserving memories. The fact that there are so many different categories of people-oriented pictures, from fashion photography to portraiture, demonstrates the depth of this particular photographic field.

Like close-ups, people pictures can be taken outdoors, in the field, or in the home or more formal settings. At home, portraits can be more formal, if you like. With a professional-looking backdrop or a "serious" background such as those shelves of professional journals you see in so many executive portraits, a studio portrait can have a formal or official appearance. Pictures taken outdoors, on the other hand, end up having a casual air no matter how hard you try to formalize them.

Let There Be Light

Most digital people pictures are taken either using available light or the flash built into the camera. You can get some fine pictures in either mode, but if you're serious about going beyond point-and-shoot, you should at least give some consideration to using more than one light source.

That doesn't mean you need three or four electronic flash units or other gadgets. You can achieve the same effect as multiple light sources just by using the light you have available shrewdly. For example, large white pieces of cardboard can bounce illumination from a window onto your subjects to produce a soft fill light that fills in the shadows, as was done for Figure 6.22. Here's a discussion of the types of lights the pros use. Think of ways you can apply these concepts to your own pictures.

FIGURE 6.22 Lights bounced off white cardboard produced this soft illumination.

Main Light

The main light is the primary light source used to illuminate a portrait. It may, in fact, be the only light you use, or you may augment it with other light sources. The main light is most often placed in front of the

subject and on one side of the camera or the other. This light might be the light coming from a window, a lamp, or other source.

When placed to one side, the main light becomes a sidelight that illuminates one side or the profile of a subject who is facing the light. Placed behind the subject, the main light can produce a silhouette effect if no other lights are used, or a backlit effect if additional lighting is used to illuminate the subject from the front.

Fill Light

The fill light is usually the second most powerful light used to illuminate a portrait. Fill light lightens the shadows cast by the main light. This might be another light source, such as a lamp or window, or a reflector you place outside the scene to bounce light into the shadows. Fill lights are most often placed at the camera position so they will fill the shadows that the camera "sees" from the main light.

Background Light

A light illuminating the background is another common light source used in portraits. This light is used to determine the degree of separation between the subject and the background, and also can provide interesting lighting effects on the background. You can even turn the background light towards the back of the subject, producing a halo or backlight effect.

Hair Light

You probably won't go so far as to use a hair light, which is a small light directed at the hair of the subject to provide an attractive highlight. A hair light must be controlled carefully so it doesn't form an overexposed hot spot on the subject's head, or spill over onto the face. If you start working with a hair light, you'll know you've definitely expanded your photographic ambitions!

Posing

The most important thing is to make your subjects relaxed and comfortable. Don't make them stand for anything other than a full-length

portrait. Stools make a great seat because they discourage slouching and have no backs to intrude on the picture.

If you're photographing an individual, you can try different poses as you work. For group pictures, you'll probably want to try and arrange everyone in a pleasing away and take several sets of pictures with each pose before moving on. Use the compositional rules you learned earlier in this chapter.

If you're shooting photos of your subjects from the waist up, position the camera at chest- or eye-level. Raise the camera slightly above eye-level if you want to elongate a nose or narrow a chin, broaden a "weak" forehead or de-emphasize a prominent jaw line. If your subject has a wide forehead, long nose, or weak chin, lower the camera a little.

The edges of hands are more attractive than the backs or palms of hands, as you can see in Figure 6.23, while the bottoms of feet are downright ugly. Bald or shaved heads are pretty cool these days, but if your subject is sensitive about a bare pate, elevate your victim's chin and lower your camera slightly. For long, large, or angular noses, try having your subject face directly into the camera.

FIGURE 6.23 Hands make a good prop for some photos, but avoid the backs or palms of the hands in favor of the side edges.

To minimize prominent ears, try shooting your subject in profile, or use short lighting so the ear nearest the camera is in shadow. If you want to minimize wrinkles or facial defects such as scars or bad complexion, use softer, more diffuse lighting; take a step backwards and photograph your subject from the waist up to reduce the relative size of the face; keep the main light at eye level so it doesn't cast shadows.

If your subject is wearing glasses, be wary of reflections off the glass. Have him or her raise or lower his chin slightly, and make sure your flash is bouncing off the face at an angle, rather than straight on.

Remember that telephoto zoom settings tend to widen faces. A long telephoto setting (say, the equivalent of 150mm to 200mm) is usually a bad choice for portraits. Wide-angle settings provide distortion as you move in close.

Pet and Child Photography

Shooting pets and children (particularly babies) is a lot like general people photography with an added twist: your subjects are likely to be a lot less cooperative than even the most persnickety teenager or adult.

You can follow all the guidelines of the previous section, and add in a good dose of patience and understanding. The willingness to take the time to capture your animal or infant in the act of being themselves will pay off.

Place your subject in familiar surroundings, such as a bed, blanket, or play area, as shown in Figure 6.24. Relax, talk it up, laugh, and joke. Then, when the moment is right, take the picture.

FIGURE 6.24 Your subject will be more comfortable if photographed in natural surroundings.

Sports

The heart of sports photography lies in getting the right subject, at the right moment. Incorporating both elements into your pictures takes some practice. Getting close and grabbing the decisive moment is excellent advice for the sports photographer, too. It's true that some action shots aren't particularly dependent on the precise moment in which the picture is made, give or take a second or two.

You need little more than a good eye and presence of mind to capture a poignant photo of a jubilant field goal kicker who has just booted the ball right between the uprights. Nor do you need hair-trigger timing to grab a shot of a pitcher watching what he thought was a high strike sail over his head and the outfield fence. In these cases, you need to know the sport, understand what events are important, and have the alertness to actually take the photo.

Dealing with Shutter Lag

For digital photography purposes, shutter lag is the time between when you press the shutter release button and when the camera actually takes the picture. Ideally, that interval should be a very tiny fraction of a second. In practice, the delay may be a large fraction of a second, or even much longer, depending on your digital camera. That means that when you see an exciting bit of action that you want to capture and press the release button, nothing may happen until the moment has passed.

It's frustrating to miss a great shot simply because your digital camera takes too long to snap off the picture. There's no way to sidestep the problem entirely, but you can minimize the damage to a certain extent.

Plan ahead. Let your camera set its exposure and focus prior to the decisive moment. Most digital cameras have a mode that locks in both settings as soon as you press the shutter release part-way. Learn to do this when the subject you may be photographing is in your viewfinder, even if a second or two may elapse before you actually take the picture. Then, press the release down all the way when you want to snap off a shot. Many cameras will respond much more quickly in this mode.

Do it yourself. Use manual exposure and/or focus. It's usually more practical to set the exposure yourself in manual mode (the correct exposure settings may not change over a brief period of time) and leave the camera in autofocus mode. However, if you prefocus on a spot where you expect the action to take place, you can eliminate both these automatic functions to speed your camera's response.

Make a guess. If you understand the sport fairly well, you can often predict when something exciting will happen, follow the action with the camera, and press the release just before the big event.

Take lots of pictures. Be prepared to erase a significant number of exposures. You'll increase your chances that one of them will be really great, while improving your skills as your experience builds.

Use burst mode. Explore your digital camera's multi-shot burst mode. This mode lets you start taking a series of pictures just before the decisive moment. With a bit of luck, one of them will be the exact picture you want.

Choose Your Positions

An important part of sports photography is choosing where to stand. At professional sporting events, you won't have much choice about where you position yourself unless you have press credentials. However, much of the time you'll be able to take pictures anywhere common sense and common courtesy allow. Here are some tips for specific sports:

Baseball. Right behind home plate may be the best place to watch a game, but it's not the best place to take pictures, unless you're intent on showing the facial expressions of a pitcher uncorking a two-seam fastball. Pro sports photographers often position themselves in the niches at the ends of the dugouts, which was the position used for Figure 6.25.

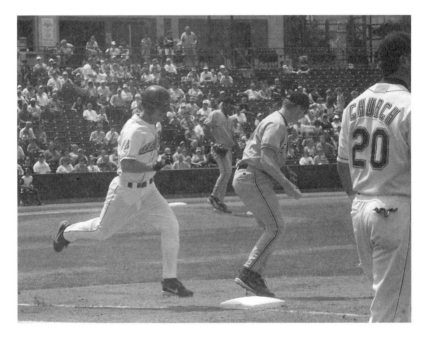

FIGURE 6.25 Wangle a seat near the dugout for great shots of the action around the bases.

Basketball. Basketball is one sport in which all the action focuses around a single spot, the basket, so you'll find that one prime location is behind the backboards. The only problem with this position is that you end up with a lot of photos of guys and gals with their arms up in the air. Don't be afraid to move to the sidelines to capture some of the action from a different angle. While low angles are not the best for a sport with so many tall players, you may be able to get good pictures seated in the first few rows.

Football. For football, see if you can gain access to the sidelines, and then position yourself 10 to 15 yards ahead of or behind the line of scrimmage. One provides good pictures of the offense in the backfield, while the other is good for catching defensive moves. Move to the end zones when appropriate, to catch the fullback bulling over from the one-yard line, or the kicker lining up for a field goal.

Soccer. From a photographic perspective, soccer is a lot like football in many ways. Follow the action up and down the sidelines. If one team is

severely overmatched, you can probably hang around their goal a great deal, because that's where most of the action will be taking place. Of course, orienting on the goals means you'll be concentrating on one team's fullbacks and goalie and the other team's wings and strikers. Alternate ends of the field and select which end is the best photographically from a physical, background, and lighting standpoint, and then photograph each team in turn (they trade ends of the field after the half).

Other sports. You can use the same rules and a little common sense to position yourself for other sports. Tennis and auto racing can often be photographed from the spectator stands using a long zoom setting; the participants twist themselves around enough during the action to give you many different angles from a single vantage point.

You can follow the gallery around during a golf tournament, but if you're allowed to use your camera, for heavens sake don't distract the players during their shots! Many digital cameras are totally silent if you disable the phony shutter "click" that's provided for your reassurance. Watch out for the autofocus and autoexposure confirmation "beeps," too. A quiet camera is an unobtrusive camera.

Hockey is one sport that benefits from a higher-than-normal angle because an elevated view lets you shoot over the glass, and the action contrasts well with the ice. The same is true of professional wrestling, unless you have a ring-side seat and can dodge the flying chairs.

No matter where you are at a sports event, don't forget to look around you for some human interest pictures. Sometimes, the best way to capture the spirit of a contest is to show the fans, mascots, or even the vendors.

Freezing Action

High shutter speeds (1/500th of a second or briefer) freeze action, and if you set your digital camera to its "sports" scene mode it will automatically choose the fastest shutter speed possible under the available light conditions. But also consider whether you want to freeze the action at all. A little blur can add some excitement to an action photo.

You can use higher ISO settings to allow shorter shutter speeds, but at the cost of extra noise, or grain in your photos.

Remember that action crossing the frame horizontally requires a faster shutter speed to freeze the movement than action coming towards you, and that action closer to the camera is harder to freeze because its apparent speed is greater. You can also move the camera in the direction of the horizontal motion (this is called panning) to provide the double benefit of freezing the action a little while blurring the background.

Remember that electronic flash also freezes action in its own way, as shown in Figure 6.26, so if you're indoors and can rely solely on the illumination from the flash, try a few pictures in that mode. If the surrounding lighting is bright, however, you can end up with ghost pictures in which a sharp image formed by the flash merges with a blurry image produced by the available lighting.

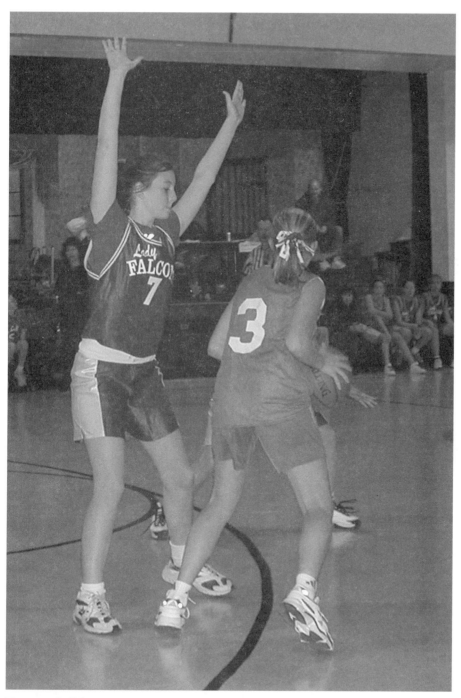

FIGURE 6.26 Electronic flash can freeze the action of most sports.

Shooting Sequences

Using your camera's burst mode is another way of increasing your chances of getting a good picture. Depending on your camera, you may have one or more of the following options:

Continuous picture-taking. In this mode, the camera continues to take pictures as long as you hold down the shutter release, at a rate of perhaps 1.5 shots per second, until the camera's memory buffer is full. At that point, you'll have to wait until some of the picture information is written to your removable memory card before you can take another shot. With my camera, I find I can snap off three shots in about two seconds, then wait a second or two, and take one or two more. The advantage of this mode is that you can usually use the camera's full resolution; the downside is that this mode will take fewer shots in a given time interval than other modes.

Ultra-high-speed. Some cameras can take pictures at a faster clip in a quasi-ultra-high-speed mode, using reduced resolution. If you're willing to accept photos with, say 640 x 480-pixel resolution, you may be able to grab them at a rate of two or three per second.

Multi-shot. A few cameras can produce a quick blast of 16 tiny pictures on a single frame. Such images might be OK for analyzing your golf stroke, but may be too small for other applications.

Mini-movie. Most digital cameras have the ability to shoot short video clips (typically 20–30 seconds) at 320 x 200 or 640 x 480 resolution. You can use the movies as is, or capture individual frames.

Burst or sequence mode can still be a hit-or-miss procedure, because a lot can happen between frames. It's very likely that you'll still miss the decisive moment, but I had that happen to me when I was using a six-frames-per-second motor drive, too. As with all sports photography, the more pictures you take, the more you increase your odds of getting some great ones.

Landscape and Travel Photography

You spent thousands of dollars on your last vacation. When you got home, what did you have to show for it, other than mounting bills, some cheap souvenirs, and envious friends? If you were smart, you also accumulated a wealth of photos you can use to preserve those precious memories, or, perhaps, make your friends even more envious.

Landscape and travel photography are related, as you can see in Figure 6.27. Both involve lots of photos of picturesque countryside, including mountains, valleys, amber waves of grain, and other scenic delights. Travel photography can also include monuments and buildings such as castles, cathedrals, great walls in China, and so forth. When visiting foreign lands, you'll also want a few pictures of the local residents who were gracious enough to make your visit memorable.

FIGURE 6.27 Scenic and travel photography gives you the opportunity to try your compositional skills.

Also falling roughly into these categories are architectural photography and night photography. All require the same skills, and all let you use your digital camera's wide-angle and zoom settings to the utmost. Most don't require much action-stopping capability, and you probably

won't have the freedom to rearrange your subject matter as much as you like.

However, all the compositional guidelines mentioned earlier in this chapter come into play. Landscape and travel photography are the perfect opportunities to create carefully composed photos. You don't need to use the precision of an Ansel Adams, but a trip to the countryside or on vacation are your chance to show exactly how much you've learned about making (as opposed to taking) good photographs.

chapter

7

Editing Digital Photos

In this chapter...

✔ Easy, Automated Image Transformations

✔ More Advanced Image Manipulations

✔ Graduating to a Fully Featured Image Editor

✔ What Can You Do with Image Editors?

One of the most enjoyable aspects of digital photography is the ability to take a great snapshot and make it even better. Perhaps you'd like to crop out some extraneous subject matter, such as that ugly tree at the left side of your landscape, or that disreputable former brother-in-law caught mugging in a family portrait. Maybe you'd like to enhance the warm glow of a sunset picture, or cancel that "red-eye" look that spoils a cute shot of your daughter. You might even want to create a fantasy picture with subject matter from several photos, or add some interesting special effects.

Digital photo editing can perform all this magic, and you don't need to become a graphics guru to achieve some masterful feats of imaging legerdemain. Editing software for all levels of picture expertise makes the job easy, fun, and rewarding. Whether you choose to work with a friendly, wizard-like program such as ArcSoft Funhouse, a more sophisticated (but still easy to use) program like ArcSoft PhotoImpression, or a multi-function application like the HP Image Zone software furnished with many HP products, you'll find the tools you need to manipulate your photographs in a way that looks professional.

This chapter serves as an introduction to what you can do with some of the most common software packages, including those bundled with many Hewlett-Packard computers, as well as a few more advanced tasks. When you've finished, you'll be ready to learn how to tackle all kinds of image editing chores with confidence. You might even be interested in "graduating" to more advanced applications, such as Adobe Photoshop or Adobe Photoshop Elements.

We're going to start off with a quick overview of what you can accomplish with basic image editing software, using the versatile Arc-Soft and HP Image Zone products as examples. However, most of what is covered here applies to any image editing program in the entry-level and intermediate categories. We'll finish up with some more advanced examples of what you can do, and why you'd want to do it.

Easy, Automated Image Transformations

The easiest way to do something with your picture is to use a program that automatically does most of the work for you. ArcSoft PhotoImpression, HP Image Zone, Roxio PhotoSuite, and Ulead Photo Express

are four of the simplest image editing applications with a broad range of capabilities. Others, like ArcSoft Funhouse, furnished with many Hewlett-Packard computers and digital cameras, are special-purpose programs that do a particular useful task, such as making calendars, greeting cards, or posters.

Funhouse, for example, lets you smoothly combine several photos to create a humorous scene or realistic photo in which you, a friend, or a family member is placed into another picture to become a star quarterback or an energetic rock star. You can add text or other effects to the finished image, which can be used to print a card, small poster, or other colorful output.

Best of all, the application leads you through most of the steps in 1, 2, 3 fashion. Typically, you'd start out with a picture to borrow from, like the one shown in Figure 7.1. Next, you'd select the portion of the picture you want to use by painting over it with the brush tool, as in Figure 7.2. You can choose another picture of your own to merge with, or select a template provided with Funhouse. Click a few buttons to blend, rotate, or match colors, as you can see in Figure 7.3, add some text if you like, and then go ahead and print your finished image, which was merged automatically by the program, as shown in Figure 7.4. What could be easier?

FIGURE 7.1 First, choose the photograph you'd like to borrow from for your composite image.

FIGURE 7.2 Next, use a brush to select the area you want to copy.

FIGURE 7.3 Rotate, blend, and match colors with the surrounding template, and add some text.

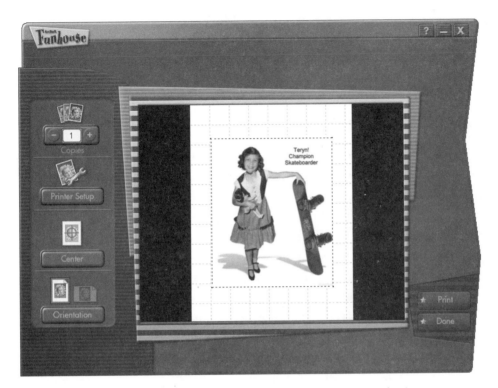

FIGURE 7.4 Print your image as a photo, post card, or other final output.

The easiest image editors provide interactive "wizards" that ask you questions in a series of dialog boxes and make the necessary modifications to your images based on your input. You can use them to crop pictures, fix colors, rotate your images, add some text, or make other enhancements quickly. Even if you don't want to get heavily involved in image editing, programs like these let you work with your pictures.

More Advanced Image Manipulations

The next step up in image editing isn't much more difficult. Applications like PhotoImpression or Adobe Photoshop Elements also include many quick fixes you can make with a few clicks of your mouse. However, they also have tools you can use to manipulate your images more flexibly and with more personal creativity. I like PhotoImpression and

Image Zone because they are furnished with so many Hewlett-Packard products and can do so much. I'm going to run through some of the things you can do with one of these intermediate image editors. You'll find most of the same features in other image editors, however.

Collecting Your Pictures

The first step to working with your digital images is to find them! That's why many image editing programs include file management modules that let you collect your burgeoning assemblage of pictures into collections of thumbnail images. Photoshop Elements includes a File Browser, while ArcSoft PhotoImpression and Image Zone both have a useful Album feature.

You can browse through your available photos by clicking the Get Photo button at the top left of the PhotoImpression window, as shown in Figure 7.5. The screen that appears includes a number of ways of selecting pictures to work with. These include:

Album, which displays small versions of any of the images you've collected into an album that you create.

From Folder, which allows you to look through your hard disk files for a specific picture.

Camera/Scanner, a feature for importing photos from your digital camera, or grabbing images of prints with your scanner.

Create New, for starting out with a blank image that you fill up with graphics by drawing or painting, or copying from other pictures.

Screen Capture, to convert whatever is visible on your computer screen into a graphic that you can edit.

FIGURE 7.5 The first step is to Get Photos from your computer, camera, scanner, or other source.

If you already have photos to work with, the Album is the place to start. You can create albums for picture categories you favor, such as Flowers, Family, Vacations, Sports, or any class of images you choose. Add pictures to your album, enter keywords that will make them easy to search for later (such as Baseball, Football, Soccer, Spain 2002), or sort them by name or picture type. Once you've collected photos into an album, you can select one or more for image editing, create slide shows that display a series of pictures, or even convert a photo to a screen saver. We'll look at interesting ways of sharing your digital pictures in Chapter 8. Our emphasis in this chapter is on editing them.

Usually, you can open your image in the image editor by double-clicking it with the mouse. Then, you'll want to click the Edit button to begin making your changes.

Image Zone's album features are also easy to use, and operate within a Microsoft Internet Explorer framework. You can view pages of individual shots, or enlarge any picture in an album to get a close-up view, as shown in Figure 7.6.

FIGURE 7.6 Image Zone's album features let you create multiple albums and browse through them.

Cropping, Resizing, and Rotating

Every picture tells a story, but even the best stories can benefit from a little trimming. One of the first things you may need to do to your digital photograph is eliminate distracting elements around it by cropping them out of the picture. That's usually done using one of several related tools found in the Crop/Resize window (with PhotoImpression, just click the Crop/Resize button at the lower left of the window, shown in Figure 7.7). A similar button is located at the left side of the Image Zone window, too, as you can see in Figure 7.8.

FIGURE 7.7 Click the Crop/Resize button in PhotoImpression.

FIGURE 7.8 *Choose the Crop function from the left side of the Image Zone window.*

Some image editors have special cropping tools: you use the mouse to drag a rectangular shape around the object so that only the parts you want to keep are within the crop rectangle's boundaries. Adjust the cropping box at top, bottom, or sides to fine-tune your image, then press the Enter key to trim the image. PhotoImpression uses a tool called a selection marquee, which is available in several versions to select rectangular, oval, free-hand shapes, or contiguous pixels.

You'll learn to use each variation as you become more adept at image editing, but the rectangular version is deployed to select the rectangular shape used to crop your picture. Once you've dragged around the area you'd like to include, click the Crop button.

You can also change the size of your image by typing the actual pixel width you want in the boxes at the lower right of the window, or, more likely, by changing the scale to a particular percentage of the original size (50 percent, 200 percent, and so forth) by typing those values

into the other set of boxes at lower right. Click the Resize button to change the size of the image.

Sometimes you won't like the orientation of a particular image. You might want to flip the picture horizontally, or rotate it, using a panel of controls called a tool palette, with PhotoImpression's version shown in Figure 7.9. Individual buttons on the palette perform functions like zoom in and out (the top two "magnifying glass" icons), reside or rotate (the top two buttons in the palette), or flip the picture from side to side (the first icon in the second row of the palette). Additional buttons let you undo or redo your last action, copy portions of an image, or delete parts and send those parts into the trashcan. The tool names and locations may vary from image editor to image editor, but all of them function approximately as I've described.

FIGURE 7.9 Tool palettes include icons you can click to perform various functions.

Retouching

Click the Retouch button in PhotoImpression to move on to the next step in enhancing your image. Image editors include a versatile set of tools in their image editing repertoire, like those shown in Figure 7.10. Retouching is easy, because you can usually "paint" the results you want onto your picture canvas, using brushes, both hard and fuzzy, of various sizes. The tools in the toolbar directly below the flower photo in the illustration include (left to right):

Paintbrush, for painting colors in broad strokes.

Pen, for drawing thin lines.

Airbrush, for adding a thin mist of color to your image like that applied by a paint spray can.

Eraser, to remove lines you've already drawn.

Clone, to duplicate parts of an image somewhere else in the picture, say, when you want to produce copies of a flower in other locations in the same photograph.

Smudge, to smear parts of an image, perhaps to reduce the harshness of a boundary, or to blend parts together.

Blur, to reduce the sharpness of a particular part of an image. This tool is especially useful for blurring the background of an image, thus emphasizing the foreground.

Sharpen, to enhance the contrast and sharpness of part of an image.

Darken, to make parts of a picture darker.

Lighten, to make other parts brighter.

The last four icons in the toolbar are non-brushlike. For example, the Eyedropper "picks up" the color from any location you click in the picture, so you can use that color to paint with. The two "paint bucket" buttons fill an area of your picture with a solid color or pattern. The final icon in the toolbar adds a colored gradient to your picture.

Below the toolbar is an area you can use to select the kind of brush you want to work with, the size of the brush tip, the color to apply, and the intensity (opacity) of the color being painted. Choose the 100 percent intensity and the area of your photo painted will be completely covered. A lower intensity will produce a more transparent effect.

FIGURE 7.10 You will find PhotoImpression's retouching tools at the bottom of the window.

Adding Text

Text is usually added to a picture in a separate step (with PhotoImpression, you just need to click the Text button in the lower left corner). You can select a font, type style, size, color, and transparency, then choose to add a shadow behind the text if you like. The text can be moved anywhere on the image, as you can see in Figure 7.11.

Use text to provide labels for objects in your photos, captions for pictures, or to turn your image into a postcard, poster, or advertisement.

FIGURE 7.11 Add text to your image.

Enhance

The Enhance step gives you the chance to adjust the tonal values of the image, applying overall brightening or darkening to an image that is too dense or too light, changing the saturation (color richness) and hue (color bias), and applying other effects to the entire image, such as sharpening or blurring. You can even turn the picture into a negative if you like. Figure 7.12 shows the controls available for this step within PhotoImpression.

FIGURE 7.12 Use enhancing tools to adjust the brightness, contrast, or colors of an image.

Effects

Special effects can turn your image into a surrealistic vision, engulfing parts of the photo in a whirlpool, as you can see in Figure 7.13, or transforming it into a patchwork quilt, a pointillist painting, or a psychedelic false-color fantasy. All image editing applications have a large selection of special effects that you can preview and apply to your images. Most of these effects have controls that let you vary the amount of effect applied. Figure 7.14 shows four versions of an image, each with a different special effect applied.

When you're all done with your image, you can save it, print it, or use it as fodder for additional applications, such as calendars, greeting cards, T-shirt transfers, or other fun uses.

FIGURE 7.13 Twist an image into a whirlpool using typical special effects found in image editors.

FIGURE 7.14 Special effects add a distinctive look to each version of this photo of a Chinese temple lion.

Image Zone's Easy Interface

You might find Image Zone even easier to use. It dispenses with most of the tools and palettes you'll find in editors like PhotoImpression, in favor of a menu of enhancement options arrayed along the left side, as shown in Figure 7.15.

When you click the arrow next to the enhancement, sliders or other controls appear that you can use to apply the kind of modification listed. These include Auto Enhance, which does a pretty good job of automatically correcting the brightness, contrast, and color of most images. You can also choose to remove Red Eye effects, crop, resize, flip, or rotate the image, adjust color, change the brightness, or sharpen/blur your image.

Because these kinds of changes take care of most problem images, you might not need any other image editor than Image Zone.

FIGURE 7.15 Choose the kind of enhancement you want to make from the menu at the left side of the Image Zone window.

Graduating to a Fully Featured Image Editor

The more you work with automated image editors, the easier it will be to graduate to a fully featured application that can do just about anything that needs to be done. The best-known, most expensive, and most difficult to learn, of course, is Adobe Photoshop. It's the tool of choice for professional photographers and others who make their living from images, but plenty of serious amateurs use it, too. If you think you might someday become a graphics professional, it's never to early to begin learning Photoshop. There are so many things this premiere image editor can do that mastering it is virtually a lifetime task.

Most of us, however, can find all the features we need from one of the so-called second-tier image editors. They're much less expensive to buy, quicker to learn, and have all the power to change digital images in interesting and compelling ways. It's very likely you'll be happy with one of the applications I'm going to describe next.

Here's a quick overview of the image editors you might want to consider.

Adobe Photoshop Elements

This image editor is an intermediate application that includes both automated wizards and manual tools that you can manipulate with great precision. Built on the same foundation as the latest Photoshop CS, Elements shares many of its older sibling's menus, tools, and palettes. If you think that you might someday want to consider upgrading to the full Photoshop application, Elements makes a great training tool, and can stand on its own as a fine image editor.

Corel Photo-Paint

Photo-Paint is included as part of the Corel Graphics Suite that includes CorelDraw, and it has a similar interface. That makes it a good choice for those who use CorelDraw and want the same kind of tools in their image editing program. It's furnished with textures, thousands

of clip-art images, and special effects add-ons that can transmogrify your images in pleasing (and amazing) ways.

Corel Painter

Corel Painter has been the vagabond of the image editing industry for the past few years, migrating from Fractal Design, to MetaCreations, to Corel, to the Corel spin-off company known by its lowercase designation procreate, and most recently back to Corel. Its long life and frequent change of ownership probably stem from the fact that Painter is truly unique among image editors, and its various owners haven't known exactly what to do with it, nor have they wanted to kill off such a rare bird completely.

Painter is cherished for its capability to faithfully capture the subtleties of an artist's brush strokes and translate them to print or the Web. Painter faithfully recreates traditional artists' media in unlimited quantities, such as oils and acrylics, airbrushes, colored pencils, chalk, charcoals, crayons, and felt pens, combined with hundreds of papers, patterns, and textures. Additionally, it offers most of the capabilities found in Adobe's Photoshop, as well as techniques not offered by Photoshop. For those with a fine-art background, this tool will both amaze and please you unlike almost any other digital tool on the market. For some of the painting features, a digital tablet (a pad that uses a pencil-like stylus instead of a mouse to draw) is desirable. However, it is more of a painting tool than a digital picture editing tool. Many graphic artists own both Painter and Photoshop.

Jasc Paint Shop Pro

Sometimes known as the "poor person's Photoshop," Paint Shop Pro has a remarkably complete set of features that do rival Photoshop in many ways, at a bargain price in the neighborhood of $100. It does have so many capabilities that it's often as difficult to master as Photoshop, but you'll find lots of help files and demos included with the program, as well as a ton of third-party books aimed at Paint Shop devotees. In

addition to its image editor, it includes animation tools and a good image browser. If your ambitions are larger than your pocketbook, this is one program to consider.

Ulead Systems PhotoImpact

PhotoImpact is especially strong as a tool for Web design and business, and its image editing capabilities approach those of all the other applications we've discussed. Its album tool is especially good, and Photo-Impact comes with a large number of preset effects you can apply to your images to achieve special looks quickly and easily.

What Can You Do with Image Editors?

So far, I've given you an overview of the kinds of things you can do with image editors, and showed you how simple editors work. For more in-depth manipulations, you need to understand some simple concepts, like color correction and retouching. Here's what you need to know.

Fix Those Colors!

Color balance is the relationship between the three colors used to produce your image; with a digital camera or scanner they are the red, green, and blue hues captured by the camera or scanner's solid-state sensor. It's not enough to adjust the relative amount of each of these primary colors. There are actually three factors you'll need to be concerned with:

Color intensity. If you have too much red, the image will appear too red. If you have too much green, it will look too green. Extra blue will make an image look as if it were created under full moon at midnight at the North Pole. Other color casts are produced by too much of two of the primary colors, when compared to the remaining hue. That is, too

much red and green produce a yellowish cast, red and blue tilt things toward magenta, and blue and green create a cyan (blue-green) bias.

Color saturation or richness. Saturation is how much of the hue is composed of the pure color itself, and how much is diluted by a neutral color, such as white or black. Think of a can of red paint and white paint. Pure red paint is fully saturated. As you add white paint, the color becomes less saturated, until you reach various shades of pink. In one sense, color can also become desaturated by adding black paint, making it darker. Your image editor can help you adjust the saturation of a color by removing these neutral white or black components.

Brightness and contrast. These values refer to the relative lightness/darkness of each color and the number of different tones available. If, say, there are only 12 different red tones in an image, ranging from very light to very dark, with only a few tones in between, then the red portion of the image can be said to have a high contrast. If you had 60 or 100 different red tones, the reds might appear to be relatively low in contrast.

The brightness is determined by whether these available tones are clustered at the denser or lighter areas of the image. If 80 percent of your red tones are dark, the reds in your image will be dark, regardless of whether there are 12 of them (high contrast) or 100 of them (low contrast). Figure 7.16 shows high-contrast/low-contrast, bright/dark images for comparison.

FIGURE 7.16 The left bust is a high-contrast image. The right bust is a low-contrast image. In each version, the left side is dark and the right side is light.

Bad color can result from a variety of reasons. Sometimes the color of the illumination is too red (at sunset) or too blue (in bright snowy conditions). If the picture was taken under fluorescent lighting, the light can even be too green. Use several light sources in a picture (such as window light combined with an incandescent lamp in the room) and the light can be too warm on one side of your subject and too cold on the other—simultaneously!

Color casts can crop up in your photofinishing, if you shot on film or used a store's lab to make prints from your digital pictures. Bad color can result from film left in a camera too long and allowed to fade or fog, or film that has been over-exposed to airport X-ray screening systems. Prints that have been exposed to bright sunlight can fade, too.

Fortunately, you can fix many of these color problems in your image editor. Keep in mind that no correction techniques can add detail or color that isn't there. All techniques work well with photographs that have, say, all the colors somewhere, but with too much of one hue or another. The extra color can be removed, leaving a well-balanced picture behind. Or, you can beef up the other colors, so they are in balance once again. Your image editing program does that by changing

some pixels that are relatively close to the color you want to increase to that exact color.

Removing one color, or changing some colors to another color, doesn't add any color to your image: either way, you're taking color out. So, if you have a photograph that is hopelessly and overpoweringly green, you're out of luck. When you remove all the green, there may be no color left behind. Or, you can add magenta until your subject's face turns blue (well, it won't happen that way), and all you'll end up with is a darker photo. You must start with a reasonable image; color correction is better suited for fine-tuning than major overhaul.

Color Balance Controls

The first way to color-correct an image is using the color balance controls that virtually every image editing program has. Depending on your particular software, you may have to hunt to find a set of sliders that can be used to adjust all colors for an entire image. No matter what program you're using, the dialog box will look more or less like Figure 7.17, with a few differences.

FIGURE 7.17 *Color balance controls let you modify colors by moving sliders.*

These let you adjust the proportions of a particular color, from 0 percent to 100 percent, or, in some cases, you can either add one color or subtract its two component colors. For example, moving the Cyan/Red slider to the right towards the red end adds red while it subtracts cyan, and has the exact same effect as moving the Magenta/Green and

Yellow/Red sliders both the same amount to the left. This is easy to master if your image editor shows a preview in real time of your image as you move the sliders. The biggest challenge is deciding in exactly which direction you need to add/subtract color. Magenta may look a lot like red, and it's difficult to tell cyan from green.

Hue/Saturation Controls

You can also color correct an image using the Hue/Saturation/Lightness or Brightness controls found in most image editors. The advantage of correcting color this way is that you can change the saturation (or richness) of individual colors, or of all the colors in an image, without modifying the hue or lightness/darkness of those colors. The color balance method changes only the relationships between the colors and leaves the saturation alone.

These dialog boxes, like the one shown in Figure 7.18, have three main controls. They let you change the saturation alone, modify the overall hue (making all the colors more reddish, greenish, bluish, and so forth), or change the overall brightness/darkness of the image while leaving the saturation and hue unchanged.

FIGURE 7.18 You can also adjust hue, saturation, and lightness separately, without affecting the other two factors.

For example, you might have a holiday picture that needs to have its reds and greens enriched, but with muted blues. Perhaps the green

grass and foliage in another color have picked up an undesirable color cast and you want to shift all the green values one way or another to improve the color. Or, you may want to darken or lighten just one color in an image.

Variations

Most image editors offer a "color ring around" or "variations" mode, in which the software generates several versions of an image, arranged in a circle or other array so you can view a small copy of each one and compare them. Photoshop Elements' Variations mode is an example of this method. You can see the dialog box in Figure 7.19.

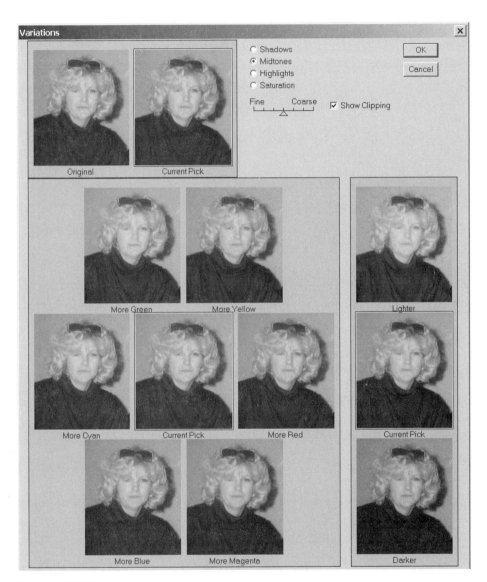

FIGURE 7.19 Sometimes, the easiest way to correct colors is to compare a set of images and choose the best-looking version.

In the upper left corner, you'll find thumbnail images of your original image paired with a preview with the changes you've made applied. As you apply corrections, the Current Pick thumbnail will change. Immediately underneath is another panel with the current pick surrounded by six different versions, each biased towards a different color: green,

yellow, red, magenta, blue, and cyan. These show what your current pick would look like with that type of correction added. You can click on any of them to apply that correction to the current pick. To the right of this ring around is a panel with three sample images: the current pick in the center with a lighter version above and a darker version below.

Fix Those Defects!

You never really believe a picture is worth a thousand words until somebody starts critiquing one of your beloved pictures. Then the words really seem to flow! Your problems may involve dust spots on a scanned image, defects in your original subject (such as skin blemishes or bags under the eyes), or simply something that appears in a photo that you wish wasn't there. The goal of simple retouching is often to remove these defects from a photograph. Image editors include a variety of tools that help you polish up your pixels.

Rubber Stamp/Clone Tools

The Clone tool, usually represented by a Rubber Stamp icon, duplicates part of an image, pixel by pixel, in a location of your choice. The stamp analogy isn't very good, however, since you're actually drawing with a brush which you can size and control in other ways allowed by your image editor (e.g., transparency of the image laid down, or some other behavior).

Cloning can be used to copy portions of an image to another location in the same or a different image. If your desert scene is too sparse for you, a single cactus can be multiplied several times or even copied from a different desert altogether. You may add a window to the side of a building by "painting" one from another building using the clone tool. Figure 7.20 shows a tree from a picture taken alongside the Erie Canal cloned into the front lawn of an elementary school that had only barren, leafless trees.

FIGURE 7.20 A tree from the Erie Canal has been cloned into the front yard of this school, copied right over the barren tree that originally appeared there.

Some image editors clone portions of an image as they were when you start the process: if you start to copy an area that has been modified by cloning, you'll apply the original pixels, not the changed ones. That helps avoid repeating patterns that result when you clone a clone. If your program doesn't operate in this way, create a duplicate of your original image and clone from that to avoid the problem.

If you're simply retouching a photo with no intent to add or subtract anything other than the defects, the clone tool is useful for copying portions of an image over the parts you want to replace. Or, you can combine several images to create visions you might not encounter in nature.

Dodging/Burning—Lightening/Darkening Tools

When color or black-and-white prints are made by exposing photosensitive paper under an enlarger, the darkroom worker can modify how the image appears. That's done by giving extra exposure to some areas of the print (burning), and holding back other areas so they don't receive as long of an exposure (dodging).

Dodging and burning tools are simply brushes you use to make the areas you "paint" over lighter or darker. You can use dodging to lighten some shadows under and above the eyes of a subject, or burning to darken a highlight that is too light. These tools are a good choice for selectively brightening and darkening only parts of an image, rather than the entire photo. To create the image at right in Figure 7.21, I used dodging, burning, and cloning, as well as blur/sharpen and orientation (rotation) tools.

FIGURE 7.21 Dodging/burning, cloning, and a bit of blurring and sharpening transformed the image at the left to the one at the right.

Blur/Sharpen Tools

Image editors have plug-ins called filters that process all of an image, or just a selection, to provide a particular special effect, such as blurring or sharpening. Most also have special brush tools that can apply blurring or sharpening effects to a section of your image as you "paint."

Sharpening isn't difficult to understand. Blurry is bad, so sharper must be good, right? Not necessarily. You should use sharpen tools carefully to avoid making your image look too sharp. When an image or portion has been sharpened too much, the defects in the picture become more readily apparent whether those defects are dust spots or scratches on a scanned print, or the pixels themselves in a digital photograph.

And blurring isn't always bad. In fact, selective blurring of unimportant areas of your image can make the rest of the picture look sharper in comparison. Blurring is also valuable for minimizing defects (including those dust spots or scratches). Figure 7.22 shows an image that has been made to look sharper by blurring the background!

FIGURE 7.22 A blurry background makes the foreground look even sharper.

Remember that sharpening increases the contrast of your photo, while blurring decreases contrast. If your image is low in contrast, experiment with applying sharpening first, then adjusting brightness/ contrast of your sharpened image. Reverse the order of the steps and you may end up with an image that is too contrasty for your taste.

Buildings and other heavily textured objects that contain many fine details can benefit from overall sharpening. Structures and other subjects with lots of details can withstand a great deal of sharpening without looking "processed."

People and faces often look better with only the edges enhanced. With most portraits, the outlines of eyes and other features should

look sharp, but you don't want every flaw in the skin to be accentuated. Also, try using blurring to smoothly blend a selection you've pasted down into an image.

If you're working from a scanned image, you may need your image editor's dust/scratches filter, which selectively blurs areas of your image that contain dust spots, scratches, and other defects. When the filter is applied, the image editor typically examines each pixel in the image, moving outward radially to look for abrupt transitions in tone that might indicate a dust spot on the image. If a spot is found, the area is blurred to minimize the appearance of the defect.

Image Sizing Tools

Image editors let you resize an entire digital image, or rescale portions of the image while leaving the rest of the picture untouched. Go ahead, make that soccer ball huge. Enlarge that tree in your front yard to see what it will look like in 15 years. Make your company's products larger in comparison to your competitors'.

Image scaling tools can be used to resize a picture or object proportionately (that is, the same amount in all directions) or in only one direction. I've used sizing to make myself look taller and thinner, to stretch out a wall, or make a patch of sky I was pasting into an image wider to fill a larger area.

Combine Those Images!

You can combine portions of two or more images, or move one part of an image somewhere else within the same image, using what are called compositing tools. The term tools applies to a broad array of image editing features that let you remove parts of pictures and paste them down elsewhere in the same photo, or in an entirely new image.

You can make photocompositions using the cloning tools described earlier. You'll also need to use selection tools, which let you zero in on a specific part of an image, extract it, and combine it seamlessly with another image.

Once you've mastered your image editor's tools, you can create photo restorations, like the one shown in Figure 7.23. If you're using a scanner to digitize old pictures, you'll find that photos 20 to 150 years old may have been damaged by the ravages of time, and you'll need to remove scratches, replace missing sections of the photo, and perhaps reconstruct facial features from the fragments that remain.

FIGURE 7.23 Copying the "good" corner from the upper right of the original photo and flipping it to cover a tear on the opposite side was the first change made to transform this damaged photo into one suitable for framing.

Or, you can fix snapshots with major digressions from desired content. That is, there's a tree growing from someone's head, an unwanted bystander gawking at the main subject, or other pictorial clutter. Perhaps the defect is as simple as a family member who posed in the middle of a picture, blocking a beautiful landscape, rather than off to one side, as shown in Figure 7.24.

FIGURE 7.24 Image compositing techniques can relocate objects or people to a more suitable position.

Other times, you may be working with an old photo of a subject wearing glasses, but who has switched to contacts years ago. An unfortunate accident of lighting accentuated slightly protuberant ears, transforming them from an interesting characteristic to features that would make Dumbo blush. Bad shadows have given someone a double chin. They don't really look like this photo—you can improve the picture using image editing.

Add Special Effects!

As you saw earlier in this chapter, special effects can create some interesting looks. Using these effects, image editors can transform a dull image into an Old Masters painting with delicate brush-strokes, or create

stunning, garish color variations in a mundane photograph. This chapter introduces you to the magic you can perform with these features.

Whether you want to blast apart your images into a cascade of sparkling pixels, or simply add some subtle sharpness or contrast to dull or blurred areas, image editors' special effects modules called filters have the power to effect a complete make-over on all or parts of a digital photo or scanned image. You can also use these add-ons to produce undetectable changes that make a good image even better.

Filters are actually miniature programs in their own right, designed to manipulate the pixels of your image. For example, the Invert filter found in all image editors looks at each pixel in turn and simply "flips" it to the exact opposite value. A pure white or light gray pixel will be changed to pure black or dark gray, and the color value of the pixel will be changed to the opposite color (a dark blue pixel will become light yellow, and so forth).

Other filters may remove pixels entirely, or shift them around in an image in relation to others that remain in place. The mini-programs that make up filters can be very simple, and require no user input, or may be extremely complex and bristle with dialog boxes, slider controls, buttons, and preview windows.

Filters fall into several different categories. They can enhance your image to improve its appearance without making drastic changes in its content. Sharpen and blurring filters are examples of this type. You can apply them to an entire image, or just to a portion that you've selected.

Other special effects filters act like a piece of frosted glass, translucent canvas, or other substance placed between the image and your eye, superimposing the texture or surface of the object on your picture. These add a texture or distort your image in predictable ways.

Distortion filters move pixels around in your image, distorting the photo as they create pinches, whirlpools, ripples, or twirling effects. Pixelation filters add texture, but take into account the color and other characteristics of your image, providing a painterly effect. Such filters don't simply overlay a particular texture—the appearance of each altered pixel incorporates the underlying image. Figure 7.25 shows the

same image processed with a pixelation filter on the left and a soft diffusion filter on the right.

FIGURE 7.25 Filters can add texture (left) or a soft diffuse glow (right).

Still other filters create "something from nothing," such as the clouds, starburst, or lens flare filters found in many image editors. Special effects filters can also hunt down the edges of objects in your photos to create glowing edges, poster effects, and other transformations, as you can see in Figure 7.26.

FIGURE 7.26 Accentuating the edges of objects in a photo produces an interesting special effect.

Using filters within an image editor is easy. The filter itself does most of the work for you! All you need to do is choose the portion of the image that the filter will be applied to, using your image editor's selection tools. (If you don't select a portion of an image, the filter will be applied to the entire image.) Then, choose your filter from your image editor's filter menu. Some filters, called single step filters, operate immediately with no additional input required from you. Many sharpening and blurring filters are of this type. Other filters pop up a dialog box with controls you'll need to set. This kind of filter usually provides a preview window that shows you what your image will look like when the filter is applied. When you're happy with the preview, click the OK or Apply button to add your special effect. If you don't like the results, use the image editor's Undo feature to cancel the effect.

Image editing is worth a whole book (and there are lots of them to choose from!), but this chapter should provide you with the background you need to get started.

8

Sharing Your Digital Photos

In this chapter...

✔ **Sharing Offline**

✔ **Sharing Online**

✔ **Creating Your Own Web Pages**

✔ **Viewing Photos on Your TV**

Banish that shoebox! One of the best things about digital photography is that your photos needn't be relegated to shoeboxes shoved under the bed, or tucked away in albums that will never be viewed. In times past, one of the favorite forms of torture was to place slides in trays where they were then used to mentally bludgeon friends, neighbors, and family into dreamland before the eager photographer even had a chance to set up a projector and screen to show vacation pictures.

Digital still photography can be shared in dozens of ways, from personal Web sites to screen savers to emailed messages or greeting cards. You can even create the computer equivalent of a slide show if you like, complete with PowerPoint-generated bullet points. And, unlike prints, your digital copies cost you virtually nothing. So, you can share your photos as widely as you want (or dare), at little cost other than the time you spent compiling your collections.

This chapter will show you some of the cool ways to share your digital photos (or conventional photos that you've scanned), using easily mastered applications.

Sharing Offline

You don't need an Internet connection to distribute your photos to everyone who wants to view them. There are plenty of offline options that let you get your pictures circulating. These include digital photo albums, which provide a selection of photos on each page; slide shows, which show single images one at a time; and screen savers, which kick in when your computer is inactive.

Photo Albums

Digital photo albums are useful for organizing as well as displaying your digital images on your computer. Although they exist primarily on your computer, you can collect all the pictures you take of certain types, such as vacation pictures, wedding photos, hobby pictures, family portraits, or snapshots you take at work, into separate albums of their own. Perhaps you need a special album of personal belongings for your insurance records. Or, you're a real estate agent or investor who wants

to store pictures of listings or property portfolios. Maybe you want to keep digital pictures of your artwork, create a record of your business's inventory, or produce a product catalog. Digital photo albums can do all these things.

When it comes time to share your photos, you can go through the albums you've organized, and create separate photo albums with only the pictures you elect to share. When you're working digitally, there's no need to go to the expense of making extra prints. Your original files can reside in several different albums. You only need make copies when you choose to distribute the images beyond your own computer, and at that point the copies are very inexpensive to make.

Digital photo albums have another advantage over the conventional kind. You can optionally associate keywords of your choice with any or all of the pictures in your albums, then use those keywords to retrieve the pictures later on. For example, your album of photos from your vacation trip to Spain could include keywords like Cordoba, Segovia, Madrid, Avila, Alicante, Cuenca, Granada, Toledo, or Cuidad Rodrigo, enabling you to locate all the pictures taken in or near a particular city or province with a few clicks. Or, you might add other keywords, such as 2004, flamenco, El Greco, castle, cathedral, fiesta, or Lladró, and swiftly locate the photos associated with those words. If you are diligent and have a lot of photographs, you can use multiple keywords to perform search magic like locating all the photographs of flamenco dancers you took in 2004 in Madrid.

Album applications all operate in a similar way. They store thumbnail images of each picture stored in your collection, organized by separate albums. You can add keywords when the pictures are stored, or at any later time. The thumbnails can be searched and sorted by a variety of parameters, such as file name, file type, keywords, date, size, and so forth. Click or double-click a thumbnail, and the album will show you an enlarged version of the picture. Click and Ctrl-click on a series of thumbnails, and you can do things like copy them to another location, send them to your printer, or burn them to a CD-ROM.

Those capabilities are all built into HP Image Zone (and Image Zone Plus) photo and imaging software, which is included with all HP

Photosmart products, including the latest Photosmart digital cameras, printers, HP Pavilion and HP Media Center computers, and some HP notebook computers. Image Zone software lets you browse through entire photo collections, organize and retrieve photos by the date they were created or modified, locate them by keyword or geographic location, and back up pictures to CD. The CDs can be used for archiving, or can include slide shows, greeting cards, and integrated video clips and music. One cool feature is a "digital negative" storage feature that keeps multiple versions of images, so you can recover copies of deleted or edited photos. Image Zone software is shown in Figure 8.1.

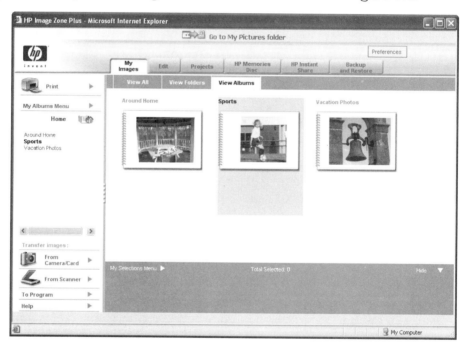

FIGURE 8.1 HP Image Zone lets you create albums like these.

You can also create and work with albums using the HP Album Printing application, and PhotoImpression, both furnished with some HP computers. These applications are shown in Figures 8.2 and 8.3.

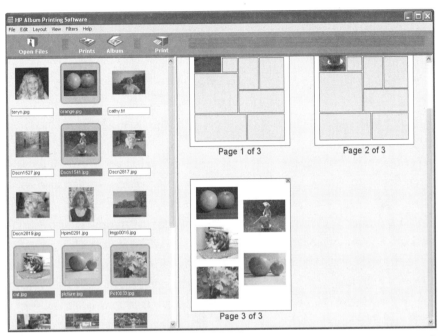

FIGURE 8.2 HP's Album Printing application lets you create albums and make prints from the images in them.

FIGURE 8.3 PhotoImpression includes its own album features.

Slide Shows

Image-based slide shows are similar to the familiar 35mm slide show, or the more recent PowerPoint presentation, only more lively. You can create these with nothing more than images, or add text, slide transition effects (such as fade-out/fade-in or dissolve), and audio comment or music. Slide shows can be simple, or full-fledged multimedia extravaganzas.

Slide shows are an excellent tool when you want the viewer to see your images in a certain order. It's easy to jump around in an album, but a slide show is presented start to finish, with some options for skipping a slide, backtracking to review a slide, or lingering longer than the programmed time over an image you want to study. Perhaps your images will be more dramatic when reviewed in the order you took them, or maybe you want to surprise the viewer with a special picture at the end. Or, maybe your slide show is designed to communicate a message, such as at a trade show. You can set up your show using a computer at the trade show booth, and let it run unattended, if you wish.

Screen Savers

Although modern computer displays don't really need saving, screen savers still are popular as a way to show an image on your screen when your computer is idle, and to protect your work from prying eyes. PhotoImpression can create screen savers for you. To activate your new screen saver, right click on the desktop and choose Properties. Then click the Screen Saver tab on the Display Properties dialog box (shown in Figure 8.4) that appears. Locate the PhotoImpression screen saver you want to use from the Screen Saver drop-down list, and activate it.

FIGURE 8.4 You can assemble your favorite pictures into a screen saver slide show.

Greeting Cards

You'll find lots of applications, including the greeting card software included with new HP computers, that let you create greetings and postcards you can print out and mail or send electronically. These make a great, personalized card with your own message and a photograph that's far more personalized than the "canned" images found on commercial cards. The Image Zone greeting card maker is shown in Figure 8.5.

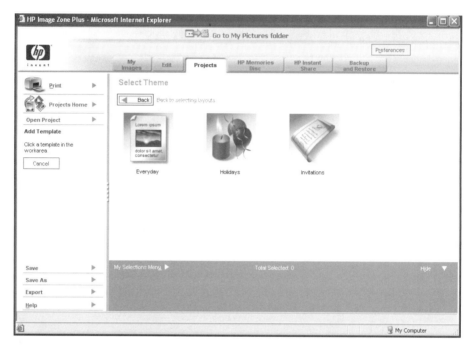

FIGURE 8.5 Image Zone lets you create your own greeting cards.

Sharing Online

Of course, sharing your images offline means that you must physically transport them to your viewers, usually on a CD or DVD. That can work fairly well, because it costs less than a dollar to make and mail a CD anywhere in the country. However, this method can be fairly slow. It can take a week to send a CD from one place to another if the mails are running slowly. Who wants to pay extra for express delivery, anyway?

Online sharing is much faster, verging on instant. You can take a picture now, connect your camera to your computer, and have a friend on the other side of the country looking at it a minute later, assuming you've set things up in advance, have a fast Internet connection, and you don't click the wrong buttons! Even better, you have a wide range of options for sharing on the Internet. You don't need to know your recipient's email address. Multiple recipients can view the same photos

simultaneously, and not all of them even need to own a computer. (They can drop by a friend's house, visit a cybercafe, or their library for Internet access.)

Your choices include the following. I'll discuss each of them in more detail later in this chapter.

Email. You can send pictures to anyone with an email box as an attachment that he or she can download and view.

Public Web pages. Post your images on a free or low-cost commercial Web page and anyone who knows the Web address can view them.

Personal Web pages. You can set up your own Web pages inexpensively and have even greater control over who views your photographs.

Size Matters

One difference between sharing online and sharing offline is that the size of the images you share online is very important. You might mail a friend a CD-ROM containing a couple of hundred high-resolution digital camera images, but sending those same images over the Internet using a high-speed connection might take an hour, or might take days if your friend is using a dial-up connection. A 3-megapixel image might even be larger than your recipient's mailbox allows; it's common for email providers to limit incoming mail attachments to a few megabytes—total. So, your goal in sending pictures over the Internet should be to make them as small as possible or, at the very least, no larger than they need to be. Fortunately, the means to accomplish this are well within reach.

Make the image size smaller. If you can reduce a 2608 x 1952-pixel image (5 megabytes) down to 1296 x 976 pixels (1 megabyte), you've saved 80 percent of the bandwidth or Internet resources that would have been required. You can resize photos within your image editor.

Compress the image more. You learned about JPEG compression in Chapters 5 and 7, and know that both digital cameras and image editors can squeeze pictures dramatically, at the cost of some image quality. An image that occupies 3.5 megabytes with the maximum JPEG

quality setting can be compressed down to 250 kilobytes or less at the "low quality" setting, a reduction of 14X.

Combine several images. Merge them into one archive using a utility like WinZip, and send a bunch of pictures in one chunk. You'll save a bit of bandwidth, and your recipient can avoid downloading your photos one at a time.

Don't email them at all. Instead, post your images on a Web site and send an email containing the address of the images. Your recipients can visit the Web page and view the images at their leisure.

Sending Photos in Email

Email is by far the easiest way to distribute your photos. You can send the pictures as an attachment to your emails, send a message with a link to a Web page where the image is posted, or embed the image right in the email using the HTML (Web-page) features of most newer email applications.

Sending attachments is painless if your photos are small enough to transmit over your Internet connection quickly and downloaded by your recipient in a timely manner. Your email application, whether it's Outlook, Outlook Express, Eudora, AOL, or one of the mail clients associated with browsers like Mozilla, probably has an Insert File choice that you can use to select the picture to be transmitted. Your recipient receives your message and the attachment, and can view the image in his or her favorite image viewing program.

There are a few drawbacks to this method, of course. As I mentioned earlier, some email services limit the size of attachments, so if you're sending a lot of photographs in a ZIP file your attachment might get blocked, or the recipient's mailbox might be full. Worse, some services or even individual users may block all attachments because they are fearful of receiving a virus.

Sending HTML Messages

You've probably received spam that looks like a Web page. You can do the same thing, sending your friends emails that have formatted text, graphics, colors, links, and backgrounds. While not as simple as just attaching your photos, this method offers a lot more flexibility and the opportunity for creativity. Of course, you'll need an application to create pages with embedded photos and other content, but your current email client can probably handle it, or you can use Microsoft Word.

Use Word's features to format a page, using any fonts you like. Insert photos (Insert>Picture>From File), and when you're satisfied, use File>Save As Web Page. When you're ready to mail the page, select the file using Windows Explorer or from Word's File>Open dialog box by right clicking it, and choose Send To>Mail Recipient. Your recipient must have an email program capable of reading HTML-formatted mail, but most can.

Figure 8.6 shows an email message formatted with HTML in Outlook Express. You can use Outlook Express's Format menu to center the picture or text, add text, or perform other customization. When the email arrives at its destination, if the recipient is using a preview pane, the mail will look like Figure 8.7.

FIGURE 8.6 *Compose your own HTML emails with embedded pictures using an email client like Outlook Express.*

This option lets you lay out your messages just the way you want, presenting your images exactly as you intend. It's like being able to email a page from your Web site directly to a recipient. Of course, all the cautions about attachments and file sizes that apply to regular email apply as well to this option.

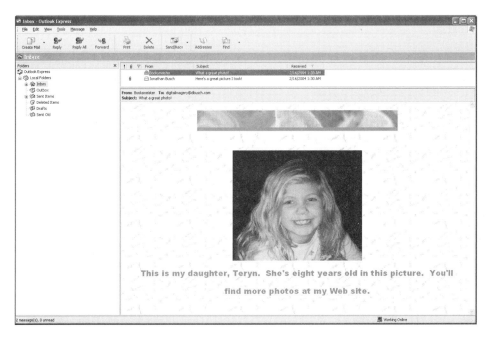

FIGURE 8.7 When your email arrives, the photo will look like this in the preview pane.

Sending Photos as a Web Link

You can also share photos by sending an email message with a Web link (called a URL) to an address where the pictures can be viewed. The recipient can click the link and jump directly to the photo using his or her Web browser. This method neatly bypasses any problems associated with sending images that may be too large or that might be blocked. The email you send is also small and can be received quickly. There's no need for recipients to load the image into a viewing program; the Web browser displays the image for them. If they like, they can right-click the image and download it to their own computer.

This method has the added advantage of letting friends and colleagues view your images anywhere, as long as they know the Web link. (I'll show you how to share photos on a Web site later in this chapter.) They don't even need to be using their own computer. All they need is a browser and Internet connection. So, a friend who has a slow

dial-up connection and who wouldn't want you to email your photos directly can visit a library or other location with a high-speed connection and view your photos there. The pictures never "expire." As long as you leave them on your Web page, they are available for viewing. Figure 8.8 shows an email message with a hot link in it.

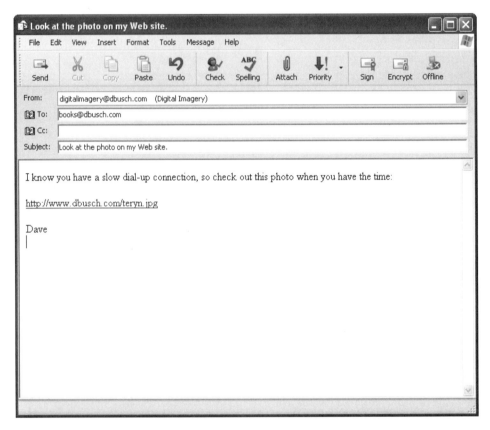

FIGURE 8.8 Send smaller email messages by including a hot link to a photo stored on your Web page.

Sending Photos as Instant Messages

While there are about half a billion letters mailed through the Post Office each day, there are roughly twice that many messages sent daily through AOL Instant Messages and similar services such as ICQ, MSN, Yahoo, and other instant messaging venues. Chat and IM appli-

cations are quickly becoming two of the most popular ways of communicating electronically. You might have a favorite service and use only that, or you might prefer an application like Trillian that lets you log onto several instant messaging services at the same time.

If you use Instant Messaging (called IMing) much, you know that this form of communication offers a lot more than quick chats. It's also being used as a business and personal information exchange tool, especially for exchanging files such as pictures. If you and your intended recipients are connected to the Internet and use a common IM client, you can exchange pictures directly with no need for email or even a Web browser. Your picture exchange can be as convenient as checking your Buddy List to see who is online at the moment, and sending your latest pictures his or her way. Figure 8.9 shows a typical picture exchange through IMing.

FIGURE 8.9 Instant Messaging is a convenient way to exchange photos.

Let the Other Guy Do It

There are lots of online services eager to accept your digital photos and provide hosting of your images, as well as prints, t-shirts, and other items produced from them. One of the best is www.hpphoto.com.

The first step is to upload your photos to the HP Web site, using a dialog box like the one shown in Figure 8.10. Once you've registered for the site and uploaded the photos, you can arrange them in albums, add keywords (as shown in Figure 8.11), create photo greeting cards, electronic post cards, order prints, email the pictures to family and friends, or make hard copies on your own printer.

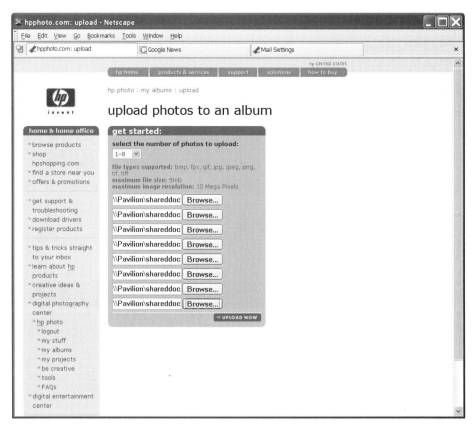

FIGURE 8.10 Upload your photos to the HP Photo Web site.

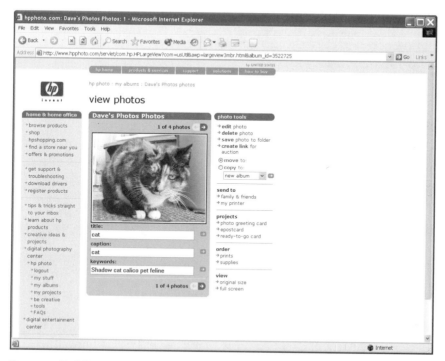

FIGURE 8.11 Then you can view them in albums, add keywords, or order prints or cards made from them.

There's lots of other good stuff at the HP Photo Web site, including tips and tricks, project ideas to work on, support and troubleshooting help, and other features. It's all free (unless you order one of the tempting products), so check it out.

Of course, HP computers include a Share to Web wizard, like the one shown in Figure 8.12, that make uploading pictures to the HP Photo Web site even easier.

FIGURE 8.12 The Share to Web wizard simplifies uploading your photos.

Hosting Your Own Web Page

Placing your photos on your own Web page is easier than you think. The first thing to do is see if your current Internet Service Provider (ISP) provides Web space as part of your package. You might need to upgrade your existing Internet service to gain this capability if it's not offered with the basic package. Quite a few ISPs offer from 2MB to 20MB or more of Web space with their basic offering. If you're using AOL, you get 2MB of space for each of your seven screen names. Your ISP may provide Web page creation tools so you don't even have to work hard to design your page. Just choose a template, upload your photos, and you're all set.

Your ISP may have restrictions on how much downloading band-width you can use. That shouldn't be a problem if you're sharing images among friends and family, but if your Web page suddenly becomes

famous, you could attract thousands of visitors and be liable for excess usage charges.

If your ISP doesn't include Web space, you can look for free or very low-cost Web hosting services. Use Google and search for "Web hosting" and you'll locate services like Lycos Angelfire (www.angelfire.com), Yahoo GeoCities (www.geocities.com), Homestead (www.homestead.com), and others.

None of these provide your own personalized Web page address with its basic package. That comes when you create your own domain name, such as dbusch.com, svideo-rca.com, futurehobo.com, and teryn.org (which are all actual domains that I purchased for my family and me). When you have your own domain, your pictures are hosted at a more prestigious URL, such as http://www.dbusch.com, or http://www.futurehobo.com.

Of course, having your own domain isn't free, but it can be surprisingly affordable. I use Affordable Host (www.affordablehost.com) and their basic $5.95 a month hosting plan. (You can pay in advance for a whole year and cut the monthly cost even lower.) For my $5.95 I have one main domain and three subdomains, which all share the same Web space and bandwidth, but which have separate domain names. In effect, I'm paying for hosting one domain and getting three others hosted on the same account for free. My only other cost is $12.95 per year for each domain name for registration renewal. If you can afford to pay for registration and can handle $5.95 a month, you can have your own domain. The hard part is finding a domain name that isn't taken.

Creating Your Own Web Pages

Most of the hosting services like Affordable Host include Web authoring tools so you can create Web pages with pictures easily and quickly. But if you want to get really fancy, you can easily learn to create your own Web pages from scratch.

There are applications you can use to author Web pages, and most of them use a What-You-See-Is-What-You-Get approach you can use without learning anything resembling "coding." However, you should have at least an inkling of what HTML is all about to work with personal Web pages most effectively.

The term HTML stands for HyperText Markup Language, which isn't a true computer language as much as it's a way of marking or "tagging" elements in a Web page to tell the browser how to display them. These tags are simple to learn. If you want to see HTML in action, visit any Web page with your browser and choose View>Source or View>Page Source (depending on whether you're using Internet Explorer or Netscape/Mozilla) to see the underlying page's HTML tags. You'll see tags like <center> or <p> (telling the browser to center the object on the page, or to insert a paragraph line break, respectively). There are other easy tags, such as (for bold), <h1> (for Headline Style 1, the largest), and so forth. Learning what these are and what they do can be helpful when you need to provide a last-minute tweak to your Web page.

The easiest way to create Web pages, though, is to use any version of Microsoft Word from Word 2000 onward, Microsoft FrontPage, or an application like Macromedia Dreamweaver. The only other skill you need to acquire is the ability to upload your finished Web pages and photos to your Web site, using a program like FTP Explorer (available for free) or another one you can easily find with a quick Google search. Your Web page creation application may have FTP facilities built in. Figure 8.13 shows FrontPage in action, while you can see the easy drag-and-drop interface of FTP Explorer in Figure 8.14.

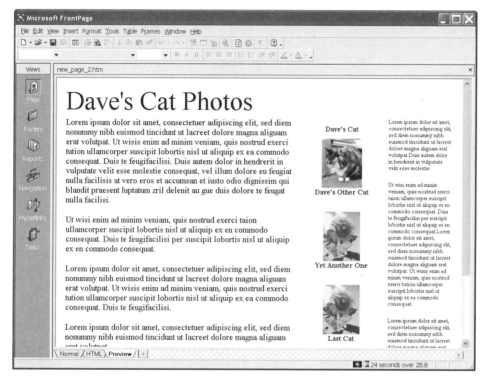

FIGURE 8.13 Microsoft FrontPage is designed for creating Web pages quickly.

Viewing Photos on Your TV

Another option for sharing your pictures is to show them on your television screen. There are lots of ways to do this. Most digital cameras have composite video out jacks and are furnished with a cable that connects directly to the AV jacks of your TV. The video jack on your TV is generally an RCA-style jack that's color-coded yellow. Just link your digital camera to the television, and use your camera's display or slide show capabilities to view the pictures one at a time. That's about as easy as it gets.

FIGURE 8.14 When your Web page is finished, upload it to your Web space using FTP Explorer or another program.

Another way to view photos on your TV is to create a video CD using a tool like the HP Memories Disk Creator, shown in Figure 8.15.

You can assemble collections of photos using the Memories Disk Creator Wizard, arrange them in the order you want, add music, specify the time for displaying each picture (as shown in Figure 8.16), then burn a CD directly from the wizard. If your DVD player can work with video CDs (most can; check your manual), this is a great way to create slide shows to view on your television.

Those looking for the ultimate in home photo viewing or audio enjoyment will want to check out the HP Digital Media Receiver and Wireless Digital Media Receiver. These gadgets attach to your television and stereo system and let you listen to music and view photos stored on your TV using a standard remote control.

FIGURE 8.15 The HP Memories Disk Creator helps you store your photos on a video CD that can be played on many DVD players.

The Digital Media Receivers use your wired or wireless network connection (the latter is 802.11b compatible—if you have wireless networking you'll know what that means) to link to media stored on your PC.

The receivers can play MP3 and WMA music files, plus JPEG, GIF, BMP, and PNG pictures. If you have a large screen TV (or, actually, any TV screen that's bigger than your monitor), this is a great way to share pictures (and music). Figure 8.17 shows the HP Digital Media Receiver.

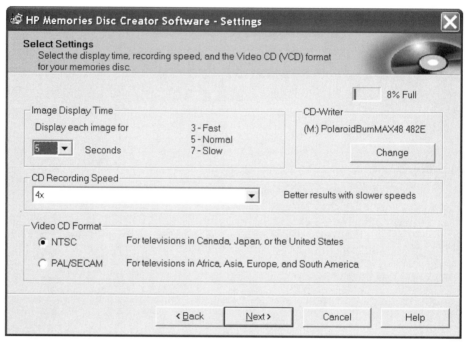

FIGURE 8.16 Choose your settings, and then burn a video CD.

FIGURE 8.17 The HP Digital Media Receiver can link photos and music on your PC to your stereo system and television, using a handy remote control device and your wired or wireless network.

9

Grabbing Images with a Scanner

In this chapter...

Got a shoebox full of great-looking prints? Interested in editing them using the techniques described in Chapter 7, or perhaps sharing them with others electronically using the tips you picked up in Chapter 8? It's easy! All you need is that handy image-grabber known as the digital scanner. Digital cameras are great, but you've probably been using a film camera for a long time, too. Scanners let you transform your shoeboxes and albums full of conventional prints and slides into images that can be edited, displayed, and shared in the same ways as your digital camera pictures.

Scanners are everywhere, and, if you're interested in digital imaging, odds are that you already own one or have been thinking about getting one. Scanners are those flat, box-like devices with a lid that look a little like a photocopier. Indeed, many personal copiers today are simply scanners mated with a printer. Or, you might have seen a scanner at your retailer's digital photo kiosk, offered as a way to capture your existing snapshots for duplication or enlarging on the spot. Maybe you've used a scanner at work, either as part of a convenience copier or for capturing images for company newsletters or other projects.

If you don't already own one, you'll be pleased to know that scanners are easier to use and more affordable than ever. Hewlett-Packard offers several models priced under $100, and even high-performance models (in case you're going to do a lot of scanning or have special needs) can be purchased for less than $300. This chapter will provide the basic information you need to acquire a scanner and start grabbing your own pictures.

What Can You Do with a Scanner?

You can use scanned images just about anywhere you would use a digital camera image: on Web pages, in publications or presentations, or shared in albums. However, there are some special applications, such as scanning documents for faxing, or translating documents into editable text, that digital cameras just aren't suitable for. Here's a quick summary of some of the most popular applications for scanning.

Presentations. Whether you're working on a computerized slide show of your family vacation or creating a presentation for your job, a scanner can transform your existing prints into digital images that can

be enhanced with bullet-point text or merged with recorded narration to create exciting presentations.

Internet. Scanners can capture pictures for display on your personal or business Web page, or be sent to friends and colleagues via email. Like digital cameras, scanners create Internet-ready images quickly and efficiently, without the need to wait for film processing and printing.

Publications. Scanners can grab pictures for your newsletter, book, poster, greeting cards, or other hard copy output. Need a copy of your company logo for a brochure? Grab a sheet of letterhead and scan away. Perhaps your company publication is going to be laid out and printed by an upscale professional printing shop? You can create "dummy" publications for review by your staff or management, complete with "roughed in" pictures you've scanned used as "for position only" previews. Even if your original will eventually be professionally scanned, your image looks better in the dummy than a gray or black box (which is how pictures are typically represented when they are not physically present).

Computerized databases. Real estate multiple listing databases, company personnel files, personal hobby collections, online family trees, and other databases all can be spiced up with scanned photographs, like those shown in Figure 9.1. You probably don't have any digital photos of your ancestors, so your scanner can come to the rescue when you want to capture old snapshots, portraits, tintypes, or what-have-you.

FIGURE 9.1 Real estate, family trees, or hobby collections can form the basis for computerized image databases.

Optical character recognition. Have a stack of documents that you don't want to retype? Scan them in and let specialized optical character recognition (OCR) software, like the ReadIRIS application furnished with many Hewlett-Packard scanners, analyze your text and convert it to word processing files. You might even be able to preserve formatting like bolding, italicizing, columns, and layout.

3D object imaging. Some scanners can capture objects like books, product packaging, Pez dispensers, coins (like the scanned image shown in Figure 9.2), or other three-dimensional objects. You don't even have to get out your digital camera. Just place the object on the scanner's bed instead and scan the object. This is a great way to capture pictures for online auctions.

FIGURE 9.2 Scanners can even capture three-dimensional objects, such as this coin.

Faxing. A fax modem, scanner, and printer give you a complete facsimile machine that works two ways, for sending and receiving. That's a great capability to have at home when you need to send a document, such as a copy of a birth certificate or that old letter from great-grandpa that you found, to a friend or relative. At work, the same tools let you bypass long lines at the departmental fax machine, while helping you keep confidential documents safe from unauthorized eyes.

Original artwork. Any scannable photograph or drawing can be further manipulated by the computer to produce a beautiful work of art.

Make copies. If you have a scanner and printer, you have your own photocopier, too! One of the most used scanner applications is to make copies at home or the office. With a low-cost color scanner and color printer, you can even make vivid color copies.

Document management. Scan those letters, memos, faxes, and other documents, and use specialized document management software to archive them, classify them with keywords, and search and retrieve an image of a particular document in seconds.

Types of Scanners

There are many types of scanners, but the variety used most by home and business users is the flatbed scanner. This type of scanner can capture images of a variety of different originals, including thick objects such as books. Hewlett-Packard even offers a special type of flatbed scanner that comes apart so you can place the scanning portion directly on the object you want to scan, as shown in Figure 9.3.

FIGURE 9.3 The HP ScanJet 4600 see-through flatbed scanner comes apart so you can place the scanning unit directly on a thick or large object, such as this 150-year-old antique map.

If your artwork is too large to fit on a flatbed, you can scan it in pieces, then reassemble it in your image editor using stitching or panorama software. With a special attachment (which sometimes must be purchased separately), flatbed scanners can grab images of transparencies or color slides, and an automatic document feeder (also an option that is sometimes sold separately) makes it possible to scan whole stacks of originals unattended. This versatility is hard to match.

Flatbed scanners look and work something like a photocopier: you lift the cover, place the original to be scanned face down on the glass, and press a physical button on the scanner or click a button in your software. Flatbeds can grab anything that is flat and can fit on the glass platen, including books, photographs, keys, watches, and similar objects. Some high-end scanners are furnished with automatic document feeders. Simply drop a stack of originals in the feeder, and let the scanner capture an image of each original, one after the other.

Other types of scanners exist, too. These include drum scanners, used for professional graphics applications such as color separation; sheetfed scanners, which feed individual documents past a fixed scanning element, one at a time (similar to the way dedicated fax machines operate); and all-in-one devices, which incorporate scanner, printer, and sometimes fax capabilities in one unit. These devices often contain their own memory, so they can be used as a copier or fax machine even when the computer is turned off. You'll also see snapshot scanners, which grab images of small prints (roughly 4 x 6 inches in size), and dedicated slide scanners, often used by professionals and photo hobbyists to capture images of 35mm or larger color transparencies and negatives.

How Scanners Work

Modern flatbed scanners all include the same basic components: a light source, optical system (including a lens, if needed), a sensor, and a mechanism for scanning down the length of the page. There are many ways to arrange these components, sometimes using the traditional flatbed layout or the innovative "book" configuration found in some of the newest Hewlett-Packard scanners.

All of them function in a similar way. They'll have a flat piece of glass on which your original is placed face down, and a lid to hold the artwork flat. Underneath the glass is a device called a carriage, which contains a light source and an optical system that gathers reflected or transmitted light and directs it to a photosensitive strip called a sensor array, as shown in Figure 9.4.

Figure 9.4 This diagram's callouts show the rough layout of the basic scanner components.

The array is a line of CCDs or CMOS elements that capture the image across the width, or short dimension, of the area being scanned. Scanners also contain memory to hold a portion of the scanned image as it is conveyed to the computer, and some computer intelligence in the form of advanced image processing circuitry that can adjust brightness/contrast, scale images to a different size, and change the resolution. Also tucked inside your scanner are electronics that convert the captured image into digital form.

The sensor arrays in scanners are sensitive only to white light. To capture color, the scanner needs three separate images of an original, each representing the relative amounts of red, green, and blue for every pixel. In this respect, scanners capture images in the same way as your digital camera. That's done by filtering the white light through red, green, and blue (R, G, and B) filters, or by using red, green, and blue light sources. The light source can be fluorescent tubes, LEDs, or some other illumination, such as the lasers found on some professional scanners.

Sensors come in several varieties: the charge coupled device (CCD) sensor and the newer contact image sensor (CIS) and complementary metal oxide sensor (CMOS) types. You can make great-looking scans with any type of sensor, as long as the sensor is of high quality. CIS scanners place the original artwork virtually in contact with the sensor (which is typically 8.5 inches wide) at a distance of a few millimeters. CCD-based scanners, on the other hand, have a folded optical path

and lens between the sensor and the artwork, and the sensor may be only 1.5 to 2.0 inches long. The optical system focuses the image onto this narrower sensor.

The primary advantage of a CIS scanner is the size of the carriage. The CIS scanning module, with LED illumination and sensors included, is very small, making it possible to design a very small, flat scanner. However, poorly designed CIS scanners suffer from a number of limitations related to depth of focus and depth of illumination (the distance from the sensor that a subject is represented sharply and illuminated evenly). The LEDs can be very dim and the focal range of the CIS sensor is short. This means that a CIS scanner, unlike a CCD scanner, may have difficulty capturing small three-dimensional objects.

Most CCD scanners, in contrast, excel at capturing 3D objects, and the better models include superb optical systems that are well-focused and free of distortion. However, because good and bad scanners are available using both types of sensors, your best bet is to test your scanner before purchasing, and/or buy from a vendor you trust for high quality.

What to Look for in a Scanner

There are many different scanners available from a large number of different vendors. In fact, before the current digital camera craze started, scanners were one of the most desired add-on accessories for a personal computer, vying only with inkjet printers for top honors. Today digital cameras are a top choice, which, if anything, has only made the scanner an even more important accessory for anyone setting up a complete digital imaging workshop, because scanners let you add conventional still pictures to your digital imagery arsenal.

Because of the plethora of models available, choosing the right scanner for you can be confusing. But you needn't be puzzled. Here's a quick checklist of the sort of things you should be considering when planning your scanner purchase.

Scanning Size

All scanners have a limit on the physical size of the original you can capture in one operation. Flatbed models can grab only documents no wider than the scanning glass itself, usually about 8.5 inches. The length of the document may be 12 to 14 inches, depending on the model. A few higher-end scanners can capture 11 x 17-inch or larger originals, but these cost significantly more. If you scan a great many legal-sized documents or a slightly larger scanning area is important to you, check out the maximum size the scanner you are contemplating can handle.

Resolution

Today, a resolution of at least 1200 samples per inch (spi), usually expressed in the slightly inaccurate but universally used measurement of dots per inch (dpi), is standard. Most scanners actually boast 2400 dpi or even higher resolution. However, these high resolutions aren't particularly practical, because they capture more detail than you need and generate files that are extremely large and unwieldy. Still, scanner purchasers usually look at the resolution or a related value called bit depth (discussed shortly) when making their buying decision.

That's unfortunate, because both resolution and bit depth (most simply, the number of different colors a scanner can capture) are not measured in standard ways. One 2400-dpi, 36-bit color scanner might produce outstanding images, while one with "better" specifications of 3600-dpi/48-bit color depth could very well produce inferior results. Superior optics and a higher quality sensor on the former scanner could easily generate better scans than the latter model with poor optics and a so-so sensor.

To muddy the waters even further, most scanners include software for predicting or interpolating the information that exists in between each scanner dot, producing a calculated resolution that's even higher than the true resolution produced optically. So, you might see a scanner listed with 3600-dpi resolution/9600-dpi interpolated resolution. Don't be fooled by the second number.

The amusing part of the fuss over resolution is that most scans require nowhere near the maximum resolution of any scanner. If you're scanning photographs, 150 dpi is probably sufficient even though you might sometimes need to scan at 300 dpi. Higher resolutions are actually useful only for small originals with lots of detail, such as postage stamps or color slides, like the transparency shown in Figure 9.5.

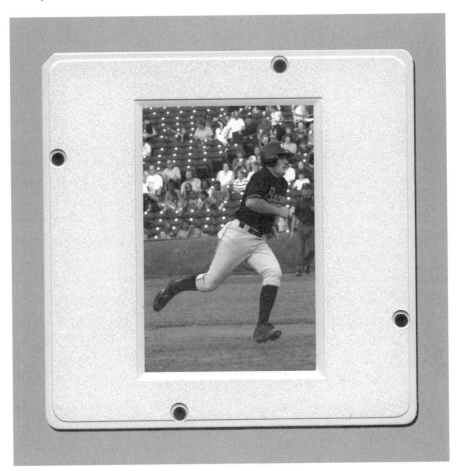

FIGURE 9.5 Originals that are small and contain lots of detail, like this 35mm color slide, do take advantage of all the resolution you can squeeze from a scanner. Some scanners have special attachments for scanning slides.

Color Depth and Dynamic Range

Color depth and dynamic range are two closely related qualities, usually expressed in the number of binary bits used to capture an image. For example, most black and white images you scan have 256 different gray tones (captured using 8 bits of information), while full color images may have 256 x 256 x 256 different red, green, and blue hues (respectively), or 16.8 million in total. Except for some advanced applications using image editors like Photoshop CS, you'll virtually never work with final images that have more than a 24-bit/16.8-million-color depth.

Yet, most scanners capture more than 24 bits of color. You'll see models that claim 30 or 36 bits of color information (referred to as dynamic range), or, more commonly, those with 48-bit ratings that can grab 65,535 different hues for each of the red, green, and blue primary colors. Why so many?

In theory, this extended dynamic range enables the scanner to capture more detail over a broader range of lightness and darkness, particularly in the inky shadows of an image, like those in Figure 9.6. So, more dynamic range should allow capturing more information that can be used to calculate the best 16.8 million colors used to represent your final image.

FIGURE 9.6 When details are lost in the shadows, as in the example at left, a scanner with a wider dynamic range can reveal the hidden information, as in the version shown at right.

In practice, however, things aren't quite so neat and prim. First, most color prints simply don't have enough detail in the shadows and highlights that an extended dynamic range is needed to capture it. Color slides are the chief kind of original that does have such detail, and most of us don't scan very many of them.

Worse, all scanners lose a bit of detail in converting the captured image information to digital form, and the amount of detail varies from scanner to scanner. No 48-bit scanner actually grabs 48 bits of useful data. One 48-bit scanner may produce only 36 bits of usable information, while another one barely generates 24 bits-worth of color. So, choosing a scanner based on dynamic range alone is as foolish as basing your decision on the myths of resolution. In both cases, you're better off testing your scanner or buying from a trusted vendor of quality products.

Physical Size

If space is tight, the size and footprint occupied on your desktop can be important. To be most useful, a scanner should be located close to your working area, so make sure you have space for the model you're contemplating. Some flatbeds are little larger than the largest area they can scan. Others, like some models from HP, can be tipped on their side so they occupy very little desk space. Find one that fits in well with your working environment.

Speed

The more scans you make, the more important the speed of the scanner becomes. If you grab an image of a 4 x 6-inch print once every day or so, it won't make much difference to you whether the scanner can capture the photo in 30 seconds or 60 seconds. However, if you're scanning dozens of pictures, or need to capture 8.5 x 11-inch documents or photos rapidly, those extra seconds can add up quickly. You might even want to consider a scanner with an automatic document feeder, so you can drop a stack of originals in the hopper and let the scanner do its thing.

Software

Look carefully at the software provided with your scanner. Some offers little more than a module to capture images. Others include clever all-in-one applications that let you scan pictures, make copies, collect scanned photos into albums, locate those photos, and make prints. Your software bundle might also include optical character recognition (OCR) like ReadIris (shown in Figure 9.7), or document management applications like PaperPort. The exact software bundle depends on the vendor and the price of the scanner you're buying. The least expensive scanners generally don't sweeten the deal with much software, while mid-level and better scanners offer more software options. However, the amount and kinds of software you get vary from vendor to vendor,

so check out the package you're receiving to make sure you're getting the software you need at a price you can afford.

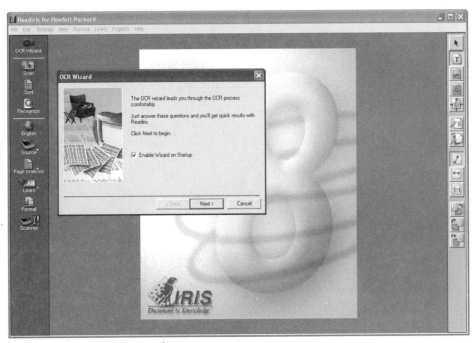

FIGURE 9.7 Optical character recognition software can convert paper documents into text you can edit on your computer.

The software provided with scanners today, coupled with one-touch scanning by pressing a selection of buttons on the scanner itself, and the easier, more automated interfaces available have really changed the way scanning works. Sometimes you don't even need to use an image editor.

Choosing a Scanner Category

You may want to choose from among entry-level, midlevel, or advanced/high-performance scanners, depending on how much scanning you're doing and the features you need.

Entry-level scanners, like the one shown in Figure 9.8, are an excellent choice for those who are new to scanning and don't know yet

exactly how much scanning they'll be doing. Don't be surprised if after you've used a scanner for a short time, you'll come up with dozens of new things to do with it that you didn't even think of before. It's not unheard of for an enthusiastic user to "outgrow" a scanner. Low-cost units provide a risk-free introduction to scanning and are very easy to use. After you've gained some experience, you may want to upgrade to a more advanced model, passing your original scanner along to the kids or keeping it as a backup.

FIGURE 9.8 This is an easy-to-use entry-level scanner.

These scanners will be compact in size, have a resolution of 1200 to 2400 dpi, and include a reasonable collection of software.

Midrange scanners are an excellent option for anyone looking for additional features and more flexibility for just a little more money. A more advanced user will be someone who's creating Web graphics, perhaps grabbing some images for online auctions, converting photographic prints to digital files, or doing a lot of optical character recognition. These scanners will sometimes be faster, have more one-touch buttons for more tasks, and may include options for making color and black and white copies in quantities using controls on the scanner itself.

Midrange scanners, like the one shown in Figure 9.9, can also include those suitable for business, especially if they have a generous selection of utilities required to scan, copy, attach images to email, and send faxes. If you work with a scanner all day long for a variety of functions, these scanners will help you work faster and accomplish more, yet are easy to use. Some of these may have an optional transparency adapter so you can scan slides.

FIGURE 9.9 Mid-range scanners have more features and higher performance.

At the top end you'll find high-performance scanners that have extra speed, extra quality, and perhaps more manual control over important functions. You can pay $1000 or more for these scanners, but they are worth it for those who have professional scanning needs. Some can be accessed over a local area network (LAN) so that anyone on your home or office network can use the scanner. The example shown in Figure 9.10 has an automatic document feeder and can scan 8.5 x 14-inch documents.

FIGURE 9.10 High-performance scanners can handle any imaginable task.

Hardware Requirements

One of the reasons why scanners have become so popular in recent years is that you don't need a special hardware setup to work with a scanner. Any computer that meets the requirements described in Chapter 1 is more than capable of driving a scanner. If you have enough memory, graphics capabilities, and a fast enough microprocessor for digital photography or movie-making, you're all set for scanning, too.

The only real "must have" hardware requirement is a USB connection, as virtually all scanners today use Universal Serial Bus to link the scanner to your computer. A high-speed USB 2.0 connection is preferred, because modern scanners are fast enough that the speedier USB 2.0 connection is needed to keep up with the data transfer to

your computer. Some scanners have a FireWire connection (discussed in previous chapters) as an optional connect. A few high-end scanners may also have a connection called SCSI, but if you need a SCSI link you'll know it, so I won't go into that option in more detail.

Multiple USB devices need to be connected through a device called a hub. The hub links to one USB port and supplies two to four (or more) new USB ports for additional devices. Hubs are inexpensive (around $50) and some devices have built-in hubs, making it possible to plug in other units in a daisy-chain-like fashion. One note: if you are buying a hub you may want to consider buying a "powered" hub. A powered hub has a power supply connected and provides power to downstream USB devices. If you have a non-powered hub, you may find that some devices plugged into it do not work because the computer is unable to supply enough power for all the devices connected through the USB cable.

Setting Up Your Scanner

Setting up your scanner is a virtual no-brainer. Hewlett-Packard furnishes a set-up poster you can use for reference, and also includes a multi-media "how to" tutorial, shown in Figure 9.11, that demonstrates exactly how to connect your scanner to your computer. The main consideration may be whether to install the software first (which is the case with most HP scanners) or whether to plug in the scanner first and then install the software. With a USB scanner, installation is usually a matter of installing the software, connecting the power supply, and plugging the scanner into a USB port. It's that simple!

FIGURE 9.11 Easy-to-follow tutorials help you set up your scanner quickly.

Here are some other things to keep in mind.

Put your scanner close at hand. Whether you're at home or in the office, you'll want to have your scanner located close to your desktop so you can insert new documents or photos and retrieve them quickly when the scan is done. So, you'll want to put your scanner within arm's reach, even if you have to move other equipment to do so. Can't your computer's system unit reside on the floor? How about moving your printer slightly? If you're willing to stretch a little to retrieve hard copies from your printer, you can make room on your desk for a compact scanner.

Watch out for vibration. Lightweight scanners are potentially more subject to blurriness caused by vibration during a scan, because they can be easily jostled by heavy-handed (or -footed) folks in the vicinity. So, don't put your scanner on top of your computer, because the fan and CD/DVD drive can cause vibration. Avoid a placement too near a

printer if you're likely to be printing during a scan. In the worst case, you might be located near a train or subway line that shakes things up a bit. You might want to consider a soft bed of foam rubber to dampen the vibration.

Avoid environmental extremes. Don't put a scanner directly in front of an air conditioner, humidifier, or heat source. Your scanner is rugged, but let's not push things.

Don't let your scanner get zapped. It's a good idea to plug your scanner into a surge-protected power source so it doesn't act as a fuse the next time lightning strikes.

Use a scanner's carriage lock when moving. If your scanner has a carriage lock to fix the moving parts in place when you relocate the scanner, use it. Lightweight scanners with a USB connection can easily be unplugged and transported to another computer, but you don't want to damage your unit's fragile moving parts. Usually a carriage lock is activated by turning off the scanner and flipping a switch to lock the carriage in place.

Getting Great Scans

Once your scanner has been set up and tested, the next step is to begin scanning. Here are some tips for getting the best possible scans.

First, start with the best possible original image. If you have a choice, choose the one that shows the least wear and fading. A 5 x 7-inch print usually has more detail than a 4 x 6-inch print. If scanning for OCR, use the original document rather than a photocopy (unless the original document, such as a fax, is somewhat faded or light and the photocopy can be made darker and crisper). Don't worry about originals that have a few dust spots or that are slightly blurry. Clean them as well as you can, and then fix the remaining defects in your image editor, or sharpen them by using the scanner's sharpening feature.

Next, preview your scan and select the area to be captured, as shown in Figure 9.12. If you don't need the entire picture or document, select only the portion you do need. The smaller file size will be easier

to handle. Many scanner applications will select the area to be scanned for you, or you can drag a selection with the mouse to manually specify the target.

FIGURE 9.12 Select the area to be captured.

Most of the time, you can just click the OK or Scan button (depending on the software) and let 'er rip. However, there are some manual adjustments you can make when you have some special needs. These include resolution and image type, such as black-and-white

drawing, grayscale photo, color drawing, or color photograph. Your scanner's software will use the image type information to adjust things like brightness and contrast. For example, a black-and-white drawing would call for higher contrast than a grayscale photograph.

If you like, you can add sharpening, which will help fix fuzzy photos by increasing the contrast between pixels at the boundaries between image areas. In-scanner sharpening doesn't work miracles; if your photo is terribly blurry, you may not be able to salvage it. Also remember that sharpening tends to emphasize dust and scratches while increasing the overall contrast of the image. It's easy to end up with a photo that's been oversharpened, like the one at the right in Figure 9.13.

FIGURE 9.13 A little sharpening (left) makes a photo look good, but too much (right) can ruin the picture.

You probably won't need to choose a resolution, but if you do, a few rules-of-thumb might come in handy. If you're scanning text and line drawings, set the resolution for the dpi of the printer, usually about 600 dpi. To scan a photograph, a resolution of 100 to 200 dpi should be plenty. If you happen to be scanning a transparency or negative, choose the highest optical (non-interpolated) resolution available from your scanner.

Your scanner will probably gauge the color of your image and capture the best color automatically. You can always fine-tune color in your image editor. However, some midrange and performance scanners include software that lets you adjust color balance and color saturation before the scan. As you gain experience in what constitutes "good" color, this option may prove useful.

That's most of what you need to know. When you're finished scanning a set of pictures, your scanner's software may automatically deposit them into a photo album for you, like the application shown in Figure 9.14. As you've learned from this chapter, scanning is an easy way to acquire digital images. No digital imagery workshop is complete without one.

FIGURE 9.14 The final destination of your scans may be an album application like this one.

chapter

10

Printing Your Digital Images

In this chapter...

✓ Why Prints?

✓ Sizing Up Your Options

✓ Choosing Printer Features

✓ Printing Your Digital Pictures

✓ Getting the Best Prints

Film may be on its way out, but prints will be with us forever. You may enjoy creating digital albums, putting your pictures on Web pages, or viewing images on your television (as described in Chapter 8), but nothing replaces a sparkling color print when it comes time to display a prized image on your refrigerator door or pin up a photo of your kid's soccer team on the wall of your cubicle at work. Don't forget the allure of making prints for framing and hanging for display in your home.

ndeed, as much fun as it is to zip pictures around the country in email or view photos up close and personal on your computer monitor, you're more likely to want a stack of photos to pass among friends and family to leaf through at their leisure. You also will love the idea of sending prints to distant relatives for them to admire, or making framed pictures to set on top of the mantel. We're as likely to see printless photography as we are a paperless office. Just as computer technology has actually increased the amount of paper generated by making the printing of flawless, edited documents easy, digital imaging has boosted the value of making hardcopies of photos while simplifying the process.

This chapter should get you excited—again—about making prints of your digital images, with some up-to-date information on the latest applications and the technology that makes them happen.

Why Prints?

The reason why consumers are abandoning film while still cherishing prints is simple. Film is, in many respects, an intermediate step; a necessary evil. What we really prize are the final images, whether they are viewed on the computer screen or distributed as hard copy prints. How the images arrived at their destinations isn't important. Now that it's simple, and less expensive, to produce high-quality images from digital cameras, we really don't care that our prints are made from bits stored on computer media rather than film.

For most purposes, digitally-originated prints have many overpowering advantages, most of them associated with making the prints yourself. I'm going to show you a few of the top reasons, just in case you haven't considered springing for your own printer.

Speed

It's natural to want to see the results of your photography immediately. That's why "instant-developing" cameras were so popular in years past, and why the LCD viewing screen on the back of digital cameras is used so often to view snapped pictures. It's good to be able to review your photos to make sure you've got what you wanted before moving on (which is why professional photographers continued to use instant cameras long after their appeal faded for consumers). However, the most compelling reason for fast access to pictures is simply that our curiosity won't allow us to wait to see our pictures if there is an alternative.

One-hour photo labs were created so you could drop off film and receive finished prints before you'd finished shopping. (Secondarily, minilabs were developed so you'd hang around the retailer longer, doing your shopping. That's why you find the labs in drug stores, supermarkets, and other retailers rather than in standalone storefronts, which were common when minilabs were first introduced.)

Digital photography goes the minilab one better. You don't have to wait an hour. You don't even have to wait a minute. If you own a photo-quality inkjet printer, you can make prints of your photos within seconds of taking the picture. You don't even need to use a computer, as many printers from HP and others let you remove the memory card from your computer, insert the card in the printer, and make prints directly. For example, the HP Photosmart 240 compact photo printer series, shown in Figure 10.1, includes an 1.8-inch image LCD and memory card slots so you can preview your pictures, select images to print, and make photos immediately. It can print 4 x 6-inch borderless pictures in less than 90 seconds. This printer is so small you can insert it in its case with an optional car-adapter and take it with you to print on the road. Or, use a USB cable to download your pictures to your laptop, edit and enhance them, and make prints even when you're not at home or in the office.

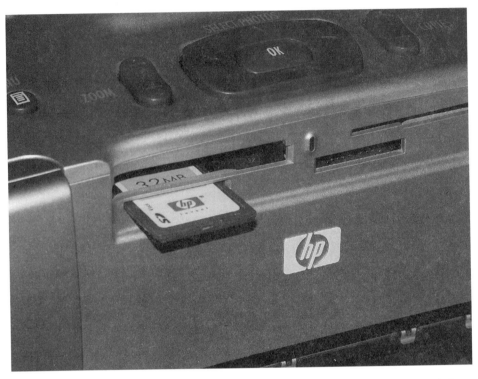

FIGURE 10.1 Slots built into this portable printer can accept memory cards from your digital camera.

Control

"We're trained professionals. Don't try this at home!" That's a warning that might apply to death-defying motorcycle stunts, but not to digital printing. You don't need to be a professional to get good prints from your digital images; in fact, much of the time you can probably do a better job yourself than the folks at your photo lab.

That's because you don't have to depend on the printing machine at the lab to optimize your photos. If you want your photo to be a little darker or a little lighter, you can make that change in your image editor before creating a print. Want to crop a photo just so? You don't need to mark up a print for the photo lab to use as a guideline. You can trim your picture exactly the way you want it.

You can make your prints warmer or cooler, print them on a special textured paper on the spur of the moment, or make a print that can be trimmed to the exact 5 x 10-inch size, as shown in Figure 10.2, needed for that panorama you've been thinking about.

FIGURE 10.2 Custom print sizes, like this 5 x 10-inch print, are a snap when you print your own pictures.

If you make your own prints, you have total control over how the print is customized to fit your vision and needs.

Economy

It's hard to beat those prints from the drugstore at 25 to 50 cents each. But did you really need a print of every single picture you shot? When you took pictures on film, you were pretty much stuck with getting one print (or double prints) from everything on the roll, and the costs could mount quickly. With a digital camera, you can use your own printer to print out only the pictures you really want. If you shot 40 photos and only want one, that's all you pay for. The digital film can be erased and reused, and you pay only for the prints you actually make.

After all, most of your shots are never intended for hard copies that you can pass around and show to friends. You may take a picture for a Web page, drop a picture into your PowerPoint presentation, or place an image in a desktop publication without the need for a print. So why pay for them?

Of course, it should be obvious that these burgeoning non-hard-copy outlets for images haven't eliminated the need to make prints. If anything, the availability of inexpensive photo quality printers encourages digital photographers to make bigger and better prints of their efforts, where they might have been satisfied with puny 4 x 6-inch prints from the photolab before.

Sizing Up Your Options

You've got lots of choices when it comes to making prints. You can upload your images to the HP Photo Web site (described in Chapter 8) and order prints there. You can visit your local discount store and pop a memory disk into a kiosk that lets you crop, enlarge, rotate, and print your favorite pictures. Many retailers have minilabs that are linked to digital workstations, so you can provide your pictures on a memory card and receive color prints made on conventional photographic paper at the same low per-print cost as for prints made from film.

Of course, the emphasis in this chapter is on prints you make yourself, and even in that arena you have lots of options even if the number of different technologies used has been shrinking in recent years. In the past, printing methods involving technologies with names like thermal inkjet, thermal dye transfer, dye sublimation, thermal wax, and solid ink all vied for your attention. Most of these technologies survive, but all except inkjet are confined to expensive printers for specialized applications.

Many people use laser printers, especially color laser printers, to print photos, favoring the relative low cost of laser prints, even if color laser printers themselves, such as the HP Color Laser Jet, are relatively expensive at $699 and up, and intended primarily for business applications.

No, the real winner in the color photo printing technology race are the color inkjets, which have evolved into a do-everything hardcopy device that can handle black-and-white text at high speeds, spot color applications (to print, say, a color logo or letterhead along with black-and-white text), and produce realistic color photos. If you're looking for a color photo printer, you're probably looking for some type of inkjet printer.

I knew the computer age had reached my small town (pop. 10,000) when I turned down an unfamiliar aisle of our new grocery supercenter and was confronted with an eye-opening shelf display. It was amazing to realize that if I ever had a printing emergency at 3 a.m. on a holiday I could trot down to our all-night grocery and purchase a back-up inkjet printer for a lot less than the cost of a week's food supplies. These ubiquitous peripherals were located in the school supplies section between the CD-Rs and the packaging tape.

Inkjet printers have come to dominate the low-cost printer market, chiefly because they are low in cost (surprise!) and, probably more importantly for digital photographers, they can produce hard copies that look very much like conventional glossy or matte photographs. A $100 printer that can produce vivid 8.5 x 11-inch photos is hard to beat. When you compare the cost of inkjet prints to those created by your photolab, you'll see that your personal, custom-tailored hard copies often don't cost that much more.

Inkjet printers operate by spraying a jet of ink onto a piece of paper, under precision computer control. Images are formed a dot at a time with a fine stream of ink, either water-based or solid (which is melted just before application) in disposable ink cartridges.

Choosing Printer Features

Selecting the best printer for you is a little like choosing a digital camera, as described in Chapter 5. You need to decide exactly what you hope to do before you can narrow down the list of features you really must have.

Hewlett-Packard makes color printers for several different types of applications. You'll find inkjet models for both business and home use which are excellent for both text and photographs, under the Business Inkjet, Color Inkjet, and Deskjet product lines. You'll also find Photosmart printers specifically intended for photo output, although they, too, do a good job with text and other more mundane printing jobs. There are even Deskjet Mobile printers for multipurpose portable use.

Although these printers share many features and capabilities, you'll usually find that the printers intended for business are a bit more rugged (and expensive) and have higher duty cycles (the recommended number of hardcopies the printer is designed to produce in a month). Business printers may also have ports built in so you can connect them to a network for use by any computer on that network. In that mode, the printer is not tied to a specific computer, unlike a printer you might use on your home network, which must be connected to a computer that is currently powered up before any of the other computers in the network can use it.

Here are some questions to ask yourself before selecting a color printer:

- How good is the quality? You'll want a printer specifically designed to produce vivid, photorealistic prints from digital images.

- What size paper can it handle? You'll want a printer that can use 4 x 6-inch paper for snapshots, and larger sizes for enlargements.

- How fast does it print? You'll find inkjet printers that can output as many as 20 pages per minute of text in black, and 12 to 18 prints per minute in color. Check to see how the vendor measures this output so you'll be able to compare speeds of various printers.

- Does it have memory card slots, and which types of cards does it accept? Make sure your printer can work with the memory cards your digital camera uses.

- Can it make borderless prints? These prints are more like the conventional prints you get from your photolab, plus, having no

borders, they use up every square inch of the photo paper for your images, wasting nothing.

- What is the paper input tray capacity? If the printer can hold at least 20 sheets of paper at one time, you'll be able to make a selection of prints before reloading.

- What capacity does the paper output tray have? You want to be able to have the printer stack finished prints neatly as they are printed.

- Does this printer also handle envelopes, transparencies, labels, index cards, and iron-on transfers in addition to document and photo paper?

- Does the printer have an LCD display screen and controls to allow selecting, enhancing, resizing, or otherwise manipulating image files before printing?

- Can this printer transfer images directly to a computer?

- What kind of ink cartridges does it use, and do they include special color photo and photo gray cartridges for the best image quality?

Once you've answered all these questions, visit your retailer. Take along some of your own pictures and ask to see sample prints. You'll be living with your printer for a long time, so you'll want to make a wise buying decision.

Printing Your Digital Pictures

As I mentioned earlier, there are three easy ways to make prints from your digital camera images. In this section, I'm going to show you just how easy they are.

Printing from Your Camera

If you have a digital camera that can be connected directly to a printer (as all HP digital cameras can connect to HP printers) through a USB or other cable, you can often make prints directly from your camera.

Connect your camera, find the printing function in your camera's menu system, select the number of prints, and start printing. You might be working with a menu like the one shown in Figure 10.3, or your particular camera may have more printing options.

FIGURE 10.3 Connect your camera to your printer, choose a printing option from the camera's menu, and print directly.

Of course, using this method means you can't do any editing of your photo prior to printing. But if you want a quick print of a snapshot, you can't beat direct printing from the camera for convenience.

Printing from Your Memory Card

A more flexible option is printing from your memory card, using a color printer especially designed for this task. Figure 10.4 shows the input panel of an HP Photosmart 7900 series color printer. Notice that it has slots for all the popular memory card types, plus a USB port for connecting a camera directly to the printer.

FIGURE 10.4 Insert your memory card directly into one of the printer's slots.

Your color printer will have a control panel like the one shown in Figure 10.5. This particular printer has controls for resizing, rotating, and saving the modified photo to your computer (if the printer is connected to one). There's even a button for printing all the new photos that were taken since that last time you printed photos from that card.

FIGURE 10.5 Some printer control panels look like this, with lots of buttons and options.

Other printers have less complicated controls, like those shown in Figure 10.6. Here's a quick rundown of what these controls do.

LCD screen. The screen in the center is a color LCD display used to preview your photos and let you view the printer's menus.

On button. At the upper left is an ON button that switches the printer on, or lets you put it into power-saving standby mode. An LED glows next to the button to let you know the power status.

Save. Under the ON button is a Save button, used to save the photos from your memory card to your computer, assuming the printer is connected to a computer. This feature is a quick way to transfer photos from your digital camera's memory card to your computer. You don't need a separate memory card reader in your computer; you can transfer your photos from the printer, even if you don't intend to print them at this time.

Menu. Next on the left side of the printer is a Menu button. This displays the menus available for the printer. These might include print layout (so you can print one, two, or four images on a single sheet of paper), or image enhancement choices (the printer can adjust brightness for you, or add colors, special effects, and frames around your images).

The menus of this particular printer also let you print index prints of thumbnails of the images on the memory card, select all the prints on the card for individual printing, or print only a range of images.

If that weren't enough, the printer can also display a slide show of the images on the card, print separate video frames from your digital camera's video clips, adjust contrast, and add time and date stamps to your prints. Remember, you're doing all this directly from the printer without using a computer at all!

FIGURE 10.6 Even a few buttons can provide many different features in a well-designed color printer.

Zoom. Underneath the LCD display and slightly to the left is a Zoom button, which can enlarge or reduce your view of a particular image, so you can check the image's detail more accurately. The button also can be used to display small thumbnails of nine images on the LCD simultaneously.

Select photos. Next to the Zoom button is a cursor keypad you can use to scroll through the photos on your memory card, position the crop box used to clip off unwanted portions of your image, or, in menu mode, scroll through the menu choices. Press the OK button in the center of the keypad to choose the current photo or activate a menu option.

Copies. The Copies button is used to select the number of duplicates of each photo you want to print.

Cancel. At the left side of the LCD is a cancel button, used to stop photo printing or another action currently underway.

Print. The big Print button starts the printer chugging away to produce the image you've selected for a hardcopy.

That's about all there is to printing from a memory card.

Printing from Your Computer

You probably don't need much instruction on printing from your computer, because you've been doing it for years, right? Actually, you may be surprised to learn about the options you do have.

The first step is transferring photos from your digital camera to your computer. When you insert the memory card into your card reader or connect your digital camera to the computer using a USB cable, you'll probably see the Windows XP wizard shown in Figure 10.7. One of the choices is to print using the Windows Photo Printing Wizard.

FIGURE 10.7 When you transfer digital photos to your computer, Windows XP will offer to print them for you.

Click OK to start the Wizard, and the next thing you'll need to do is choose the photos on the memory card that you want to print. You can mark one or more with a check to select that photo for printing, as shown in Figure 10.8.

Next, you'll need to select your printer from those available to your computer. If you have only one printer, it will be selected automatically, as shown in Figure 10.9. After that, you can choose a layout for your prints, and the number of images to print per page, as shown in Figure 10.10.

The wizard does a good job of leading you through all the steps you need to follow to make prints from your unedited digital pictures, directly from the memory card.

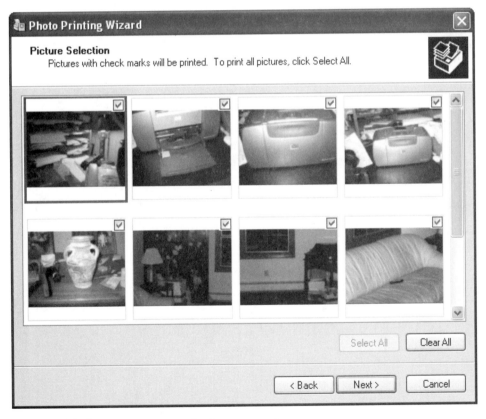

FIGURE 10.8 First select which photos to print.

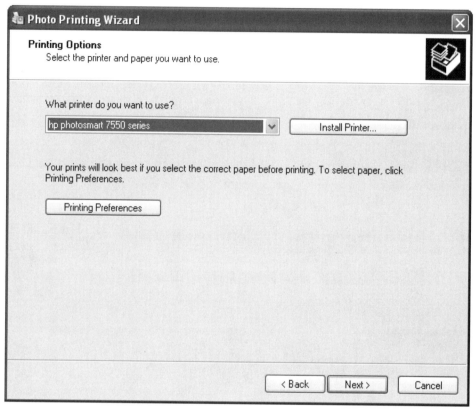

FIGURE 10.9 Choose your printer.

FIGURE 10.10 Select a layout. That's all you need to do.

You can also load your photos into an albuming program, like the HP Album Printing Software shown in Figure 10.11, or modify them in an image editing program like PhotoImpression, Photoshop Elements, or a similar application, before printing. (Check out Chapter 7 for more information on what you can do with an image editor.) Once you've made a few prints, you'll find the process easy, fast, and fun.

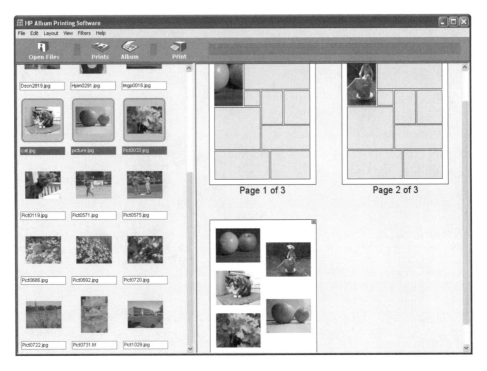

FIGURE 10.11 HP Album printing software helps you organize your photos.

Getting the Best Prints

If you make prints from your digital images yourself, you'll want to keep these tips in mind to get the best quality and best economy.

Calibrate. Use your image editor's provision for calibrating your monitor, if available, and any procedures offered for calibrating your scanner to your printer. This will help insure that what you see (on your monitor) is what you get (in your prints). If you're an advanced worker, learn to use the color-matching software provided with your printer.

Use the recommended paper. If quality is important to you, get the best glossy photographic paper for printing out your images. You can also get fine quality on the best matte-surface papers. Experiment with several different stocks to see which you like best. You'll probably find

that the paper offered by your printer manufacturer will be fine-tuned for your particular printer.

Clean your printer's printing mechanism regularly. Remember to clean your inkjet's print heads periodically and keep the printer's rollers and paper path clean. You'll avoid blurry or spotted prints and unwanted artifacts like visible lines.

Avoid marring finished prints. Don't touch your prints after they've emerged from the printer. Give them a chance to dry before you handle them.

Play with special papers. Experiment with special paper stocks that let you get even more use from your digital prints. You'll find paper designed especially for making t-shirt transfers, fabric printing, making greeting cards, or creating overhead transparencies.

Play it safe. Don't risk ruining one of those expensive sheets to a paper jam. If you're making prints one at a time, load your printer with one sheet of photo paper each time. Load multiple sheets only if you want to print many pages unattended, and even then make sure that only photo paper is loaded.

Don't overdo enlargement. Avoid disappointment by not blowing up your digital images more than the resolution of your camera allows. Use these guidelines as a rule of thumb:

Camera Resolution	Recommended Maximum Print Size
640 x 480 pixels	3.5 x 5 inches
1024 x 768 pixels	5 x 7 inches
1280 x 960 pixels	8 x 10 inches
1600 x 1200 pixels	11 x 14 inches
2400 x 3600 pixels	20 x 30 inches

Index

DIGI** 7 **PHY

Fr o R, MP

VIDE PE VD, and More!

David D. Busch

invent

www.hp.com/hpbooks

 Prentice Hall PTR
Upper Saddle River, New Jersey 07450
http://www.phptr.com
PRENTICE HALL PTR

Editorial/production supervision: *Kathleen M. Caren*
Cover design director: *Jerry Votta*
Cover designer: *Sandra Schroeder*
Art director: *Gail Cocker-Bogusz*
Executive editor: *Jill Harry*
Editorial assistant: *Brenda Mulligan*
Marketing manager: *Stephane Nakib*
HP Books publisher: *William Carver*

© 2005 by Hewlett-Packard Development Company, L.P.

PRENTIC HALL
PTR

Prentice Hall books are widely used by corporations and government agencies for training, marketing, and resale.

For information regarding corporate and government bulk discounts please contact:
Corporate and Government Sales (800) 382-3419 or corpsales@pearsontechgroup.com

For sales outside the U.S., please email international@pearsoned.com

Company and product names mentioned herein are the trademarks or registered trademarks of their respective owners.

Printed in the United States of America
Third printing.

ISBN 0-13-147219-4

Pearson Education LTD.
Pearson Education Australia PTY, Limited
Pearson Education Singapore, Pte. Ltd.
Pearson Education North Asia Ltd.
Pearson Education Canada, Ltd.
Pearson Educación de Mexico, S.A. de C.V.
Pearson Education—Japan
Pearson Education Malaysia, Pte. Ltd.